High Fashion Hats
1950 to 1980

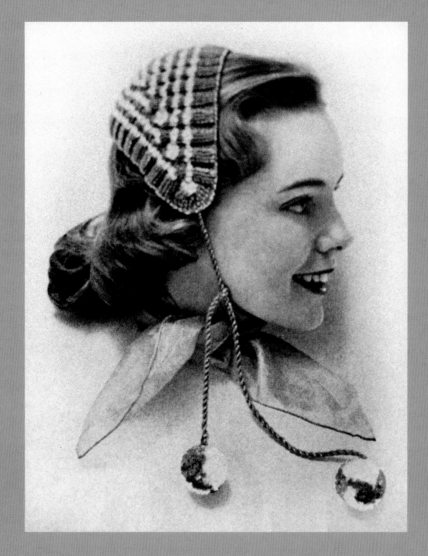

Rose Q. Jamieson and Joanne E. Deardorff
Photography by Joanne E. Deardorff

Schiffer Publishing Ltd

4880 Lower Valley Road, Atglen, PA 19310 USA

Dedication

This book is dedicated to the photographers and milliners of
past decades, in remembrance of their art and craft.

Published by Schiffer Publishing Ltd.
4880 Lower Valley Road
Atglen, PA 19310
Phone: (610) 593-1777; Fax: (610) 593-2002
E-mail: Info@schifferbooks.com

For the largest selection of fine reference books on this and related subjects, please visit our web site at
www.schifferbooks.com
We are always looking for people to write books on new and related subjects. If you have an idea for a book
please contact us at the above address.

This book may be purchased from the publisher.
Include $3.95 for shipping.
Please try your bookstore first.
You may write for a free catalog.

In Europe, Schiffer books are distributed by
Bushwood Books
6 Marksbury Ave.
Kew Gardens
Surrey TW9 4JF England
Phone: 44 (0) 20 8392-8585; Fax: 44 (0) 20 8392-9876
E-mail: info@bushwoodbooks.co.uk
Website: www.bushwoodbooks.co.uk
Free postage in the U.K., Europe; air mail at cost.

Other Schiffer Books on Related Subjects:
1000 Hats Norma Shephard
Stetson Hats Jeffrey B. Snyder
Baker's Encyclopedia of Hatpins and Hatpin Holders Lillian Baker

Copyright © 2006 by Rose Q. Jamieson and Joanne E. Deardorff
Library of Congress Control Number: 2006926536

Cover design by: Bruce Waters
Type set in Florens and New Baskerville

ISBN: 0-7643-2450-0
Printed in China

Contents

Acknowledgments

We give special thanks to Paul Jamieson for his support, interest, enthusiasm, concern, and patience at this time and always. Also our sincere gratitude goes to Denny Deardorff, Kelly Quaresimo, and Abby Deardorff for their understanding and support. And our deep appreciation goes to the Stroudsburg Foto Shop for their attention to detail.

Our friend, author Ellie Laubner, offered us her friendship over the years, and was our mentor both before we started this book and during the writing process. We appreciate all of her helpful suggestions, advice, insight, and inspiration. Anna Schildknecht, instructor of Introduction to the Fashion Industry offered at Northampton Community College, was a great help to us. Ernestine Elder, an Albright College instructor for Clothing Construction, Bishop Method Tailoring, Textiles, History of Costume, and Design, is my deceased college professor. Eleanor Pinto gave us her course in French Couturier custom tailoring. Dr. Eugene Stein, retired from the East Stroudsburg University graduate school as a professor of Introduction to Research, was an invaluable resource and inspiration.

The many contributors to the book include Kay Aristide, Adelaide Avella, Arthur Avella, MD, Martha Barnes of American Home Antiques, Phyllis Blanchfield, Dolores Bouch, Ann Bird, Jacqui Bird Smith, Jeanne L. Call of Facet Designs, Betty Carpenter, Bea Cohen, B. Lucille Compton who is a hat collector and lecturer, Marie Claus Danko, Joan Debolt, Antoinette DiBella, Dale and Mary Jo Eden, Bobbie Ellsworth, Victoria and Jim Emele of Emeles Antiques, Mary Anne Faust of Yesterdays Delights Vintage Clothing, Nancy Fedick, Sharon Fornaro of Rose Cottage Antiques, Anna Freed, Bill and Maria Fretz of Hex Highway Antiques, Antoinette Avella Gearhart, Gayle Gorga, Shari Gorga, Theresa Grassi, Joseph Grollman, Dot Grumer, Marguerite Grumer, Sandra and Ronald Hammer, Donna Hahn, Bobbie and Ernest Hemphill, Dave and Sue Iron of, Iron's Antiques, Helen Jiorle, Robert and Jackie Jiorle of Eclectibles, Karen Johns, Ted Johns of Harmony Barn Antiques, Kathy Kays of Rose Cottage Antiques, Barbara Kennedy, Kimberly Kirker of, Kimberly Kirker Antiques, Marion Kingsbury, Shirley Kohr, Wayne and Barbara Laucius, Colleen Lavdar, Marion Mahoney, Tony and Rose Marra, Suzanne Fretz McCool, Marianne Meyer-Garcia of Rose Cottage Antiques, George Miller of Ghost Mt. Manor, Roy and Eleanor Miller of Salisbury House, Beth Ann Mohler, Jane Shaneberger Moyer, Marlene Oberly of Plant Farm, Mary Frances O'Gorman, Violet and John Pammer, artist Karoline Schaub-Peeler, Eleanor Pinto, Judy Pisano, Jane Quigley, Lynn and Nelson Quigley, Mildred Quigley, Eleanor M. Rothermel of Eleanor's Antiques and Uniques, Francis Rufe, Tamara Selden, Faye Shaffer, Vangie and Donald Shweitzer, Josie V. Smull, Rene and James Stoufer, John and Carole Trombadore, Virginia Van Doren, Georgette and Paul Wolf, David Yost, Albright College Library in Reading, Pennsylvania; the Northampton County Historical and Genealogical Society in Easton, Pennsylvania; the Phillipsburg Library in Phillipsburg, New Jersey; the Warren Hill Regional High School Library in Washington, New Jersey; and Ellie Laubner's personal fashion library, and Joanne E. Deardorff's personal craft library.

Preface

One may wonder what would be the inspiration for writing a book such as this. It is the wonderful memory of all the beautiful hats we saw being worn by all types of people during our childhood. We remember the importance placed on hats by our grandmothers and our mothers. They even decorated their own hats! Hats were a most important fashion accessory. To be properly dressed, men and women alike, would never go out without a hat. It just wasn't done. Women had to wear a hat to be respectable. A man never ever went to work without his hat, whether he was a gentleman or laborer. Hats were also worn to complete *a look*, to make a statement, and to identify social class.

Young girls usually received their first fancy hat at Easter, called the Easter Bonnet. To be a young girl and to receive a fancy, fashionable hat was a thrilling experience. It was a rite of passage and let her know she was finally growing up.

Readers who are old enough to have lived through the hat eras will enjoy this book and the review of hat history it offers. Readers who were born after the end of the hat era will have a first hand view of what was going on in the fashion world before they were born. These younger readers will be made aware of the world of hats through period photographs and the photographs of the actual antique and vintage hats.

To understand the fashions of each period, a brief listing of historical events is included, along with a short summary of the fashion information of the time period. This will enable general readers, dealers, collectors, and students of fashion to view the hats in their chronological context or setting. Fashion plates, illustrations, and period photo-

graphs were included to give evidence of the different time periods. The hats are the final evidence. In some instances we had a period hat and were then able to find a period photograph showing how the hat was worn in its time period. We felt this would be of value to readers in dating their own antique and vintage hats.

Hats were so important in setting off an outfit and showing the personality of the wearer that they were worn for indoor and outdoor photography sessions. The art of the early photographer is very important, because it captured the people, their demeanor, and their costume for later generations to view and enjoy. The old photographs are a record of history and a source of primary research.

Included is a study of the important designers and milliners who made fashion history. Information about the history of some of the old stores is included to give a perspective of how the hats were sold.

The captions describe the hats and give the stamped and affixed label information, the fabric and how the hat was made and decorated. Interiors of some hats were photographed to show the detailed workmanship involved in their linings. A simple grosgrain band sewed around the inside was overlapped in the back, and this denotes the back of the hat. When labels were used, they were placed over the back seam.

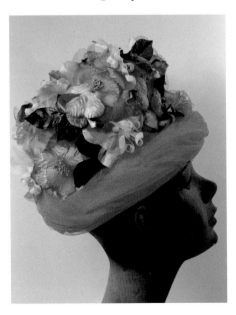

We included a listing of popular hat expressions and their meaning, information on care, restoration, and storage of hats. Pricing of hats is included and how the prices were derived.

Introduction

The Second World War caused leisured women in America and Europe to become workers at an accelerated rate, and these women really enjoyed the freedom and independence they gained, with money of their own and new-found skills and pride in their work. In the 1950s, the wearing of hats was prolific for social occasions, but gradually declined from what it had been in preceding decades.

Also, travel by airplane was becoming more popular in the 1950s. There was not enough storage space in aircrafts for women to bring a collection of hats and hatboxes for each outfit, so the number of hats they took on their travels became limited. As families began to move from the cities to the suburbs during this decade, their life styles changed as they became actively involved in community affairs. Clothing styles gradually became less formal and there were fewer occasions to wear a hat.

The hairdressers' art had survived since the 1920s and was constantly evolving, so that by the late 1950s fancy hairstyles interfered with hat sales. In the mid-1950s, a new, short, Italian Boy haircut became so fashionable that women went hatless at the Ritz Hotel in Paris! Another popular 1950s hair cut was the short, curly, poodle cut. Women were so exited about their new hairstyles that they had to show them off.

By the early 1960s, young women associated hat wearing with an older and more formal generation. Hats didn't fit in with their busy life style. New fashion leaders were also young and new hairstyles were the new important thing. Fashion designer Lilly Daché realized that hat wearing was on the decline. To keep her own business going, she gave hairdresser Kenneth a salon in her building.

By the 1960s, hair was considered a *headdress*. The beehive, a tall hairstyle, was teased and held in place with plenty of hairspray. The French Twist was another popular hairstyle that interfered with a hat. Hats had to be large enough to cover the hairdo, or a pillbox or whimsy sat on top of the hairstyles. The popularity of professional hairdressers forced many milliners to cut their staffs and to eventually go out of business. (Funny, this was the same situation in Marie Antoinette's time with tall powdered wigs. Hats had to be large enough to cover the hairstyles or something small that sat on top.) Hairpieces and falls were quite popular for eveningwear, and wigs were also big sellers. Half a million women wore wigs in 1962. Hairdressers would properly cut and style the wig to suit the individual. The hair coloring industry grew to be so successful that by 1961 $250,000,000 was spent in beauty parlors on hair coloring. By 1968 the hat was no longer a necessary fashion accessory. When Mr. John closed his shop, he said that it was due to the *orthopedic hairdos and French fried curls* the women were wearing.

An interesting perspective on the history of hats is given in the following 1959 business broadside for the Ethel Atkins Hat Shop of Boston, Massachusetts, which includes the poem "Then and Now," by Ethel Atkins.

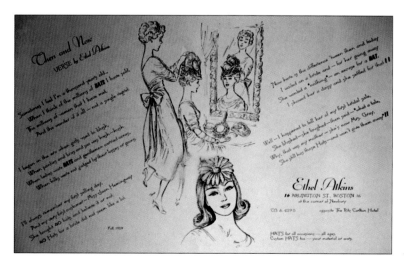

1959 business card of Ethel Atkins Hat Shop, Boston, Massachusetts with the poem "Then and Now," by Ethel Atkins. *Courtesy of Josie V. Smull.*

Who Wears Hats Today?

Cowboys wear cowboy hats on the job for protection from sun, heat, dust, and rain.

African American women wear beautiful large hats to church on Sundays and to other society functions.

Skiers wear warm headgear for protection while skiing.

The Easter parade is still a popular occasion, where people participate to show off their unusual Easter bonnets.

Large, impressive hats are worn each year for the **Kentucky Derby** horse races.

Hats are popular accessories worn for protection from the sun by fashionable women of all age groups in **Palm Beach, Florida**, according to Arthur Avella, M. D., a winter resident of the area.

Men and boys wear **baseball caps** to display their favorite team's name and to give protection from the weather, making the baseball cap a huge business today.

Today, women wear all kinds of **vintage hats** to fancy afternoon teas, which have become a popular event. Of course, the most popular hats worn by women today are "red."

Norwegian Princess Mette-Marit wears fashionable, 1960s-style, tall crown hats made feminine with ribbon trim.

In England everyone traditionally wears hats to important social occasions, such as weddings, christenings, and funerals. In 2004, everyone was excited to be present at the wedding of Prince Charles and Camilla Parker Bowles through television viewing. Camilla wore a large, white feather-covered, picture hat, a very feminine style. Viewers were excited to watch the "Royal Hat Show" and see the parade of guests and their hat choices for this most formal and festive occasion.

Hats are always worn at the **Ascot horse races** and to social events with the Queen.

Queen Elizabeth of Great Britain has her own large collection of beautiful hats, which are all color-coordinated to match her dress and coat ensembles.

Hat Expressions

It is fun to explore the roots of some well-known expressions that refer to hats. See how many you recognize.

Mad as a hatter – people who worked in the felt hat trade inhaled fumes from mercuric nitrate used for felting rabbit furs. Besides damage to the lungs, the fumes damaged the brain. Sufferers twitched violently, became paralyzed, lost their memory, and were mentally deranged before they died. Lewis Carroll was aware of mercury poisoning, because the process was in use by 1750; consequently he included the Mad Hatters tea party in *Alice in Wonderland.*

Put on your thinking caps - a statement made by teachers to their students.

At the drop of a hat – abruptly stopping one activity to begin another activity.

Hat in hand – implies humility. "I come to you, hat in hand." Also removing ones hat is a sign of respect.

Hats off to you – a form of congratulations.

To throw my hat in the ring – join an activity or project, or to be considered for a job.

A person who wears many hats – a person who has more than one role, job, or responsibility in his or

her life such as parent, coach, or family provider wears many hats.

Hat trick – make something, which is difficult, seem simple. By 1820 a French magician had already pulled a white rabbit out of his top hat. Also in British cricket if a team made three goals in a game, they received a hat from the local club.

Hat hair – a hairstyle that is flattened because of wearing a hat. An expression made famous by Harrison Keeler.

Talking through your hat – talk profusely on a subject, while having insufficient or incorrect information.

The men in white hats – refers to the "good guys," from early movies when they were so identified.

Tip of the hat or **Tip his hat** – a gentleman would lift his hat (fedora in the 1940s) off his head when a lady passed by and quickly put it back on his head. This was called *tipping his hat*. It was a means of acknowledging a lady and a way to show respect. A man also would *tip his hat* to congratulate someone.

Pass the hat – take up a collection to raise money for a cause.

Keep it under your hat - keep news to yourself; keep it a secret.

Throw your hat in the air – celebrate, such as college graduates who often demonstrate the tradition.

Bet your hat – risk everything

Old hat – something which is ordinary, common, or boring.

Values, Condition, and Care

The values of antique and vintage hats are based on the prices attained at auction sales. Visiting antiques shops and antiques centers gives another perspective on pricing. General antique shows and vintage clothing shows or shops are yet another source for pricing information. Hats can be seen for sale at outdoor flea markets, yard sales, and garage sales where prices vary from very affordable to expensive. The Internet also gives another perspective to hat prices.

Values of hats are always based on general beauty, originality of design, color, style, period of hat, designer, and general condition. Antique hats in excellent original condition always command the highest prices. Although vintage hats are still quite plentiful, they are bringing good prices, especially when they are in fine to excellent condition or when made by a desirable designer.

Hats are works of art from another time period and should be preserved. Attractive hats in lesser condition can be purchased and "revived" with a positive spirit and a loving hand. Some useful hints for restoring and repairing hats include cleaning the hat outside in the fresh air by gently brushing with a soft brush. Wool and fur felt hats respond well to a gentle cleaning with a dampened cloth, after a gentle brushing. Felt hats also can be carefully re-shaped by using a dampened press cloth and placing it at the spot to be steamed. Set the tip of the iron lightly on the press cloth and allow steam to form and then lift the iron up off of the hat. Do not slide the iron. Move the tip of the iron to the next spot to be steamed, using the press cloth. These hat-restoring techniques have worked for the authors, but in no way do they take responsibility for any dissatisfaction by others.

Rearranging and reshaping flowers along with bending the wire in the leaves can restore decorations on hats. Ribbons can be pressed, rearranged, and edges can be trimmed. Veils on hats can be pressed on a piece of waxed paper to add stiffness to the old veil. Sometimes hats with wires in the brims become misshapen and can be reshaped by a quick bend in the opposite direction, using both of your hands, thumbs, and index fingers.

Dealers sell supplies of antique ribbon, flowers, veils, and other decorations that can be used to restore an old hat. It is important to redecorate in keeping with the original period of the hat to keep it authentic. Try to keep stitches small and hidden, when making repairs with a needle and thread. The thread color should match the hat color perfectly.

Hats should be stored in cleaned out hatboxes, which are lined with acid free paper. Overcrowding of hats in boxes ruins the shape of the hats. Hats should be stored out of high temperature and humidity.

The 1950s
Prosperity and the Suburbs

Historical Events of the 1950s

1950-1953 The Korean War was in progress.
1952 Dwight D. Eisenhower becomes president of USA.
1953 Queen Elizabeth II of England is crowned.
British mountain climbers reach summit of Mount Everest, a coronation gift to the new Queen.
1956 Grace Kelly married Prince Rainier of Monaco.

High Fashion in the 1950s

When Christian Dior brought out his revolutionary "New Look" fashion collection in 1947, women in the Western world were ready for a change and the new look was widely accepted. This led to the popularity of full skirts and longer dresses during the fifties. Crinolines, going back one hundred years in fashion history, were worn to maintain the full silhouette. Popular skirts were almost ankle length, a complete circle, and made of taffeta, which rustled as the young lady walked. Cinch belts were worn with these skirts. After going through WWII, this new type of feminine clothing was a pleasure to wear and well received.

Besides the full skirt, Paris high fashion designers were showing tailored slender, straight dresses and suits. Coats of excellent quality wool fabrics were made in full and straight styles. This was a time of luxury after World War II. Balenciaga, known as the "master" designer, was producing custom-made clothing.

In the 1950s women continued wearing hats to church, as it was still required. Hats were worn because they were so beautiful and finished off an outfit. Hats were still worn for the important social occasions such as graduation, weddings and christenings, in addition to dining out and in nightclubs. The fancy little cocktail party hat was a highly fashionable item. Many were made in black only. To be properly dressed for business, women had to wear a hat and gloves to work. Of course, stockings were a must. Bare legs were con-

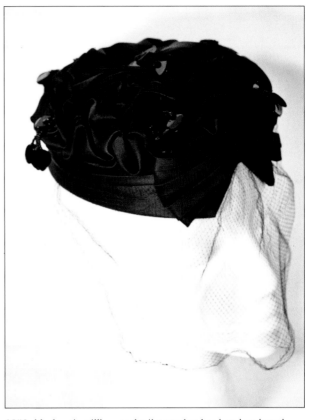

1950s black satin pillbox cocktail party hat has hand gathered crown decorated with jet beads and notched out band and bow. A full-face fine mesh veil finishes the hat, which is held on with two tortoise shell combs. Designer: Gottleib. Store label: Bonwit Teller. $95-125.

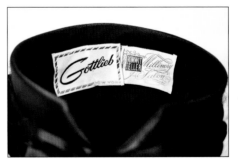

Inside of hat showing full lining, tortoise shell combs and designer label: Gottleib. Store label: Bonwit Teller Millinery Salon.

sidered improper and sleeveless dresses were not worn to work. By the 1950s women on some college campuses could wear slacks to class such as the calf length, tapered leg "toreador" pants, or the new knee length Bermuda shorts. Blue jeans were still not accepted for men or women at colleges in the 1950s.

1953 photo by Jaffe Studio, 175 Western Ave., Morristown, New Jersey showing a group of women wearing dresses, suits, coats, a "topper," and a large variety of 1950s hats, including half hats, Dior style picture hats, and popular small hats.

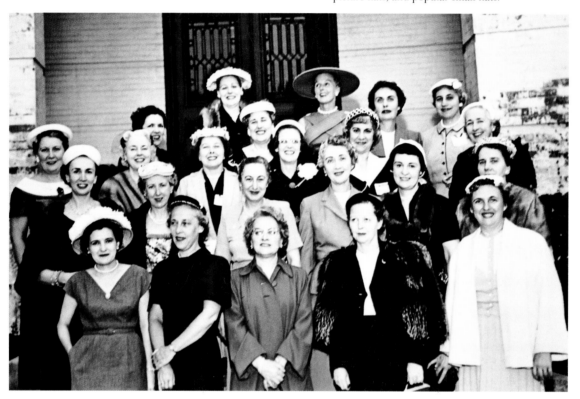

Hairstyles of the 1950s

During the early 1950s, women popularly wore their hair in the long pageboy style and pinned it up in a chignon. With the "New Look," some women cut their hair short, which created the "small head look." The new popular short hairstyles were the Poodle Cut, Italian Boy, and Pixie. Small, fitted hats were worn over the short haircuts of the "small head look." Later in the 1950s women were wearing long hair that was piled high on the head, creating the need for wide crowned hats to cover the big hairstyle. This fashion continued into the 1960s.

Young girls and teenagers who chose to wear their hair long combed it up and back to fasten it into a ponytail, which was tied with ribbon or a neckerchief.

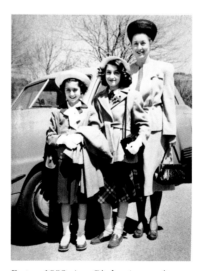

Easter, 1952. Ann Bird wears a suit set off with a large toque. Younger daughter, Carol, left, wears a Breton sailor with her suit. Older daughter, Jacqui, wears a simple bonnet with her "topper." Both girls wear gloves and all carry lovely purses.

Hats of the 1950s

In the February 12, 1951 issue of *Life* magazine, pages 67 and 68, the article "Hatless Hats" explains the spring hats of 1951 and shows pictures of new hats. The conventional hat was still used and veil hats were the new spring fashion to be worn at cocktail parties. The veiling was stiffened and blocked to form the new hat making material for these veil hats, which were also called "hatless hats."

Lilly Daché originated this latest fashion and the other designers followed. The most expensive veil hat Lilly designed was a fencers mask, selling for $79.50. Designed to cover the head and stand out in front of the face, it masked only the eyebrows and the lip area of the wearer was left uncovered, so the lady could smoke. Mr. John designed a cloche made of veil, which was covered with a full face and neck chicken wire veiling, selling for $65.00. He also designed "the eyes of youth," a narrow band of veil covering the wearers eyes and eyebrows, selling for $5.50.

1950s cream-colored cellophane straw hat with double folded front brim has two large black velvet buttons, which hold large black mesh trim. $50-65.

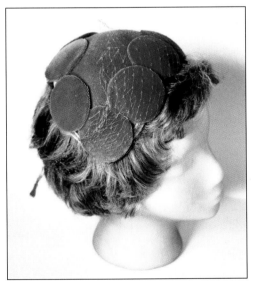

1950s tan velvet half hat decorated with circles and veil. Circle decoration was a popular 1950s motif. *Courtesy of Vangie and Donald Shweitzer.* $25-35.

1950s off-white straw crown with crocheted straw petal appliqué has self-covered hatpin. Remains of veil exist. Store label: Best and Company. $50-65.

John Frederics designed a "coverall" which veiled the wearers face and neck. It sold for $39.50. Another of his veil hat designs was the chignon snood, which was made to cover the popular 1950s chignon hairstyle. It was made of linen that was appliquéd to veiling and sold for $35.00. A veil hat made by Madcaps that only covered the crown and had a few petals sold for $6.50. These hats were intended for cocktail parties only, but some women were so excited about them they began to wear them with street suits.

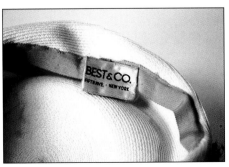

Label for off-white straw crown is Best and Company Fifth Ave. New York.

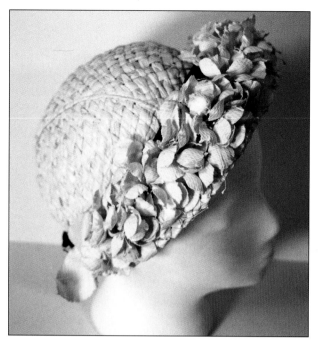

1950s hat is made of white cellophane straw woven in a diagonal design. Crown is made in three sections and trimmed with a black band. Brim is covered with bird's eye piqué flowers. $75-95

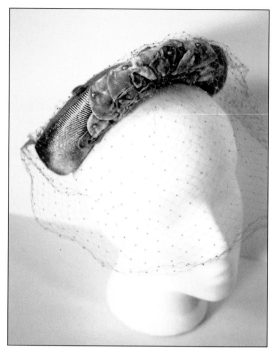

1950s close fitting cap of powder blue silk in twill weave has pink velvet petals, pearls, and nose length veil. Label: Miriam Lewis. $50-75.

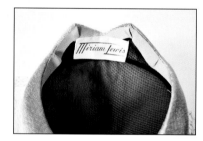

Inside view of hat showing Miriam Lewis label and capenet, an open mesh foundation fabric, which needs no lining because it is pleasing to the eye.

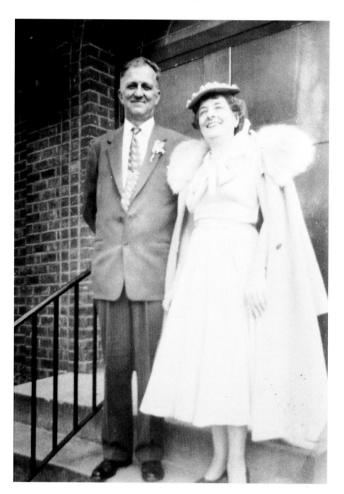

1950s couple comes out of church. The woman is wearing a long, full dress and fox fur trimmed coat. Her hat is a popular fifties flat style.

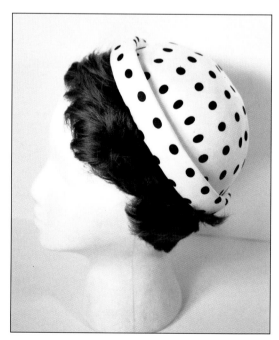

1950s white polka dot cap made of printed silk with rolled brim. Large polka dots were a popular motif. *Courtesy of Jane Shaneberger Moyer.* $40-50.

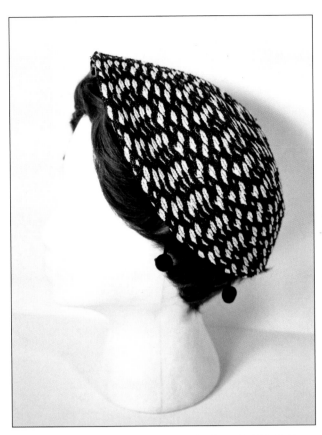

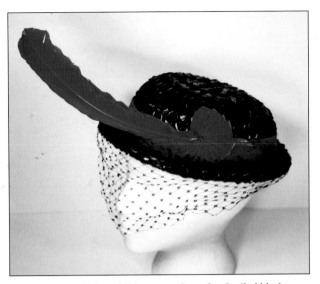

1950s boater style hat with low crown is made of coiled black cellophane straw. The trim is a red velvet band and cockade with a foot long red feather and nose veil. *Courtesy of Josie V. Smull.* $60-75.

1950s navy blue and white coiled straw hat is trimmed with ball fringe. *Courtesy of Jane Shaneberger Moyer.* $25-35.

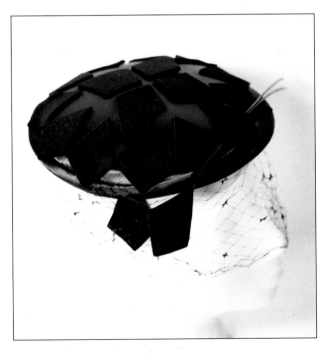

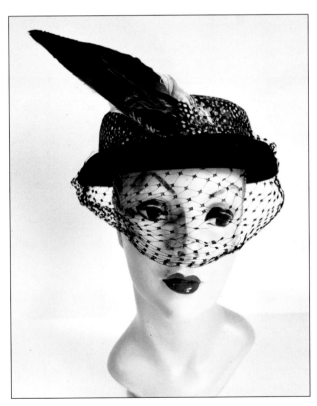

1950s velvet turned up brim and guinea hen feather crown made this sporty fifties hat with tall feather and nose length veil a popular style. *Hat and mannequin courtesy of Barbara Kennedy.* $125-150.

1950s navy blue felt diamonds are glued onto a purple saucer style foundation. The hat is held on with felt covered wire side tabs, called sideburns. Feather and veil trim hat. $50-65.

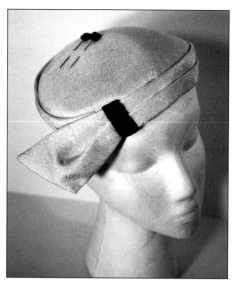

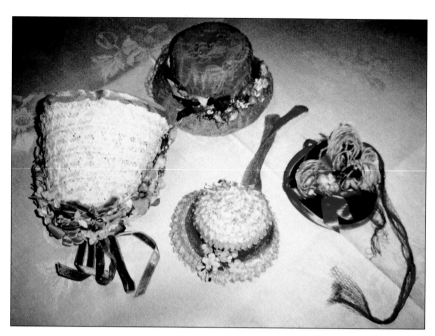

1950s white rayon fabric pillbox has navy blue velvet loop on belt style band. The hat is held on with two self-hatpins. Designer: Kay and Guy Anderson, New York. $40-55.

Group of four handmade hats made by milliner Helen Weaver. The large straw bonnet on the left was made as a gift for her niece, Joan Debolt, in 1950. *Courtesy of Joan Debolt.*

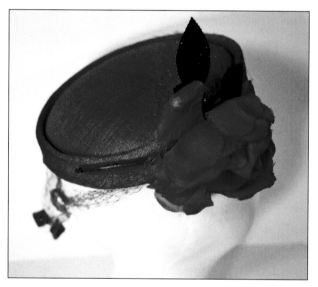

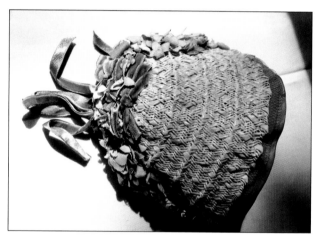

1950s outside view of Helen Weaver's straw bonnet showing blue satin bows and pink flowers. *Courtesy of Joan Debolt.*

1950s back view of hot pink pillbox with large rose and veil tied in back. Hat is made of plain weave rayon. $50-75.

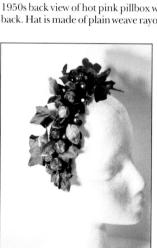

1950s well-made headband is decorated with green ivy, pink velvet and silk leaves, red velvet berries and pearls. $30-45.

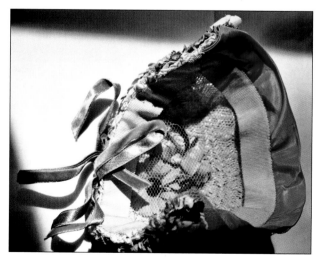

1950s inside view of straw bonnet by Helen Weaver showing net, satin grosgrain band, and flowers inside. *Courtesy of Joan Debolt.*

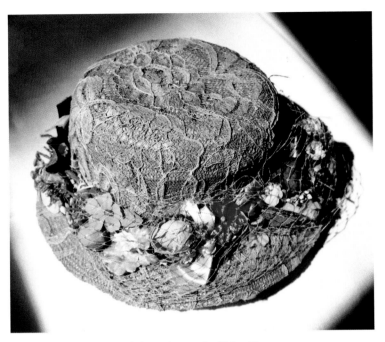

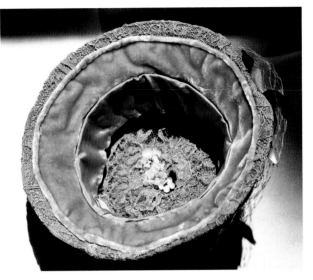

Outside of miniature bonnet by Helen Weaver. *Courtesy of Joan Debolt.*

1950s inside view of miniature handmade bonnet, by Helen Weaver, showing intricate lining. *Courtesy of Joan Debolt.*

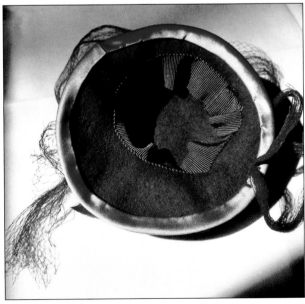

1950s top view of fancy miniature blue felt sailor's hat by Helen Weaver showing flowers, satin ribbon, feather, and veil trim. *Courtesy of Joan Debolt.*

1950s inside view of miniature blue felt sailor hat made by milliner Helen Weaver. *Courtesy of Joan Debolt.*

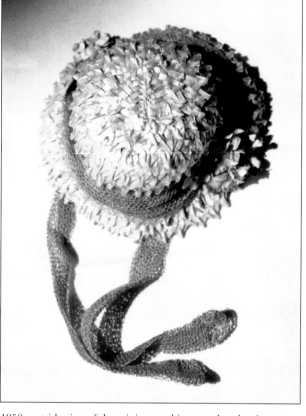

1950s outside view of the miniature white straw hat showing net and flower trim. *Courtesy of Joan Debolt.*

For Christmas in 1950, Joan Debolt was given a collection of miniature hats, which was made by her great Aunt Helen Weaver of Marietta, Ohio. At first Helen worked in a millinery shop there, and later moved to Columbus and worked in the hat department of Montalvos Department Store. Someone at the store had a luncheon and Helen made the miniature hats as favors for the guests. Helen also made custom hats for her customers.

The full size bonnet was made for Joan Debolt by her great aunt in the 1950s when Joan was a child. These hats are a treasured remembrance of Joan's aunt, who hand sewed the hats with a long thin milliner's needle. Interior views of the hats are offered to show Helen's excellent workmanship.

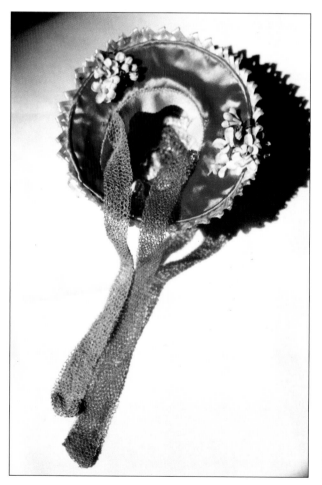

1950s inside of miniature straw hat by Helen Weaver showing pink satin lining, ties, and flowers. *Courtesy of Joan Debolt.*

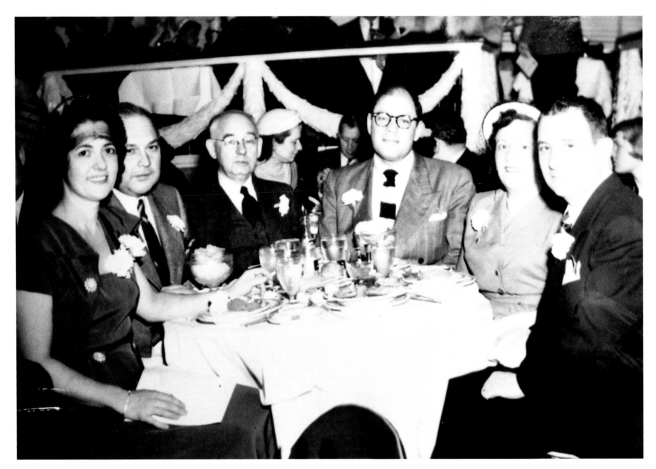

1953 souvenir photo of people dining out at the Copa lounge of the Copacabana. Women are wearing small hats with veils.

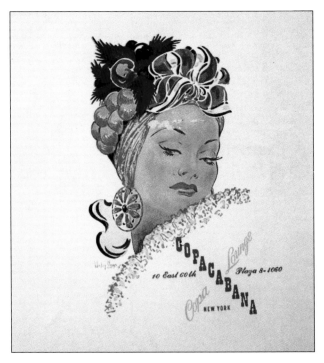

1953 cover of a souvenir picture from the club Copacabana, 10 East 60th, New York. Woman's head is wrapped in a bandana and decorated with fruits and leaves, which reminds us of movie star Carmen Miranda. Artist signature on bottom left.

The March 5, 1951 issue of *Life* magazine gave the first report about the Paris Collections. The cover shows a model wearing a printed Dior dress with a matching stole. Its full skirt had fine pleats and was held out over a stiff petticoat; hence, we see the popularity of the finely pleated Dior style hats.

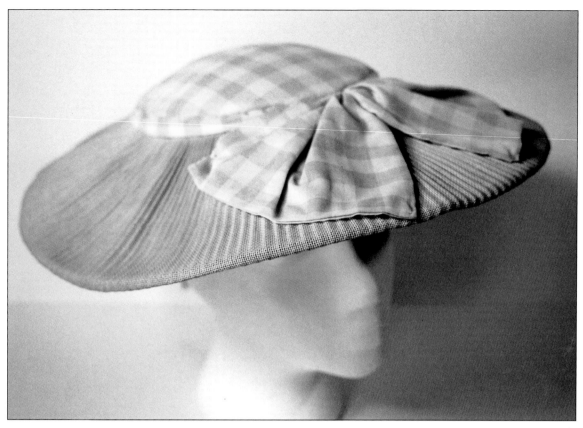

1950s Dior style dish hat is made of finely pleated beige fabric and large check gingham. Crown was hand covered and a band was hand sewed in place. Large soft bow rests on brim. $50-75. *Courtesy of Shirley Kohr.*

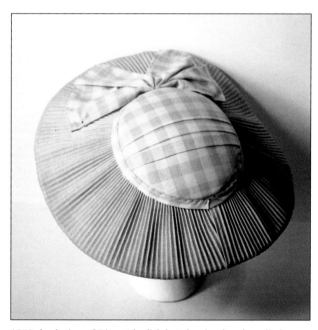

1950s back view of Dior style dish hat showing hand applied gingham trim and pleated beige fabric. *Courtesy of Shirley Kohr.*

Also covered in the March issue were five spring hats made by Schiaparelli each selling for $100. They were all off-the-face hats worn at the back of the head. One was worn at the back of the neck, cowboy hat style. A pleated fan hat was worn with a pleated bodice dress. Dior had also designed a similar fan hat. Schiaparelli designed a cone hat made in the style of an Etruscan tutulus and adapted it by using two narrow brims against the cone body, instead of one. This hat sat back on the head, while the Etruscan men wore theirs squarely on their head. This is the origin of the 1950s cone hats.

Alfred Solomon, of Madcap Hats, attended the showing and bought some designer hats. He reproduced them for U.S. women and they sold for $7.00 each.

In November 1952 Queen Elizabeth presided over her first Parliament. For the occasion she was dressed in her great-great-grandmother Queen Victoria's long robe and coronet. Queen Elizabeth was photographed riding in the coach and the picture was so popular that Prime Minister Winston Churchill bought himself two copies of this photograph.

In the May 14, 1956 issue of *Life* magazine, an article entitled "Gainsborough Look in New Fashions" discussed the summer Dior collection. For his New York summer collection in 1956, Christian Dior designed four beautiful English dresses inspired by 18th century portraitist Thomas Gainsborough. The dresses were calf-length made of yards of all-white or pastel sheer silk, piqué, dotted organdy and eyelet. They sold for $195 to $385. The full, ruffled dresses were shown with Dior's cartwheel hats made of natural Italian leghorn straw.

Sally Victor designed a large garden party hat with large roses in the 18th century romantic style selling for $75. Another Sally Victor style was the large leghorn straw trimmed with a wide ribbon that could be worn draped down the back or framing the face in front. Cost was $75.

Older, well-established women who could afford these expensive designer hats kept the high fashion industry alive.

Hats of the 1950s were designed to compliment or complete the outfit. Popular hats of the 1950s were the shallow pillboxes held on with the elastic back band. They were worn flat on the head. Later styles were held on with a small tortoise shell plastic comb on each side.

In 1947 Dior brought out the large dish hats to top off his "New Look." These were popular well into the 1950s. Some were held on with the elastic back band as well as the platform or sideburn frame. This style had a small, round, flat crown and a large brim and it was a new form of picture hat. Dior brought out a large cartwheel to go with his Gainsborough collection. Other large picture hats were popular at this time. For women who still had long hair, Dior, Emme, and Givenchy brought out chignon hats worn to cover the chignon in back. Dior was noted for his turbans in bright and soft colors. Dior introduced his large Sou'wester hat, which was based on a fisherman's style hat, long in the back and short in the front. The hat covered the larger hair styles and was still popular in the 1960s. Half hats and flower hats were other popular styles.

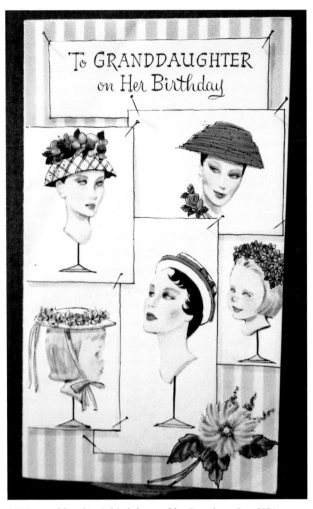

1956 granddaughter's birthday card by Greetings, Inc. USA, showing a fuchsia-draped peachbasket hat and other women's and children's hats of the 1950s.

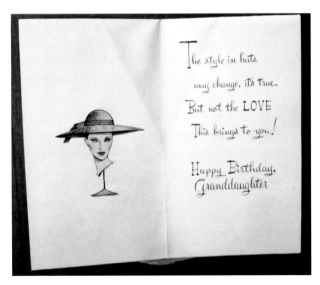

Inside the card showing a popular large picture hat.

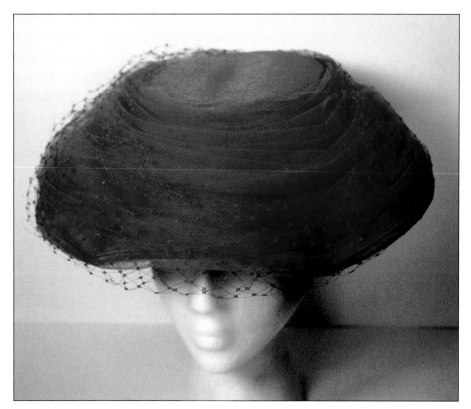

1956 hot pink draped peach basket style hat with a downward brim is trimmed with netting and veil. $60-75.

1950s beige and champagne daisy bandeau hat with veil and bud pearl trim. *Courtesy of Marguerite Grumer*. $20-25.

1950s powder blue twill weave fabric hat decorated with silk flowers and held on with wire side burns. Back veil ends in pompom and rhinestone decoration which keeps veil from spreading out. The rhinestone at the end of the veil is the sign of a 1950s hat. $50-65.

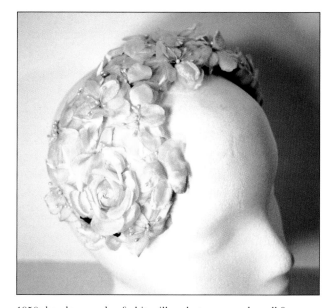

1950s bandeau made of white silk, velvet roses, and small four petal flowers with pearl centers. $25-35.

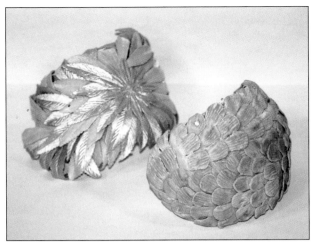

Two 1950s beige half crown hats are made of embossed velvet petals and leaves. $20-30.

1950s five leaves are applied to the skullcap to form the brim. Hat is decorated with hand sewed seed beads, sequins, self-ribbon, and bow. Store label; John Wanamaker. Stamped: Fur Felt Made in France. $45-65.

1950s popular bandeau hat trimmed with velvet bow and rhinestones. *Courtesy of Marguerite Grumer*. $15-20.

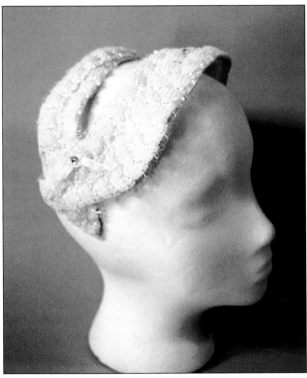

1950s black silk velvet hand made draped toque is made by Betty Jaeger, 667 Madison Ave., New York City. The hat is finished off with a large velvet back bow. $65-80.

In the late fifties hair was still worn long and up in the big, high styles. Milliners wanting to stay in business designed hats with crowns large enough to hold "all of the hair." For riding in a convertible, kerchiefs, petal toques, or wig toques held the hair in place during the windy ride. Dinner and theater required the "little black hat," which was made in so many styles.

The Davy Crockett coonskin cap was a big seller for children and teens.

President Dwight Eisenhower wore a Homburg to his presidential inauguration, instead of the top hat. This led to a period of large sales for the Homburg. Mrs. Eisenhower was a good customer of Sally Victor and wore a Victor hat to the inauguration.

In the 1950s British Prime Minister Anthony Eden wore the Homburg.

Designer Lilly Daché

Lilly Daché was born in Beigles, France in 1895. She had an attractive sister with curly hair. Lilly's mother always compared the girls and told Lilly she was so unattractive it would take a large dowry to marry her off.

Lilly was dissatisfied with school and wanted to quit to get an apprenticeship with milliner Caroline Reboux. That didn't last long and in 1924 with $13.00 in her pocket, she was sent to America to live with her uncle in Atlantic City. She got a job in Philadelphia and didn't like the city; however, when she took the train to New York, she fell in love with the city. Her first job was at Macy's where she didn't like the complicated, impersonal routine she had to follow, because she wanted to get involved with each of her customers.

After Macy's she worked at a hat shop on Broadway at 77th Street. Lilly and the other assistant bought out the owner when she left to get married. Eventually her partner left to get married and Lilly bought her out. In less than two years in America, she owned her own building. In 1928 her new location was 485 Madison Avenue and in 1937 she was at 78 East 56th Street in the award winning building she built.

At the high point of her career she produced 9,000 hats a year. She designed for 40 years, retiring in 1967 and is noted for the turbans she draped on her client's head while they sat in her shop. She considered the woman's facial features, hairstyles, and clothing as she did the custom designing. She was a top New York milliner when hats were the most important part of a woman's outfit. She also designed berets, slouch hats, cloches, cartwheels, and lampshades; in addition, she is noted for hat shapes and ornamentation.

Two of her Hollywood clientele were Marlene Dietrich and Audrey Hepburn. When Halston graduated from art school, she gave him his first apprenticeship. In the 1950's Lilly Daché had clothing lines, costume jewelry, face powder, Dashing and Drifting perfumes, men's ties, and wigs. She also wrote two books: *Talking Through My Hats* and *Lilly Daché's Glamour Book*. Her hat labels included Mlle. Lilly, Lilly Daché Debs, and Dachettes.

In the early 1960's she realized that hat wearing was on the decline due to the large hairstyles and she gave hairdresser Kenneth a hair salon on her premises. In 1968 Lilly's husband Jean Despres, executive vice president of Coty, was retiring and Lilly decided to retire with him. Her last customer was movie star Loretta Young who bought the last thirty hats in the shop. Lilly enjoyed wearing wigs. She thought they were comfortable and versatile. She designed the famous "wig hat."

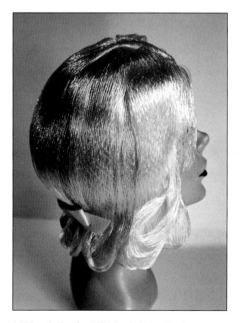

1950s wig hat by Lilly Daché New York covered with net and trimmed with grosgrain bow. *Hat and mannequin courtesy of Barbara Kennedy.* $450-500.

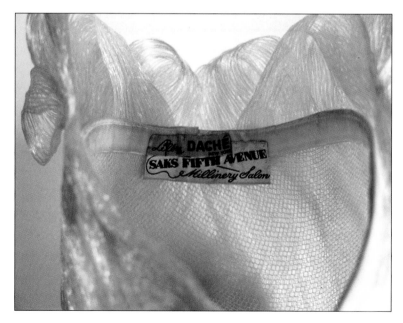

1950s inside view of Lilly Daché New York wig hat showing inner construction and label. *Courtesy of Barbara Kennedy.*

1950s designer hatbox decorated with logos of four designers: Sally Victor Headlines, Dachettes designed by Lilly Daché, Mr. John "Pace-Setters," and Emme Boutique. $25-50.

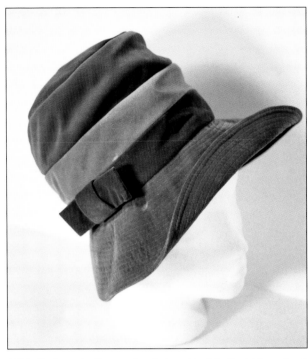

1960s Dachettes' tall crown hat designed by Lily Daché is made of cotton velveteen in mustard shades. Crown is constructed of four sections and has a side tailored bow. Brim has eighteen rows of machine stitching and is sewed up in front. $90-110.

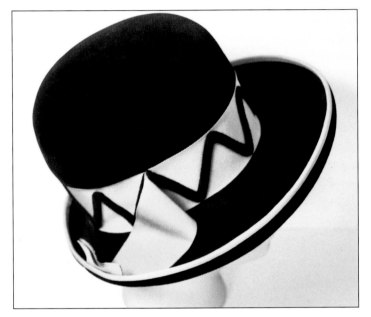

1960s black felt tall crown derby with rolled brim has tan grosgrain ribbon trim, which is decorated with black felt in a zigzag pattern. Label: Dachettes' designed by Lilly Daché. Stamped: Contessa HB Imported Fur. Body Made in Italy. $75-125.

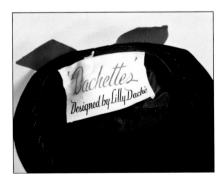

Inside of hat showing label: Dachettes' by Lilly Daché.

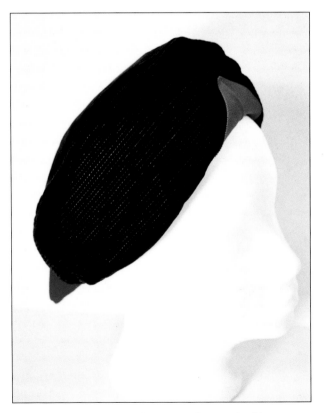

Lilly Daché navy blue velvet beret has red grosgrain ribbon diamond in front and tie in back. Rows of red machine stitches trim side. $85-135.

Designer Hattie Carnegie

Hattie Carnegie was born Henrietta Kanengeiser in Austria, in 1886. Her father brought his family to New York when she was six years old. By the age of eighteen, she was working for R. H. Macy's store as a messenger. In 1910 she changed her name to Hattie Carnegie, taking the name of the wealthy industrialist, Andrew Carnegie.

Hattie Carnegie established a shop in New York in 1909 to sell custom clothing that attracted wealthy clients, including Mrs. Randolph Hearst. "Carnegie Ladies Hatter" was her early label; by 1918 she was "Hattie Carnegie Inc." Her lines of clothing gradually included jewelry, hats, perfume, and other accessories. She moved to East 49th Street, New York, and continued to promote her business by wearing her own creations to fashinonable establishments. The Dutchess of Windsor, actress Joan Crawford, and other famous people became her clients. During W W II, she designed the uniforms for the Women's Army Corps (WACS). Her shop closed in 1950, but the business continued supplying other retail stores. When she died in 1956, she left a fashion empire with a thousand employees.

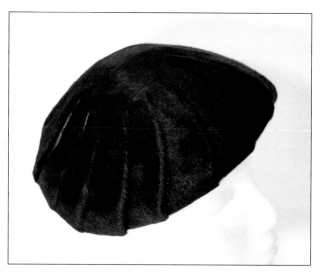

1950s black fur felt beret is made over a net frame. Designer: Hattie Carnegie. Store label: Mrs. Franklin Shops of Philadelphia, Inc. $50-75.

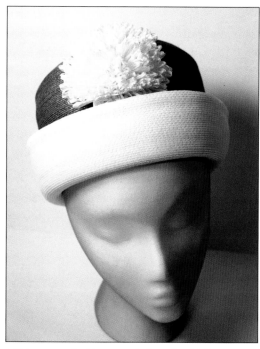

1960s gray and white straw derby style with large cellophane straw carnation. Label: Union Made U.S.A. Store label: Sold by Gimbels. Designer: Miss Carnegie by Hattie Carnegie. $70-85.

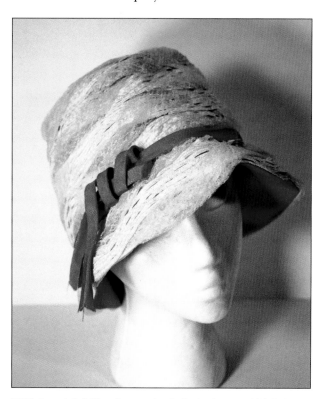

1960s hot pink faille tall crown hat is the basis over which beige and off white nylon net and straw were applied. The tie trim around the crown and informal knot are made of self-fabric. Designer: Hattie Carnegie. $95-110.

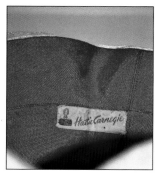

Label: Hattie Carnegie.

Designer Elsa Schiaparelli

Elsa Schiaparelli was born in Rome, in 1890, to a family of intellects. As a teenager she married and moved to New York City. She had a daughter and eventually the marriage failed. Having to support herself and the child, she used her talent to design and knit sweaters. In 1929 she opened her knitwear business, a couture house in Paris, which quickly became a success. She made the most unforgettable sweater, a black silk pullover with white bow tie knit into the sweater. It looked real and the technique she used was tromp l'oeil (trick of the eye). A store buyer saw the sweater and placed orders, putting her in business.

In 1935 Schiaparelli opened a boutique and increased her line by adding dresses. She made evening dresses with matching jackets, which had wide lapels, large shoulders and small waistlines. By 1936 she had 2,000 employees. Her signature color was "Shocking Pink," which also was used for her hatboxes. Her perfume called "Shocking" in an hourglass-torso bottle was another of her trademarks. A "Shocking" perfume bottle sold for $193.00 at a New Jersey auction gallery in July 2004.

She was interested in ethnic costume and created the fashion for Tyrolean Peasant clothing in the 1930s. Austria was the popular resort at this time for the elite. In 1938 Schiaparelli designed the coat, which had the square, masculine boxy shoulders.

In the 1940s during WWII she stopped designing and moved back to the U.S. During her stay she lectured throughout the United States and opened a store in New York. After the war Schiaparelli returned to Paris and began her business designing her classic black dresses. She closed her business in 1954 and remained a consultant to companies licensed to use her name. She died in 1973.

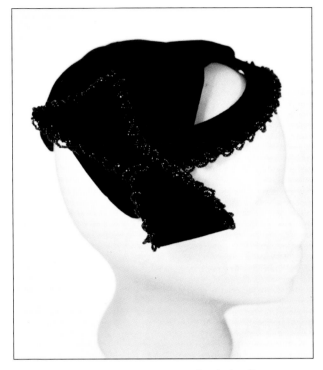

1950s Schiaparelli little black hat has jet bead trim. $75-95.

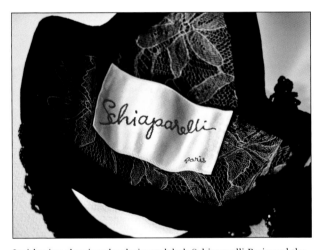

Inside view showing the designer label: Schiaparelli Paris and the fully lined lace interior.

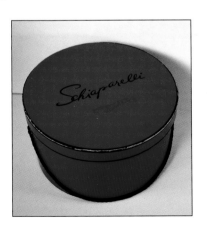

1950s hot pink Schiaparelli hatbox. $40-50.

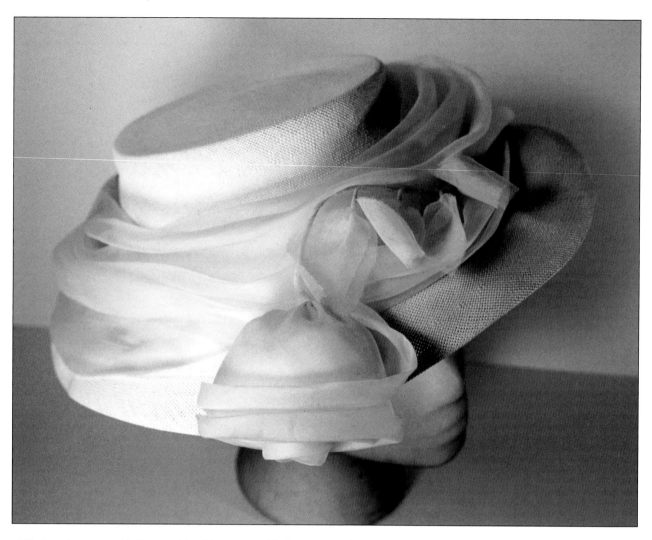

1950s fine white straw with bias cut white silk organza softly draped around crown with matching handmade rose. Designer: Schiaparelli. Store label: John Wanamaker. *Courtesy of Fae Shaffer.* $95-125.

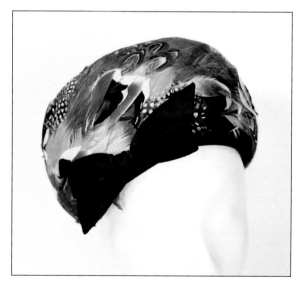

1963 fur felt satin banded bubble toque covered in feathers is set off with bow. Designer label: Schiaparelli. Stamped: Made in Italy. *Courtesy of Fae Shaffer.* $75-95.

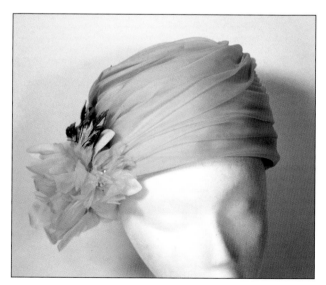

1974 wedding hat worn by Fae Shaffer is a bias cut draped silk chiffon turban by Schiaparelli. Bouquet was worn at the side. *Courtesy of Fae Shaffer.* $70-85.

Designer Christian Dior

Christian Dior was born in Granville, France, in 1905, the son of a wealthy industrialist. He began his designing career with hats for milliner Agnés. Marcel Baussac, a businessman in the textiles industry, backed Dior so he could open his own business in 1947, when he designed his revolutionary Corolle Line, nicknamed the "The New Look." The clothes had a beautiful, feminine silhouette with a mid-calf skirt made of many yards of fabric. Fabric had been scarce during the war and to use enough to design this style was a true luxury. At this time, Britain was still under fabric rationing, and an outfit using so much fabric was unthinkable. The skirts for his "New Look" outfits were held out with two or three petticoats. His jackets had a tight fitting bodice with rounded sloping shoulders and a fitted waistline. Hips were padded to make the waistline seem even smaller and the tight corset was back. The Dior large-brimmed, flat dish hat was designed to set off his long, full skirts. Miss Dior was the less-expensive Dior line. He died too early, in 1957, only ten years after his "New Look."

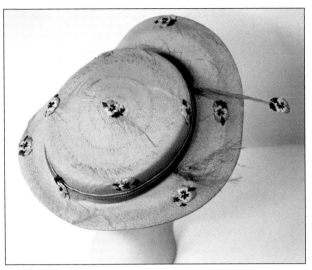

1950s finely woven yellow straw hat in Dior style has pansy appliqués placed on crown and brim. Remnants of veil and streamer remain on brim. $60-75.

1950s Designer Christian Dior Chapeaux Paris New York beret is made over mesh form. Top of crown is white nylon straw and a border is made of woven strips in lattice design with fine mesh showing through the lattice design. *Courtesy of Marion Kingsbury.* $95-125.

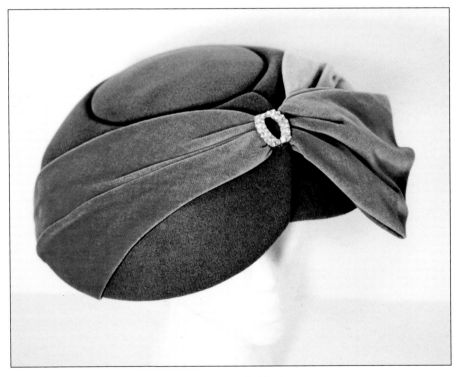

1950s Dior style dish hat made of gray felt trimmed with bias cut cotton velveteen "belt style" band of lavender, which is fastened by Aurora Borealis pin. Store label: Lazarus Model, Cincinnati Paris. $95-125.

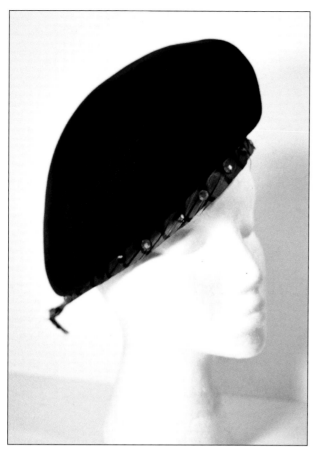

1960s Christian Dior brown felt beret has a band of pheasant feathers and colored rhinestones. $95-110.

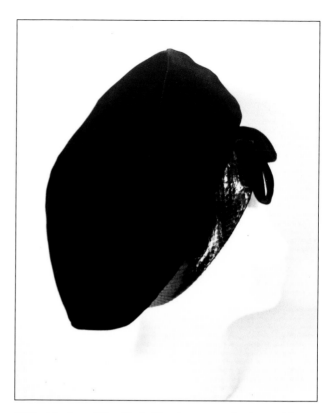

1960s side view of Dior black silk velvet two-section beret with genuine cobra band.

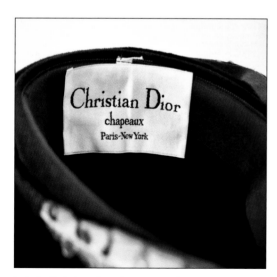

Label: Christian Dior Chapeaux Paris – New York.

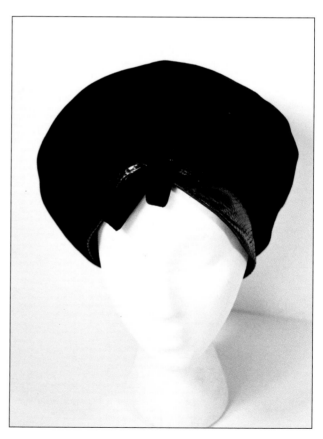

1960s two section black silk velvet beret with genuine cobra band. Designer label: Dior. $80-95.

Hat Manufacturer Alfred Zins Solomon, Mr. Madcaps

Alfred Zins Solomon (1899-2004) was the founder of his own hat company called Madcaps, operating in the garment district of Manhattan. His sister Janet Sloane was his partner. In the 1920s Mr. Solomon was already in the hat business and was importing hat trimmings from Europe. Paris milliners were using marcasite stones and he was able to import the same from Czechoslovakia. He started his hat business by going to Paris and buying designer model hats to show to New York hat manufacturers. They could select their choice of trimmings from him and copy the high fashion model. They could make their own "knockoff" and sell it.

When he was beginning his own manufacturing business, he had help from Parisian milliner Agnés in designing the model of a little hand crocheted hat. He continued to make it in different styles over the years. His shop was on 39th Street. Customers visited the shop and selected from high fashion versions of hats. Coco Chanel was his friend and he was selling "knockoffs" of her hats, too. Mr. Solomon and his wife attended the Paris fashion shows and those in other European cities to buy designer hats and to get ideas for manufacturing.

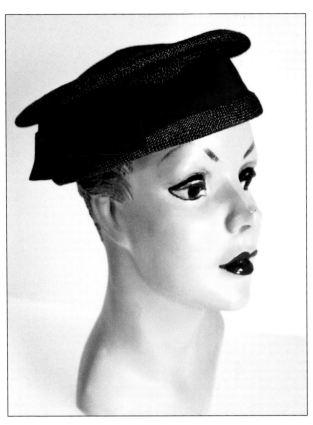

1950s blue straw sailor hat has trim of grosgrain ribbon band and side bow. Label: Madcaps Paris New York. $25-35.

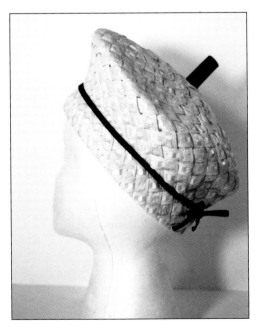

1950s tam style hat is woven on a diagonal from a combination of white cellophane straw tape and trimmed with navy blue grosgrain ribbon around crown and at the top. Manufacturer: Madcaps, New York, Paris. $35-50.

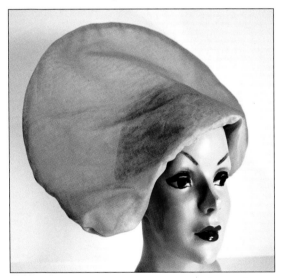

1950s powder blue silk organza bicorne style hat made over net base by Madcaps is held on with two tortoise shell combs. *Hat and mannequin courtesy of Barbara Kennedy.* $80-95.

Inside view of hat showing construction and labels: Original Fashion by Madcaps Paris – New York and on the label, Mr. Solomon gives credit to the original designer: Reproduction of Hubert De Givenchy Paris. *Hat and mannequin courtesy of Barbara Kennedy.* $80-95.

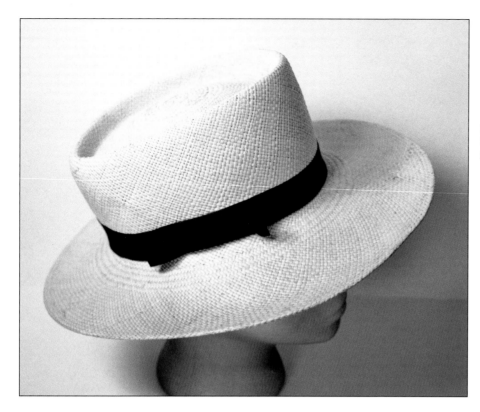

1950s masculine style woman's straw Panama has pork pie crown and black grosgrain trim. Label: Madcaps. $50-75.

According to Mr. Solomon, in the early 1930s there were only two types of hats: "better" which sold on the fifth floor and "budget" which sold on the third floor. He worked hard to get hat sales moved to the main floor with accessories and originated the idea of "hat bars," placing all of the hats on the counters out in view so women would be able to try on many hats in a short time.

In the 1950s and 1960s, to advertise his hats, he visited Bloomingdales and Bonwit Teller. The stores announced his visits by calling him Mr. Madcaps. Solomon had a collection of fifty of his own straw hats that he wore. He lived in Saratoga, New York on Madcap Farm.

1970s raspberry colored molded felt bicorne is by Madcaps. $25-35.

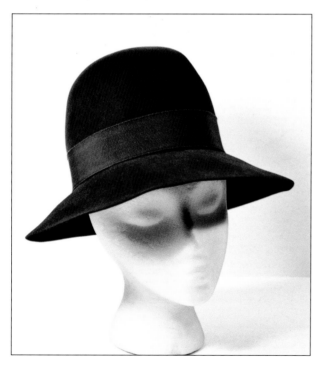

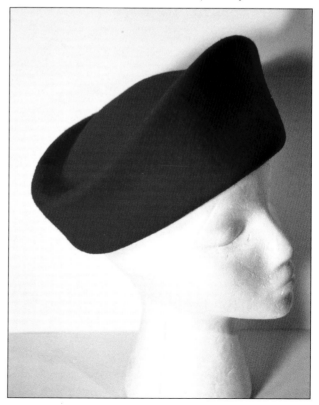

1960s brown felt with wide, tall crown is designed for large hairstyle. Stamped: Made in France. Designer: Mad Caps by Flechet. Store label: Peck & Peck Fifth Ave. New York. $30-40.

Designer Sally Victor

Inez Robb in her article, "Sally's Sensational Hats" in a *Post* issue explained Sally Victor's life and work. Sally Victor's father, Adolph Josephs, came to the United States in the early 1900s from Austria and settled in Scranton, Pennsylvania. When Sally was two years old, the family moved to Brooklyn. Sally's mother thought all of her daughters should become competent homemakers; consequently, all were taught to sew.

By the time Sally was a senior in high school she was already making hats for the neighborhood women. She made a hat for a woman whose husband was in the retail millinery association. The lady liked the hat so much that her husband gave Sally a letter to the vice president in charge of millinery at R.H. Macy & Co. Sally was hired to be a stock-room girl for twenty-five dollars a week. In her spare time on the job she designed and constructed a sailor hat trimmed with flowers and berries. It was put in the millinery department and sold in five minutes. Mr. Meyer ordered Sally to make 400 more of the same hat. The hats sold out in one day and Sally's salary went up to $40 a week. In fifteen months she got a job as a buyer of millinery for Bambergers in Newark, NJ for $100 a week. Two years later she married Sergiu Victor who had his own wholesale millinery business. After the stock market crash in 1929, she worked in her husband's business under the label "Sally Victor of Serge."

In 1932 Dorothy Shaver, then Vice –President of Lord and Taylor, featured Sally Victor in the Lord and Taylor monthly window display, which was a great honor. Sally's husband gave her $10,000 to start her own business at 18 East 53rd Street. She continued her wholesale business and went into the *haute couture* design. By 1938 her business was so large her husband had to join her, and it became Sally Victor, Inc.

In the 1930s Sally was designing pillboxes and Breton sailor hats. She went to museums to study paintings for inspiration. She had a photographic memory and could easily remember details and incorporate them into her own original designs. She worked with felt, velvet, fur, satin, tulle, and feathers on a milliners block. She had to feel the fabric in her hands in order to design and create.

In 1956 Sally Victor won the Coty "Winnie" for a flowered hat she designed. That was the beginning of the all-over flower hat popularity. In 1956 Prince Rainier bought an Easter bonnet from Sally for his fiancée Grace Kelly. Sally had a label in the 1950s called Sally V, which sold for $15. This inexpensive line helped to make her wealthy. She designed 2,000 hats a year and her originals sold from $65 to $400 each in 1962. She also revived cloches, off-the-face hats with wide brims, and dinner and theater hats. In the 1960s Sally Victor hats were sold by Sears under the label Sally Victor Headlines.

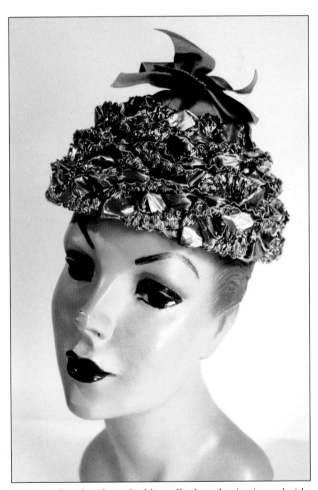

1960s small, pointed powder blue cellophane hat is trimmed with grosgrain bow. Sold by Jeanette, Reading & Harrisburg. Label: Sally Victor Headlines. *Hat and mannequin courtesy of Barbara Kennedy*. $60-75.

1970s red lacquered straw Gaucho style hat with grosgrain ribbon trim. Designer: Sally Victor Headlines. $40-55.

1970s picture of inside of Sally Victor hat showing label and satin lined crown.

Sally Victor hatbox. $20-45.

Designer Frank Olive

Frank Olive was born in Milwaukee, Wisconsin. He used to go to the movies with his grandmother and would recreate the costumes and sets he saw when he got home. After he moved to New York, he became a sketcher on Seventh Avenue. Norman Norell saw the sketches and suggested he become a milliner. Olive began by opening a small millinery shop in the early 1950s in Greenwich Village, called La Boutique. He also made scarves and blouses there.

Olive traveled to I. Magnin in California, Neiman Marcus in Texas, and Saks Fifth Avenue in Florida to meet personally with his customers and to bring custom-made hats to them. He designed for women of all ages and kept their individual needs in mind. He believed that hats were props that created a scene or set a mood. Olive apprenticed with Chanda. His labels were "Counterfits," a mass-market label; "Franks Girl," a moderately priced label; and "Frank Olive," his designer label. His love was designing and making hats.

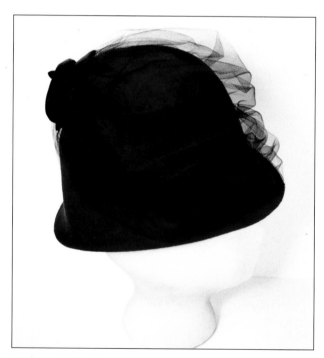

1960s purple fur felt English Bobbie style hat is trimmed with black veil and rosette in back. Mr. John also used the technique of trimming masculine style hats with veil. Designer label: Frank Olive. $50-65.

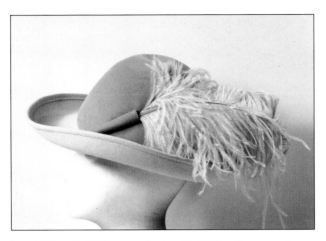

Late 1960-early 1970s tan and beige felt William Penn style hat has a large soft-looking crown and turned-up brim set off with beige ostrich plume. Crown sewed to brim with hand stitches. Designer label: Frank Olive. Manufacturer: George W. Bollman & Co., Inc. Label: 100% Wool Escello. $60-75.

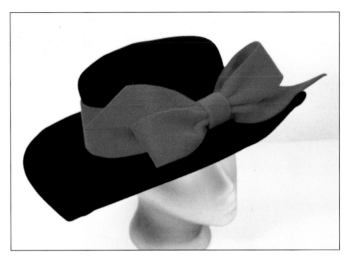

1970s black felt wide brim is trimmed with wide red felt band and large front bow. Label: Frank Olive for Saks Fifth Ave. $35-50.

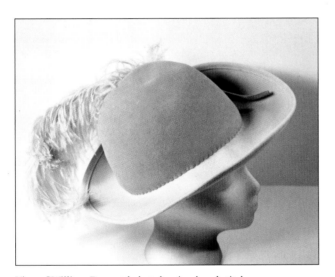

View of William Penn style hat showing hand stitches.

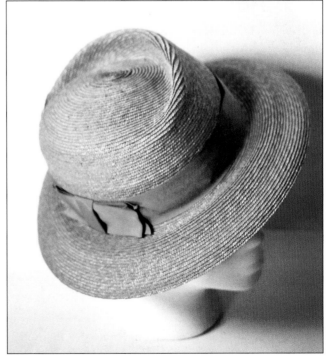

1970s straw sun hat has asymmetric sculptured crown. Aqua grosgrain band and bow trim crown. Designer: Frank Olive. $65-75.

Designer Cristobal Balenciaga

Balenciaga is the *couturier* who was known as the "master," because he did all operations in the making of a tailored garment: design, cut, sew, and fit. He was born in Spain and had three shops. Balenciaga moved to Paris during the Spanish Civil War.

Designer and Milliner Mr. John

Mr. John was born in Germany to Rose and Henry Harberger. They came to America when he was just a child and settled in New Rochelle, NY. Mrs. Harberger ran her own millinery shop in New York on Madison Avenue called Madame Laurel. Her mother was also a milliner in Vienna. John worked at his mother's shop until he formed a partnership with Frederic Hirst in 1928. They were in business together until 1948, making hats under the John-Frederics label and with locations in New York, Hollywood, Miami, and Palm Beach.

Working under the John Frederics label, John designed the straw cartwheel trimmed with green velvet ribbons worn by Vivian Leigh in the movie "Gone with the Wind." He also designed the green bonnet Rhett Butler gave her. In the late 1930s, he designed a variation of the wimple and skull caps.

After their partnership dissolved in 1948, John opened his own business, Mr. John Salon, at 53 East 57th Street, New York. He changed his name to John Pico John and designed women's clothing, jewelry, and furs, but was best known for his hats.

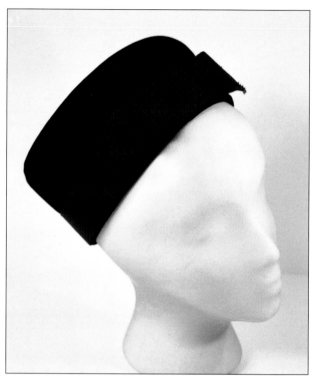

1950s black velvet pillbox with a pork pie crown is banded in grosgrain with a tailored bow. Label: Mr. John. $60-75.

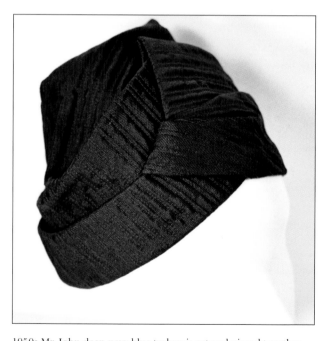

1950s Mr. John deep navy blue turban is cut and pieced together, lined with black taffeta and held in place with two tortoise shell combs. The fabric is faille with pairs of machine stitches running in the lengthwise grain of the fabric to create a quilted effect. $70-95.

Inside view of hat showing lining, combs and Mr. John Boutique Paris New York label.

In 1955 Mr. John started the John Juniors line of hats to be sold under $25. Mr. John loved classic styles and had a theatrical flair. He designed hats and fashions for numerous movies. Mr. John became well known early in his career when he designed hats for Mary Pickford. He also collaborated in the design of hats for "My Fair Lady" with Cecil Beaton. After designing doll hats, Stetsons, wig hats, masculine styles, huge toques of fur or flowers and using tulle to dress tailored hats, Mr. John closed his business due to the decline of the hat in the early 1970s.

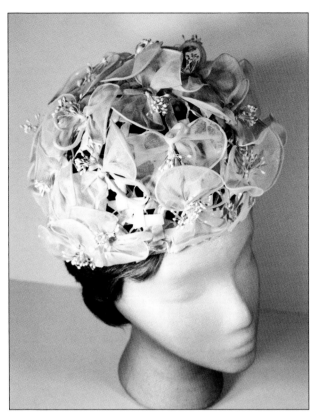

1960s off-white flower toque constructed over a wide mesh cellophane frame. Hat was worn by Mrs. O'Gorman. Designer label: Mr. John Jr. "For the World's Best-Dressed Debs and Misses." *Gift of Mary Francis O'Gorman*, who said her mother purchased the hat at Mr. John's shop in New York. $75-85.

1960s inside of Mr. John hat showing label and inner construction.

1960s close-up of Mr. John Jr. hatbox. $20-30.

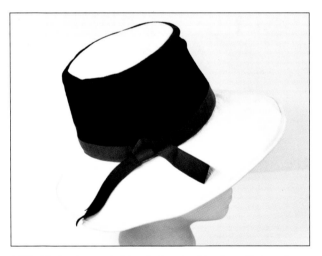

1960s black velvet and white vinyl grained leather tall crown is trimmed with grosgrain ribbon. Label: Mr. John. $35-45.

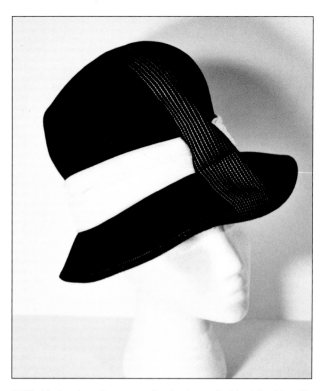

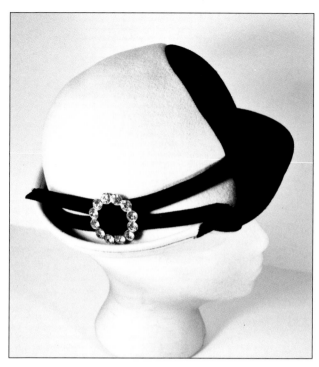

1960s black velour deep crown hat is trimmed with wide white silk chiffon band around the crown. A panel of fifteen rows of machine stitching runs from front to back. Designer: Mr. John Jr. *A gift from Joanne E. Deardorff.* $60-75.

1960s black and cream felt derby style hat is trimmed with black band and rhinestone pin. Label: Mr. John Classic. $50-65.

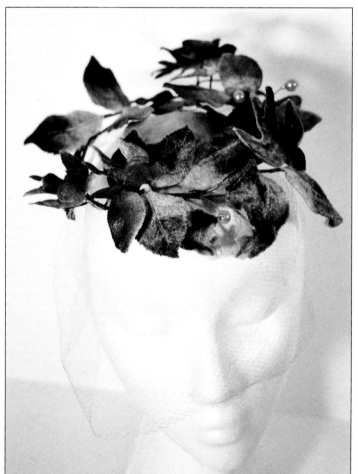

Label: Mr. John Classic New York & Paris.

Late 1960s whimsy made by Mr. John Caprice, New York and Paris. Hat is constructed on a 2" x 2" piece of felt. Royal blue velvet embossed leaves and barn swallows encircle the crown. Veil is nose length. $30-40.

The Hess Department Store

Brothers Charles and Max Hess founded Hess's department store in Allentown, Pennsylvania. Charles, the oldest, came from Germany to America first, and Max came in 1877 at age thirteen. Their father had died and they supported themselves by working in different dry goods stores. In 1889 they were able to open their own business in Perth Amboy, New Jersey. When Max attended a volunteer fireman's convention in Allentown, Pennsylvania, he saw the Grand Central Hotel on Hamilton Street. In 1897 they opened a second business at this hotel in the storeroom.

The Allentown business was so successful that they were able to sell the Perth Amboy store. In 1902 they bought the five-story hotel and remodeled it, making it into a department store. Max Hess believed in treating all customers equally and having only one price for merchandise. Customers had to pay the fixed price. He was good to his employees, calling them "coworkers." He died in 1922.

For the next ten years the store's leadership was not strong until Max Hess, Jr. took over in 1933. He added two more stories, remodeled, and put in air conditioning. As part of the remodeling project, large mirrors were placed all over the store so they could reflect the light from two hundred crystal chandeliers. At Christmas, the chandeliers were decorated with poinsettias, creating a beautiful and exciting effect. Very expensive objects of art and antiques were placed throughout the store, giving it a museum quality.

The people of the Lehigh Valley and the many busloads of shoppers from other areas remember fondly the store that made original designer clothing and hats available. The high fashion clothing ranged from $1000 to $10,000. Patrons throughout the store and in the famous Patio Restaurant could watch professional models walk through the store wearing the expensive designer clothing and hats. Max Hess was interested in doing things in a big way and wanted people to have a good time. He didn't care that the ready-to-wear was a better seller than the high fashion. People came into the store to see current fashion and to enjoy themselves.

Fae Shaffer remembers that the high fashion clothing was sold on the second floor in the French Room and Jerry Golden was the Director of Fashion. Elsa Schiaparelli had a line of lingerie that had its first showing in America at Hess's department store.

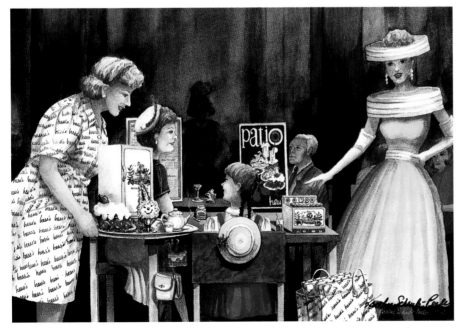

Dining in the Patio, Hess Brothers store Patio Restaurant, Allentown, Pennsylvania. Limited edition print of an original watercolor painting by artist Karoline Schaub-Peeler of Schnecksville, Pennsylvania. The interior of the Patio Restaurant with waitresses wearing Hess printed dresses and serving their famous fresh strawberry pie with whipped cream. High fashion models wear the latest Paris designs, as they make their way through the restaurant. Guests wear their own attractive hats for dining out and shopping. The model wears an open crown tambourine hat.

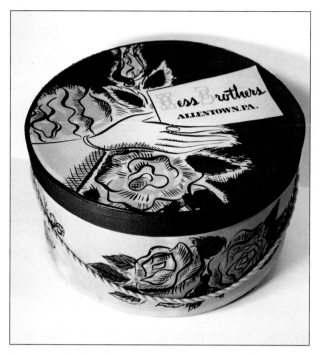

1950s round hatbox from Hess Brothers store. $25-35.

Phyllis Blanchfield remembers the beautiful hats on the first floor in Accessories. They were more reasonably priced than those in the French Room. She fondly retold her memory of going to the Patio Restaurant in the basement for a piece of her favorite pie, apricot (although strawberry was famous). After dessert, she shopped the large selection of beautiful hats in the basement hat salon which sold at quite reasonable prices.

Fae also remembers that the hat department was next to the French Room. She called it an ultra hat department with a wide selection of all kinds of beautiful designer hats, including Mr. John and Schiaparelli. Everyone was welcome to shop or browse in the hat department and there were gracious salespeople to help and guide you.

Inside view of 1950s purple fur felt close fitting helmet showing its Grenadier label, decorator label, the Hess Brothers' store label, and hand stitches.

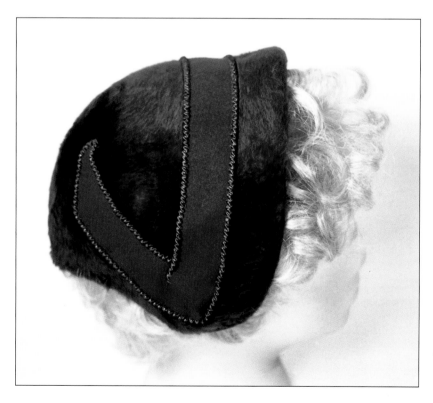

1950s purple fur felt helmet with felt decorative band. Body made by Grenadier in Austria and decorated by A. Frances and Walter Helkin. Hat was sold by Hess Brothers store, Allentown, Pennsylvania, "One of America's Better Stores." $50-65.

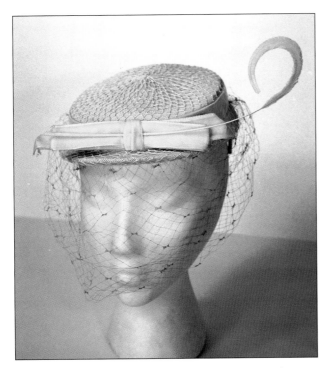

1950s cream-colored Panama straw hat with flat crown and narrow brim trimmed with cream velvet band and bow, curled feather, and full-face veil. Store label: Hess Brothers store, Allentown, Pennsylvania. *Courtesy of Fae Shaffer*. $60-75.

In 1967 Max Hess retired and sold the department store to Philip Berman and a group of Hess's executives. They opened many local branch stores, bringing the sales from $42 to $95 million in 1976. The store was later sold and became The Bon Ton.

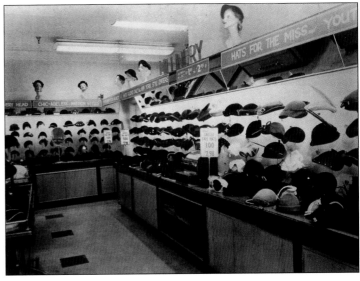

1950s millinery department showing the hat display. *Courtesy of Marie Claus Danko*.

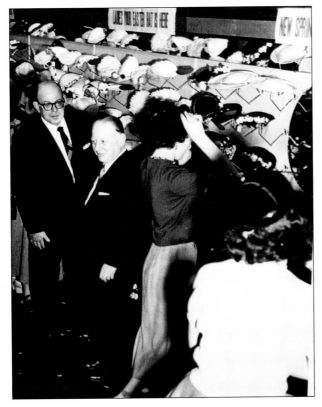

Inside the hat department in a 1950s department store. Executives are in the "hat bar," while ladies try hats on. *Courtesy of Marie Claus Danko*.

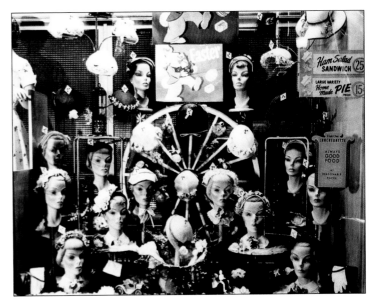

1954 window display showing the latest Easter bonnets. *Courtesy of Marie Claus Danko. Photo by Charles E. Tilton, Winston-Salem, North Carolina.*

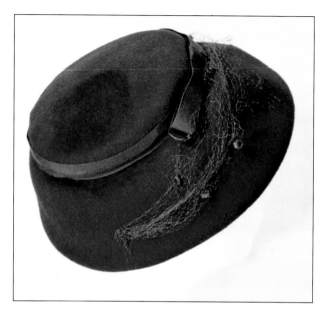

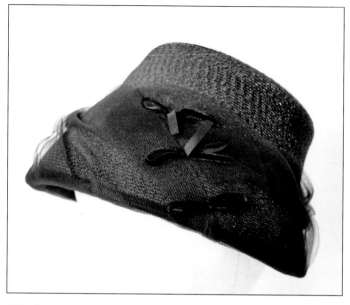

1950s purple wool felt bonnet style hat stamped with Henry Pollack label and trimmed with purple grosgrain and chenille dot veil. $25-35.

1950s black, straw bonnet-style hat trimmed with netting and three velvet bows was worn back on the head during the period. $20-30.

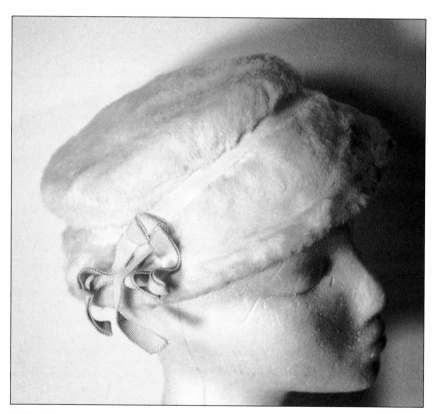

1950s winter white faux fur bonnet style hat has a grosgrain ribbon band and bow at side. $25-35.

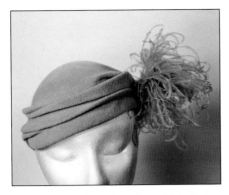

1950s Marché pink velour draped felt cloche is decorated with a large pink plume. Label: Genuine Imported Velour Marché Exclusive. $50-75.

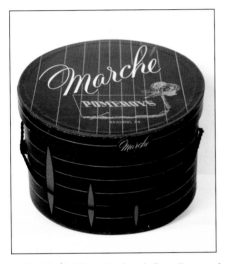

1950s Marché Brand hatbox is from Pomeroy's store in Reading, Pennsylvania. $15-20.

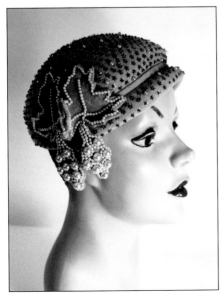

1950s powder blue felt cloche decorated with star sequins, seed beads and pearls all hand sewed in place. *Hat and mannequin courtesy of Barbara Kennedy.* $95-125.

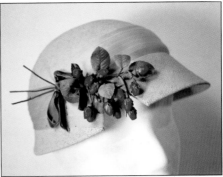

1950s pea green straw cloche style hat with notched brim is trimmed with a pleated silk organza band and a rosebud bouquet with velvet ribbon. $45-65.

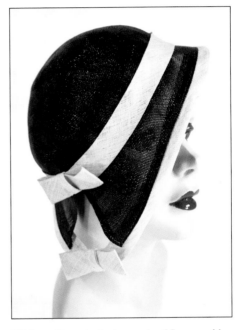

1950s profile style cloche, made of fine navy blue and natural straw, is trimmed with two bows. *Hat and mannequin courtesy of Barbara Kennedy.* $90-110.

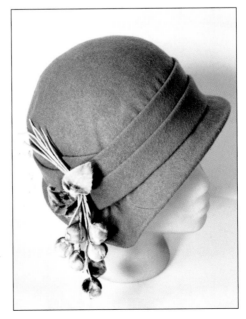

1950s dressmaker hat of powder blue wool in cloche style with double folded band and flower trim. Tailoring techniques of shrinking fullness out of wool and hand stitches can be seen. Hat was made to match a suit. $30-50.

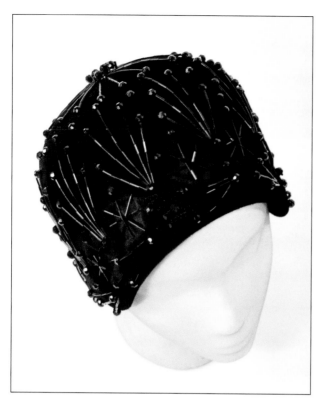

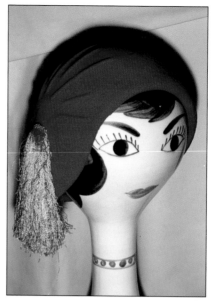

1950s fine quality red wool cloche with a 1920s style long, full, pink silk tassel. Stamped label: Riviera Finest Quality Velour. Made in Italy. Store label: Hess's Allentown, Pa. $35-60.
Stangl pottery mannequin head. $245.
Courtesy of Violet and John Pammer.

1950s black helmet shaped cloche decorated with black jet bugle and faceted beads. Cutwork along the edge is backed with grosgrain. Stamped label: Roma Best Quality Velour body Made in Italy. Designer: Gwenn Pennington Exclusive. $75-85.

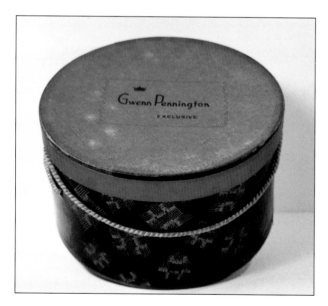

1950s Gwenn Pennington hatbox. *Courtesy of Robert and Jackie Jiorle, Eclectibles.* $20-30.

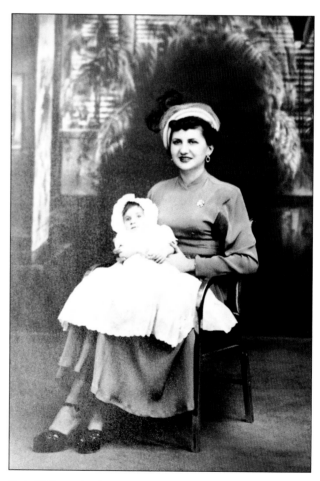

Early 1950s mother is holding child wearing long christening dress and bonnet. Mother is wearing long, rayon crepe dress and platform shoes. The small profile cloche frames her face, while the veil and plumage of stripped coq feathers complete the hat. Photographer was Attilio Ruisi, 332 E. 14th St., New York, New York.

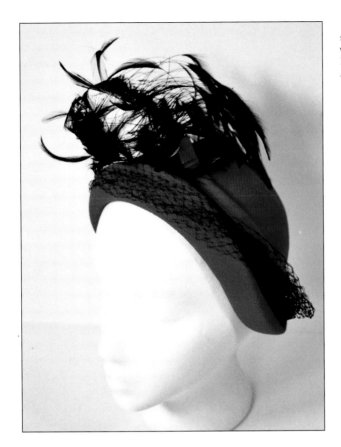

1950s red molded felt profile cloche has black stripped feather trim and veil. Hat is held on with elastic band. Stamped label: 100% Wool, Merrimac Hat Corps. Made in USA. *Courtesy of Dave & Sue Irons, Irons Antiques.* $95-110.

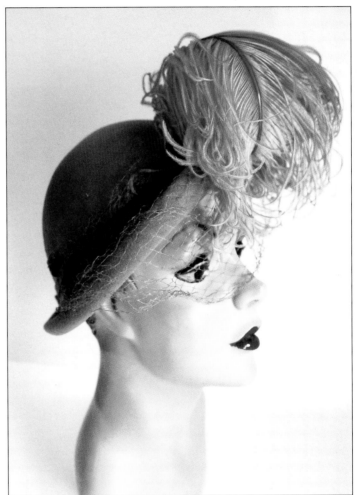

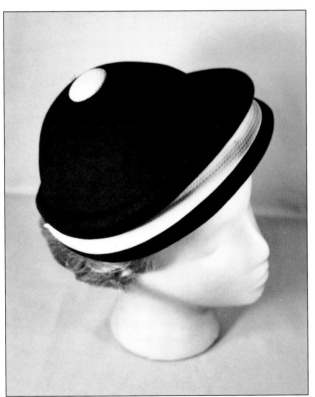

1950s navy blue felt hat has a white waffle piqué band and button trim. The remains of the veil can be seen under the button. Label: M.S.C. ADJ. $35-45.

Dusty rose felt cloche with rolled brim is trimmed with a flamingo colored ostrich feather and narrow band. $95-110. *Mannequin courtesy of Barbara Kennedy.*

Widow Peak Hat

Fine Straw Tape Hats

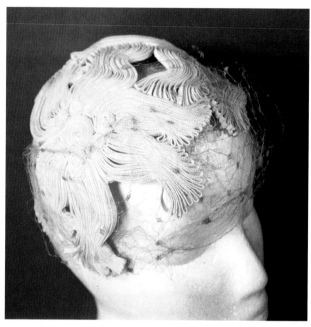

Widow peak hat made of natural straw and red ribbon trim. Dior brought out the style. $30-50.

1950s white tape straw hat with eye length veil was made by Colby and sold by B. Altman and Co., New York. Hat also has peek-a-boo crown to show off hair. $25-35.

Egg Shell

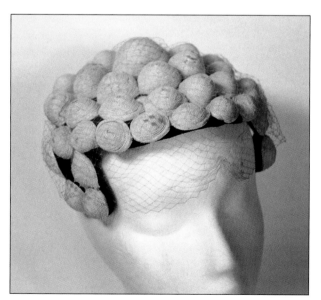

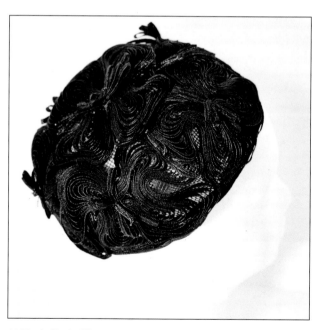

1950s eggshell motif was made popular by Givenchy. The eggs for this hat were made by winding thread and were placed on a wire frame. The hat was sold by H. Leh & Co. Fae Shaffer wore the hat to the Persian Room at The Plaza Hotel, New York City to go dancing. *Courtesy of Fae Shaffer*. $50-75.

1950s shallow pillbox made of black narrow straw tape formed into five four-petal designs. The hat was made over fine net. $40-50.

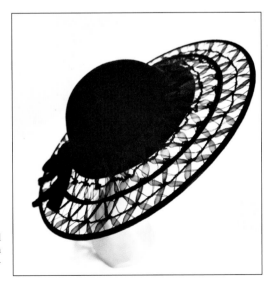

1950s blue tape straw bandeau in four petals is made over a headband. $30-50.

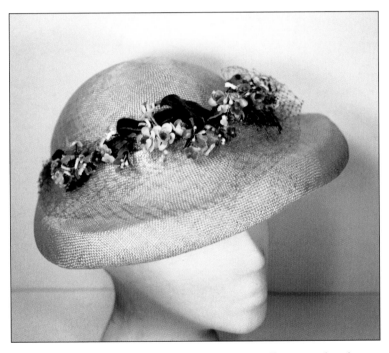

1950s fine one-piece straw bonnet has delicate flower wreath and veil decoration. *Courtesy of Josie V. Smull*. $50-75.

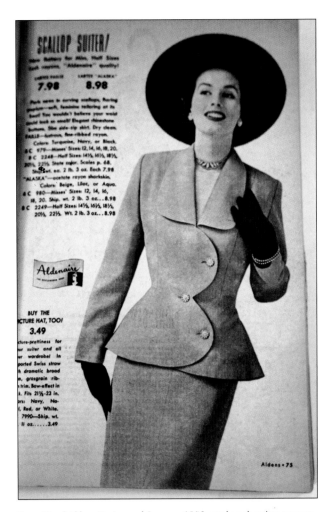

Page 75 of *Aldens Spring and Summer 1952* catalog showing young lady dressed in scalloped edge suit with peplum. Suit is set off with a large picture hat selling for $3.49.

1950s large picture hat is constructed over a small black velvet hat and has a lacy open work brim and back bow. *Hat and mannequin courtesy of Barbara Kennedy*. $95-135.

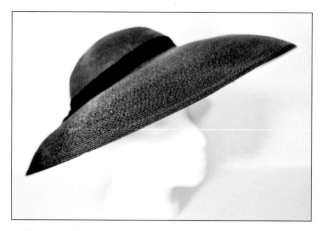

1950s large black lacquered straw picture hat with set back crown, sold by Kresge Newark, is trimmed with velvet band and bow. $50-75.

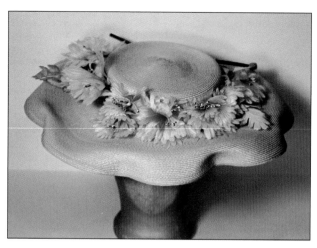

1950s yellow lacquered straw picture hat with fluted brim and shallow crown is trimmed with a wreath of orange silk flowers. $60-85.

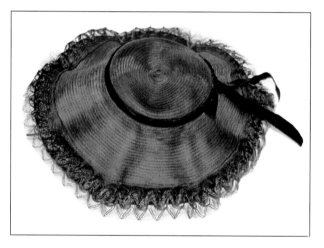

1950s black nylon picture hat with shallow crown is trimmed with velvet ribbon. Horsehair trim extends from the brim. $50-75.

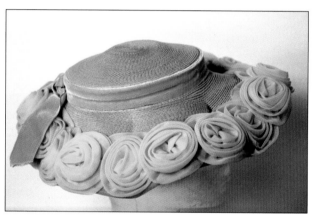

1950s yellow straw picture hat is trimmed with bias cut nylon rosettes at edge of fluted brim. The shallow crown is trimmed with a matching velvet band and back bow. $60-85.

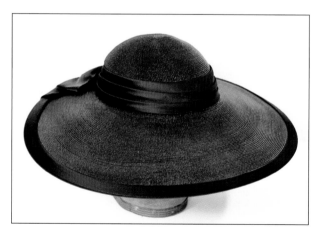

1950s large black straw picture hat designed by Lucilla Mendez Exclusive, New York. Crown is trimmed in a triple pleated black satin band with large back bow. Edge of brim is bound in satin. $95-125.

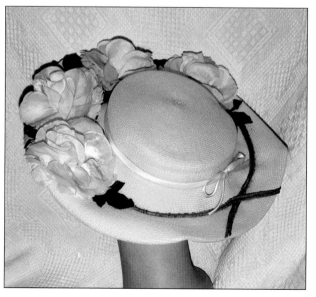

1950s yellow straw picture hat with velvet and silk rose trim. *Courtesy of Kimberly Kirker, Kimberly Kirker Antiques.* $65-110.

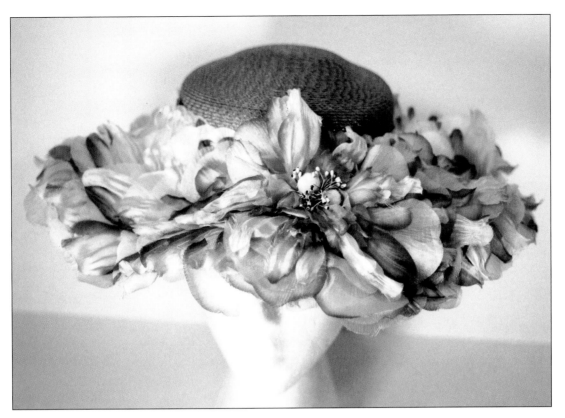

Front view of powder blue straw Gwenn Pennington picture hat is trimmed with large silk flowers. $95-125.

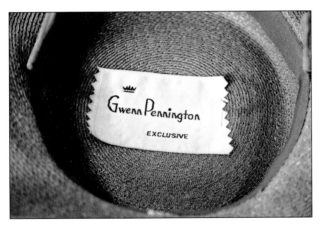

Inside view showing label of Gwenn Pennington Exclusive.

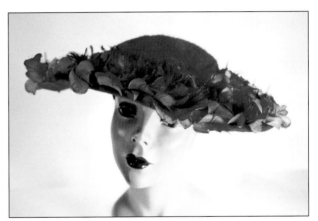

1950s fuchsia plush picture hat decorated with silk flowers and feathers. *Hat and mannequin courtesy of Barbara Kennedy.* $75-95.

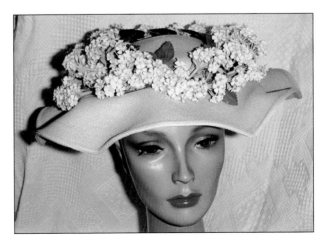

1950s soft pink straw picture hat with wide fluted brim is trimmed with a ring of tiny pink flowers. *Courtesy of Kimberly Kirker, Kimberly Kirker Antiques.* $95-135.

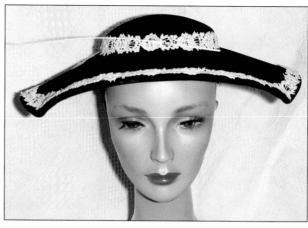

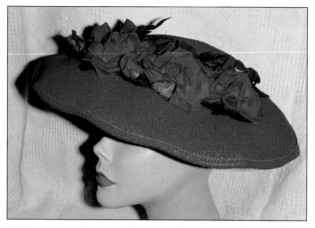

1950s black velvet Dior style picture hat is trimmed with Venetian lace and feather. *Courtesy of Kimberly Kirker, Kimberly Kirker Antiques.* $60-75.

1950s red straw Dior style picture hat is trimmed with a wreath of fuchsia roses and buds. *Courtesy of Kimberly Kirker, Kimberly Kirker Antiques.* $75-95.

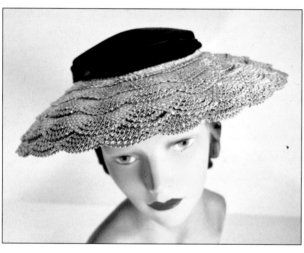

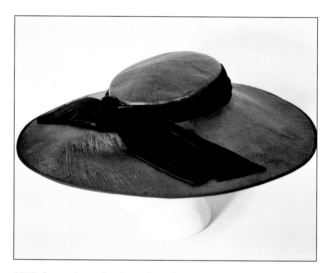

1950s large picture hat is made of finely woven black straw giving the hat a sheer appearance. Crown is set back and trimmed with a black velvet band and oversized bow. Hat is by G. Howard Hodge. $85-120.

Early 1950s picture hat with a scalloped straw brim and a blue velvet crown, is constructed over a Dior frame. *Hat and mannequin courtesy of Barbara Kennedy.* $90-125.

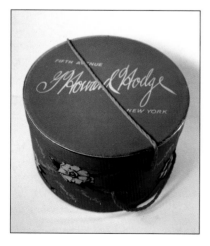

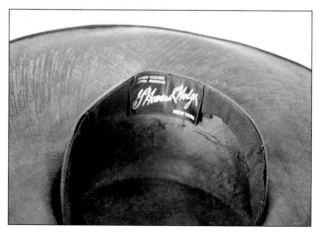

1950s G. Howard Hodge Hatbox Fifth Avenue New York. $25-35.

Inside view of picture hat showing G. Howard Hodge label.

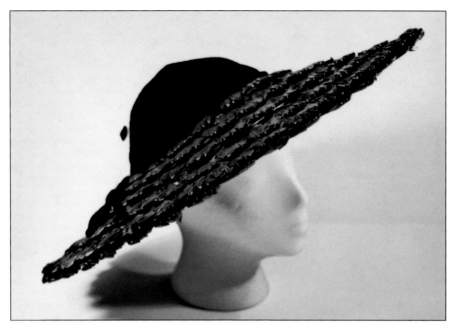

1950s wide black cellophane cartwheel hat has straw brim and shallow three-section velvet crown. Long velvet tubular bow trims the hat, which is held on by two self covered hatpins. Label: Childa, 4838 York Road, Phila., Pennsylvania. $75-125.

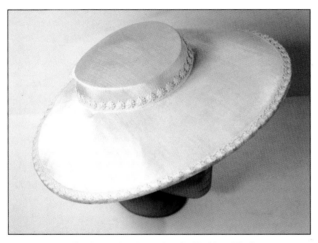

1950s Dior style picture hat is made of off white silk shantung. Cotton daisies encircle the crown and edge of brim. A velvet bow completes the trim. $45-65.

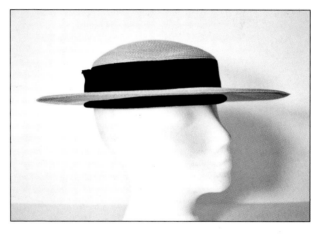

1950s large straw picture hat is constructed over a black velvet ring with crown trimmed in wide black grosgrain band. Designer: Jon Pierre. Store label: Hess's Allentown, Pennsylvania. $80-95.

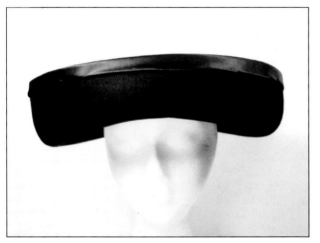

1956 large black felt tambourine brim is made with diamond shaped open crown and hand sewed black satin trim. $60-75.

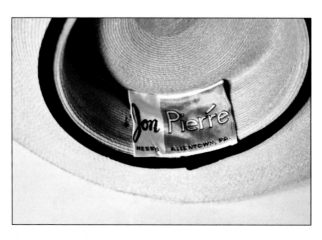

Inside of Jon Pierre large straw picture hat showing label and inside construction.

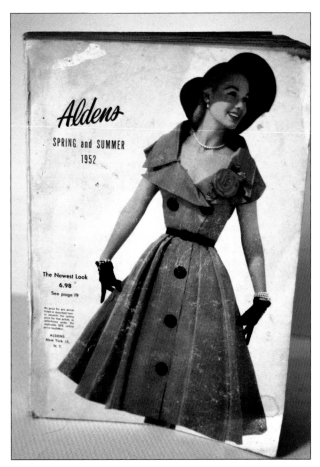

1950s pea green straw dish hat trimmed with chenille dot veiling and velvet ribbon. $35-50.

Cover page of *Alden's Spring and Summer Catalog 1952* showing the large Dior style picture hat. Dress has nipped in waist, long full skirt, and large button trim.

Left: 1950s Dior style hat has crown of black straw. Brim is formed from four rows of finely woven straw tape constructed over wide mesh foundation. $45-65. Right: 1950s Dior style mesh hat is decorated with black velvet trim and back bow. $25-35.

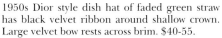

1950s Dior style dish hat of faded green straw has black velvet ribbon around shallow crown. Large velvet bow rests across brim. $40-55.

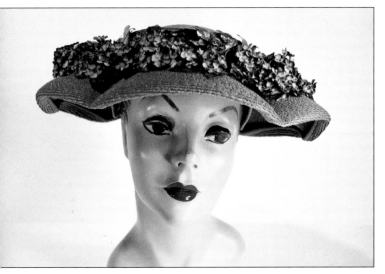

1951 lavender wide ripple brim dish hat has blue forget-me-not trim. *Hat and mannequin courtesy of Barbara Kennedy*. $95-125.

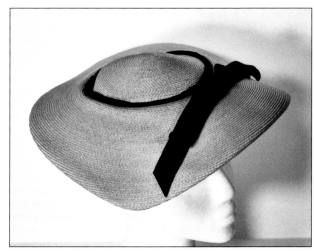

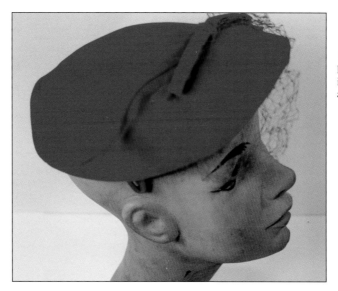

1950s red velvet Dior style flat hat constructed over wire frame is trimmed with bow, feather, and nose length veil. $30-50.

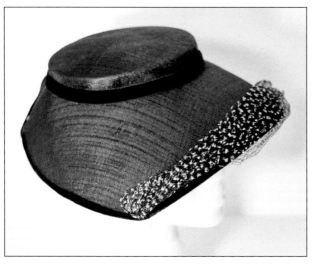

1950s navy blue Dior style fine straw hat is trimmed with velvet ribbon around the crown and edge of brim. Veil trim at front of hat is reminiscent of dotted Swiss fabric. Navy blue and white was a popular 1950s color scheme. $50-75.

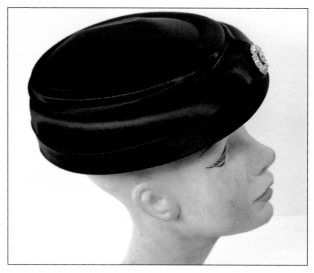

1950s black satin Dior style flat hat, constructed over wire frame, is trimmed with popular 1950s rhinestone pin. $35-55.

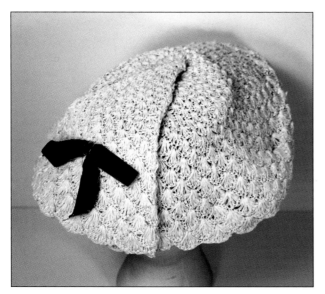

1950s dish hat is covered with a mat of hand crocheted straw in shell stitch and is finished with a triangular back pleat with green velvet bow. *Courtesy of Josie V. Smull.* $40-60.

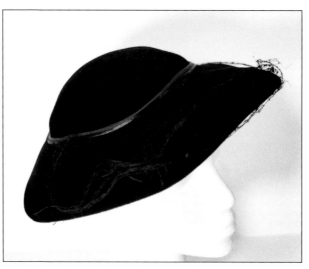

1950s black velvet Dior style hat has remains of veil showing. Registered B. B. Ruth. Stamped: Genuine Velour. Store label: Scharf 's 1688 Chestnut Street, Philadelphia. $70-85.

1950s rayon turquoise Dior style pill box hat is constructed over wire frame with white rose, feather, and nose length veil. *Courtesy Kimberly Kirker, Kimberly Kirker Antiques.* $25-45

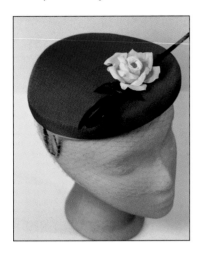

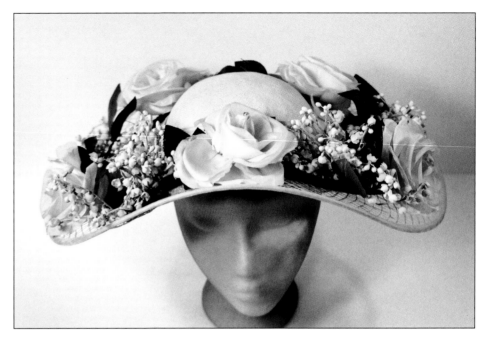

1950s picture hat formed over a wide mesh frame is trimmed with large roses and lilies of the valley. Label: Originals by Flo Raye, New York. *Courtesy of Eleanor Rothermel, Eleanor's Antiques and Uniques.* $95-125.

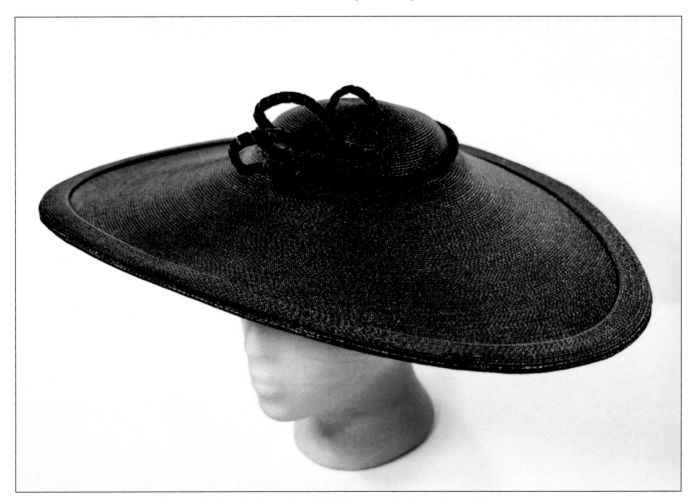

1950s navy blue lacquered straw large oval Dior style picture hat with shallow crown is trimmed around the crown with chenille-covered wire. Brim is finished off by turning edge up. Label: Christine Original, 16 Park Ave., New York. $175-200.

1950s top view of black straw picture hat with velvet ribbon trim in tricorn shape. Label: Henry G. Ross Original New York Paris. $85-110.

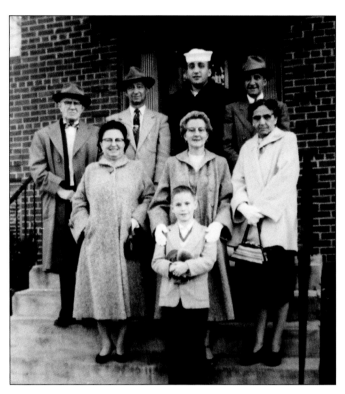

1956 photo of Billy Boyer, Anna Zartman, Mary Boyer, Marie Boyer, George Zartman, Russell Boyer, Bill Boyer, and father Bill Boyer wear typical coats and fedora hat of the period. Woman on right wears a "topper," short coat. Sailor Bill Boyer, Jr. was home on leave. *Courtesy of Anna Freed.*

1950s wide hot pink lacquered straw Dior-style picture hat has side creased brim. Velvet ribbon around crown is tied into loops resting in crease of brim. $125-150.

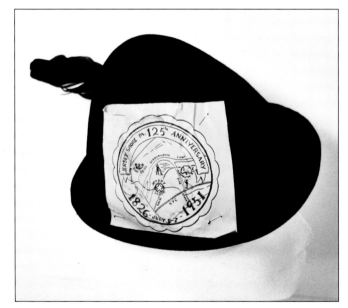

1951 Robin Hood style felt hat worn to commemorate the 125th anniversary of Jersey Shore, Pennsylvania. Stamped: Renay-Albert Novelty Co., Brooklyn, New York. Made in USA of 60% Reused Wool. $50-60.

Weddings

December 1, 1950, wedding photo showing a bride's hair pulled back on the left side with long curls on the right. Her hat has elaborate trim of ruffles, feathers, and a veil.

Early 1950s bride and groom pose with their mothers. Groom is wearing a white tuxedo jacket. Bride is wearing a two-tiered lace dress and pointed pierced halo style headpiece. Both ladies wear platform shoes with high heels. Mother on right is wearing long, fingerless gloves and hat with milkmaid style brim.

Early 1950s bride poses in stairway wearing a lace edged fingertip veil with a pierced halo headpiece.

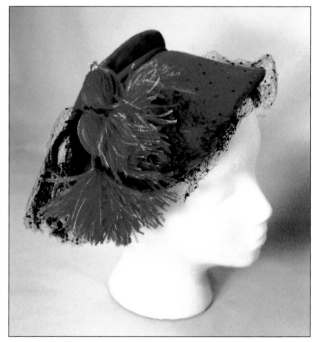

1950s fuchsia velvet bonnet style hat has small milkmaid brim and marabou feather trim. There was a full-face black veil. The hat is fully lined with white taffeta. Label: OPE 3121 Rose Nemours, 8. Rue De La Paix, Paris. *Courtesy of Kathy Kays, The Rose Cottage.* $175-200.

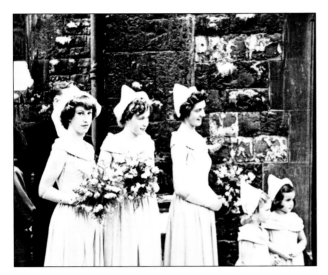

1950 photo of bridal party for a wedding in London. All bridal attendants wear Dutch style caps. *Courtesy of Jane Quigley.*

1953 bridal headdress of Antoinette Avella is made of pearls and rhinestones in fleur-de-lis motif. $50-95.

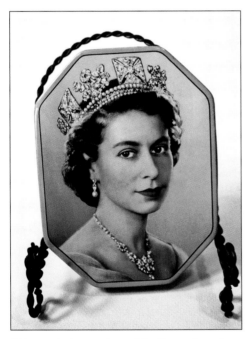

Lithograph tin container of the Coronation of Her Majesty Queen Elizabeth II 1953. Tin made in England by George W. Horner & Co. Ltd. Chester – Le Street, County of Durham. Tin showing the Queen's coronation crown. *Courtesy of Joanne E. Deardorff.*

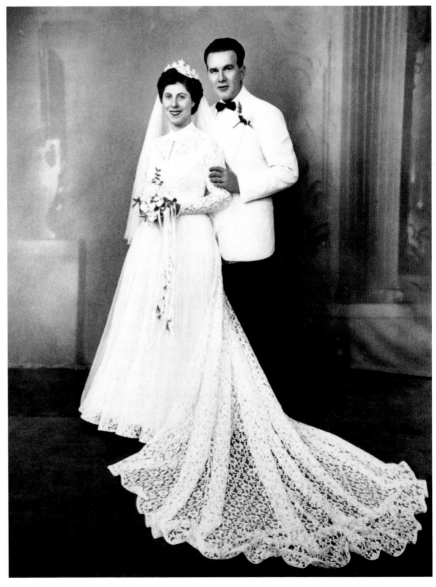

Photo of bride Antoinette Avella and groom Sheldon Gearhart in June 1953 showing bride's headdress, a crown made of pearls, rhinestones, and seed beads in Fleur-di-lis. Queen Elizabeth's coronation and her coronation crown in 1953 influenced this headdress.

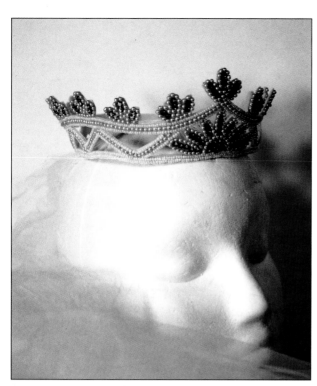

1953 bridal headdress of Antoinette Avella made of pearls and rhinestones in fleur-de-lis style. *Gift of Antoinette Avella*. $50-95.

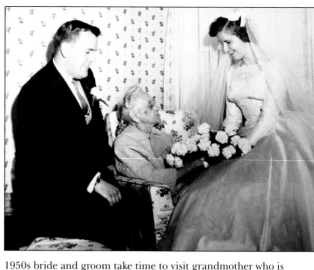

1950s bride and groom take time to visit grandmother who is dressed in a quilted housecoat. Bride's headpiece is a small bandeau worn at crown of her head and it holds a full-length veil. Gown is silk organza.

1950s back view of horsehair open crown picture hat, popular for bride's maids, is trimmed with pink satin ribbon, bows, and three streamers. Open crown showing off beautiful hair of the wearer. *Courtesy of Dave & Sue Irons, Irons Antiques*. $45-65.

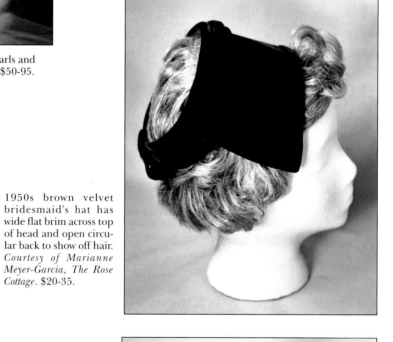

1950s brown velvet bridesmaid's hat has wide flat brim across top of head and open circular back to show off hair. *Courtesy of Marianne Meyer-Garcia, The Rose Cottage*. $20-35.

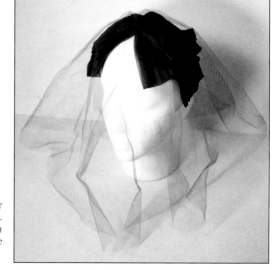

September, 1959 bridesmaid's bow headpiece of hunter green silk organza is constructed over a plastic headband. The green veil covers the entire head. *Courtesy of Marion Kingsbury*, who wore this at her sister's wedding in Rhode Island. $20-35.

Graduation

Early 1950s photo showing young graduate posing with his proud family who wears the latest 1950s fashions. Ladies on left wear long dresses, fancy hats, and 3/4 length gloves. Lady on right wears a finely tailored suit, mink tails and picture hat. Gentleman on right is wearing a double-breasted suit.

Turban Styles

Aurora Borealis tiara was worn to high school winter dance by Rose Jamieson in December 1958. $20-25.

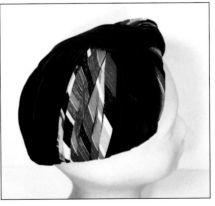

1950s helmet shaped hat of draped purple velvet and pleated striped corduroy creating a turban effect was owned and worn by Louella Seabrooks. Label: Magdalene Raybold, Easton, Pennsylvania. *Courtesy of Josie V. Smull.* $60-85.

Inside view of 1950s hat and label of Magdalene Raybold, Easton, Pennsylvania. *Courtesy of Josie V. Smull.*

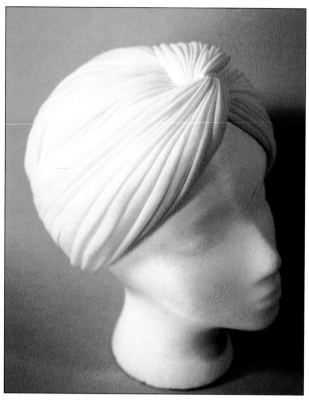

1950s white turban composed of strips of silk fabric with a center layer of batting and a silk lining. $50-65.

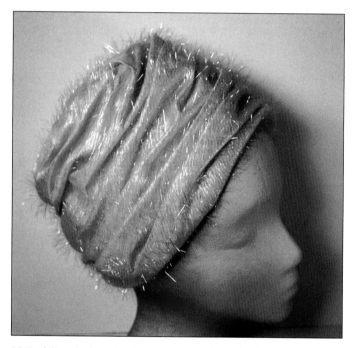

1950s delicately draped turban with aurora borealis filament. $45-65.

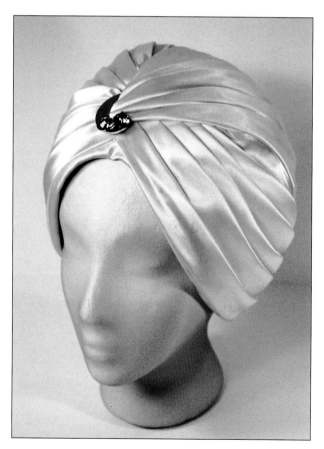

1950s white satin draped turban made over a hat form. Trim is fancy costume pin. Label: Saks Fifth Ave. $50-75.

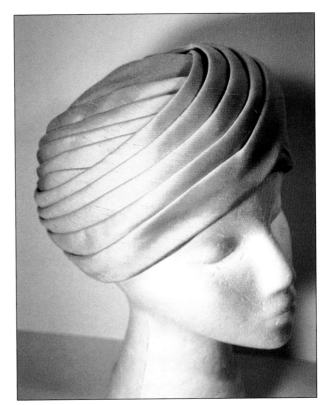

1950s beige silk shantung turban with many folds is draped over a hat form and is fashioned after a 1924 Paul Poiret turban. $50-75.

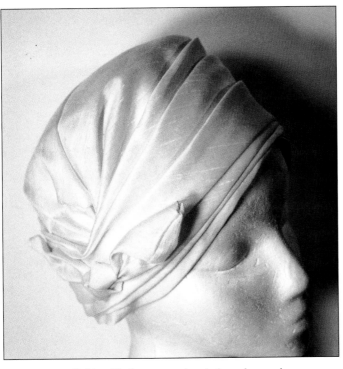

1960s off white silk shantung turban is draped around a form and tied in a bandana type side bow. Lining is faille. Designer: Lucilla Mendez. $50-75.

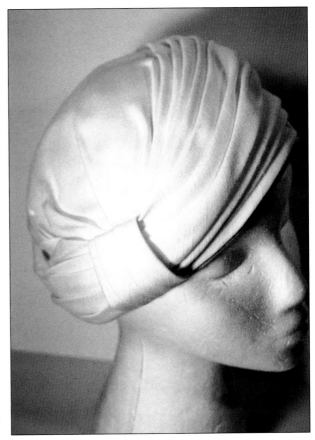

1950s cream silk shantung draped turban is made over a hat form. $45-65.

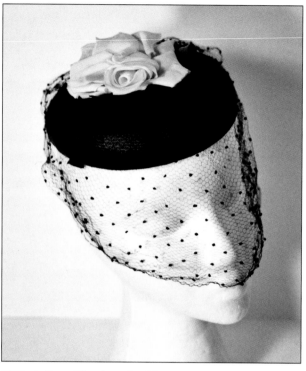

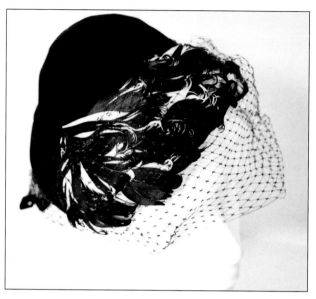

1950s black velvet cone hat is trimmed in a wide band of black and white curled feathers and eye length veil. Curled feathers were a popular 1950s style, although cone hats were more popular in the 1960s. $50-75.

1950s shallow pillbox is made of finely woven black straw; a single white velvet rose crowns the hat. Nose length veil is chenille dotted. Two tortoise shell combs hold hat in place. Label: A Miriam and Suzy Original 142 Seventh Ave. South, New York. $95-110.

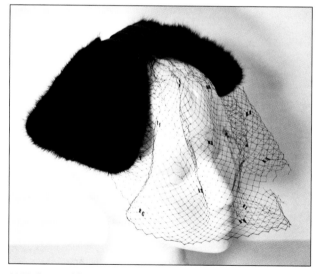

1950s large sable fur bow with satin band has a tapered full-face veil. Designer: Miriam and Suzy Original. $60-75.

1950s navy blue cocktail hat has self-covered wire applied across top of crown and down each side. The hat trim holds hat in place. Stamped: Riviera Finest Quality Velour & Body made in Italy. $50-65.

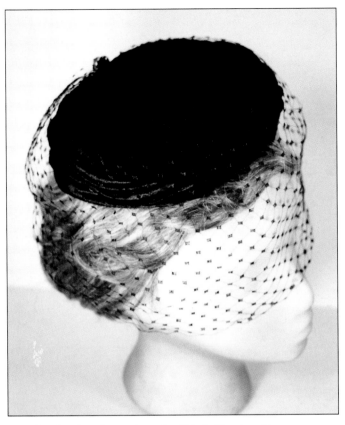

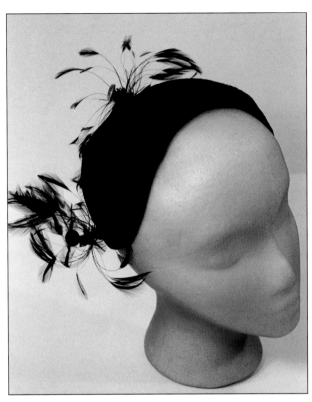

1950s black velvet hat with stripped feather trim. $20-30.

1950s hand gathered toque is made of black silk velvet. Nose length veil is held in place by aurora borealis pin. Hat is made by Chanda. $95-110.

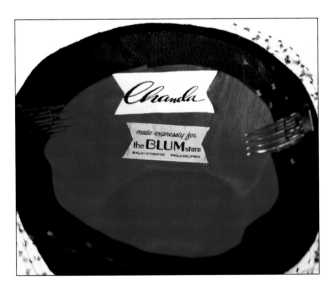

1950s inside view showing label of Chanda hat made expressly for the Blum Store Bala Cynwyd, Philadelphia. Hat is fully lined with red taffeta and is held in place by two tortoise shell combs.

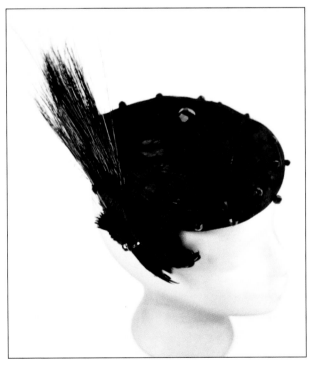

1950s small black cocktail party hat is hand-made by a milliner. Lining is fine black lace; trim is a simulated milliner's bird and jet beads. $85-110.

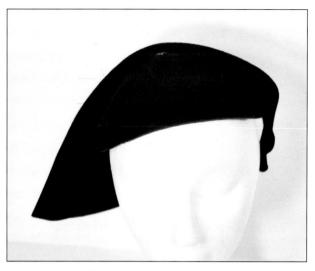

1950s black velvet beret has a large stylized leaf applied from one side to the other side of the beret. Stamped: Leslie James Trademark. $50-75.

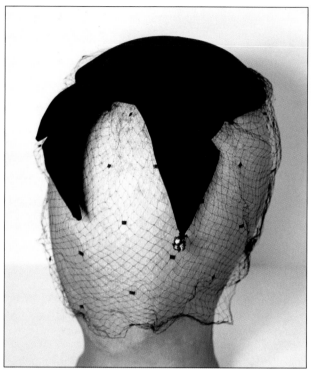

1950s cocktail hat of black silk and flocked full-face veil has bow resting on forehead. Store label: I. Magnin and Co. $45-65.

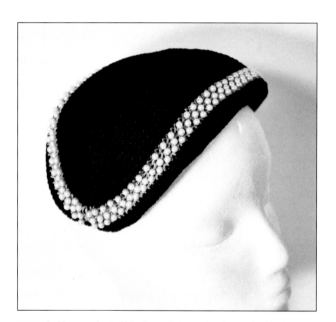

1950s half crown hat of black cordet yarn is trimmed with three rows of pearls and gold metallic thread. $25-35.

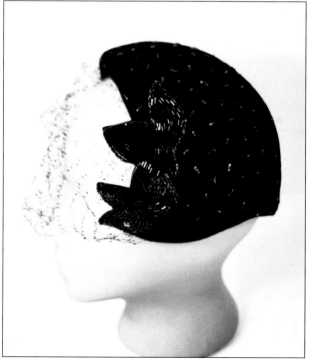

1950s black fur felt helmet is made in Italy. Hat is trimmed with seed and bugle beads and nose length veil. Decorations are hand sewed on. $55-70.

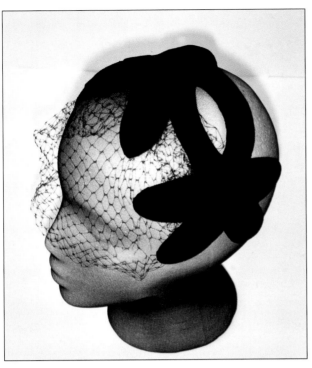 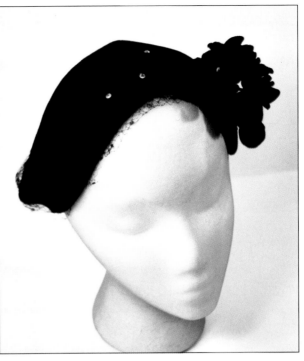

1950s black cocktail hat has a scalloped velvet motif and full-face veil. The hat is lined with satin. $25-35.

1950s helmet hat stamped Genuine Velour is black with velvet leaves, cherries, rhinestones and a nose length veil. Label: Registered B.O. Ruth, Gimbels, Philadelphia. $30-40.

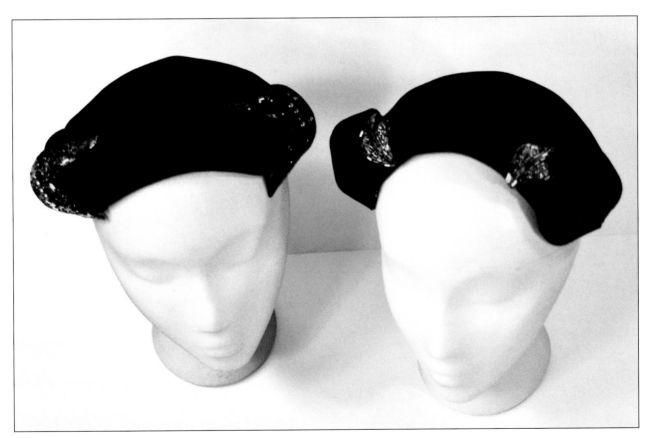

Left: 1950s brown felt hat with beaded decoration at each side. $30-40. Right: 1950s black shell hat was sold by Margaret Davis Shop Plainfield, New Jersey through the Jos. Lazarus Co. The hat is stamped Genuine Velour and has two velour leaves at temples and two leaves covered with iridescent glass bugle and seed beads. $35-45.

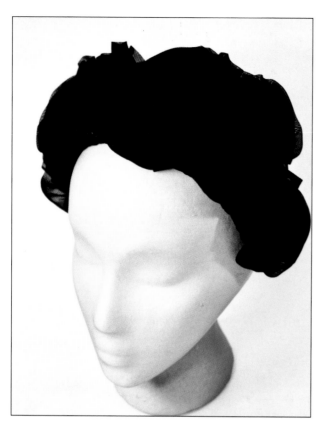

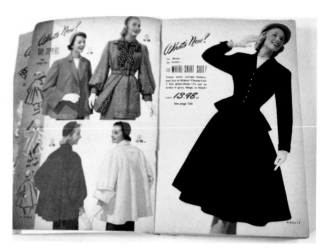

1950s bandeau hat made of nine bias-cut, black nylon, handmade rosettes. $25-50.

1950s black velvet half crown hat is trimmed with a string of rhinestones and has a large applied leaf on the side. $15-25.

1950s soft black velvet draped head hugger cap is trimmed with gathered leaf positioned at the side. $25-35.

Summer Hats

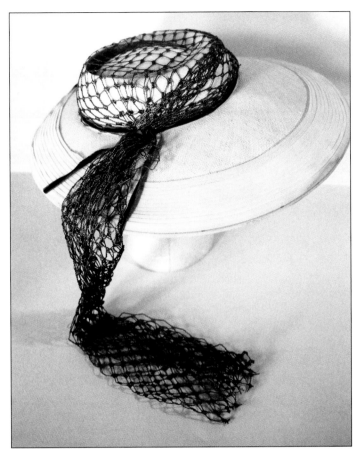

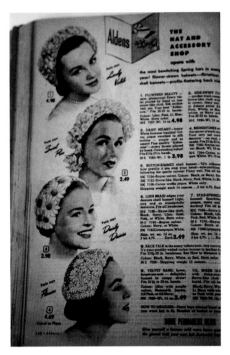

Aldens Spring and Summer Catalog, Page 152, shows flowered hats, Paris says flowers!

1950s picture hat designed by Janeth Roy New York is made of white Panama style straw with pleated nylon around the edge of brim. Open crown is covered with coarse net and tied in a bundle at each side forming long streamers. Velvet ribbon circles crown and continues at sides. $90-125.

1950s natural straw Panama sun hat with wide band of matching pleated silk crepe and original hatpin. *Courtesy of Kay Aristide.* $50-75.

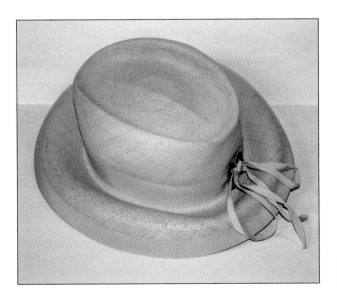

1950s Ecuadorian natural straw hat with creased crown and grosgrain ribbon trim uses metal eyelet to fasten the bows. Brim is bound in grosgrain. $50-75.

Beret Styles

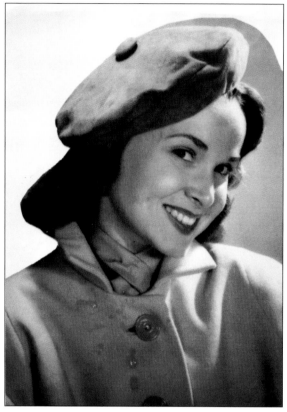

1950s Bobbie Ellsworth is wearing a two-section beret with button decoration. *Courtesy of Bobbie Ellsworth.*

1950s Bobbie Ellsworth is wearing a six-section suede beret pulled to one side, set off with a silk scarf. *Courtesy of Bobbie Ellsworth.*

1950s black velvet six-section beret has a loop and knot at top. $15-25.

1952 black velvet beret with side tilted shape and the new popular French inverted bow. $25-30.

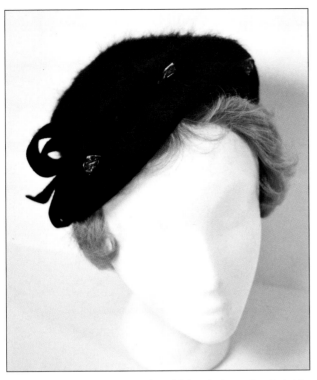

1950 black fur felt close fitting hat with jewel trim and curled side brim. Stamped: Melosoie and Henry Pollak, New York. *Courtesy of Mildred Quigley*. $30-45.

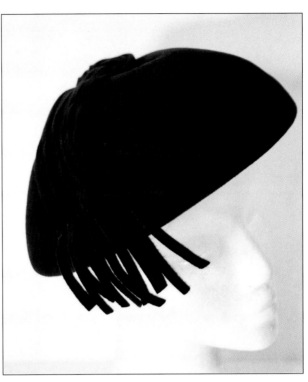

1950s brown beret style hat is stamped Genuine Imported Velour Union Made in USA. Hat is finished off with a topknot and hand sewn in place self-streamers. $50-65.

1950s beret style black velour hat is covered with small flowers. The rhinestones sparkles are riveted in place. $15-25.

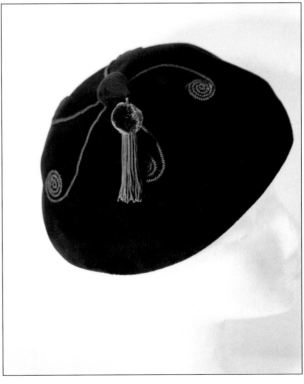

Late 1950s brown fur felt beret is trimmed with silk cording and tassel. Stamped: Made in France. Store label: Nan Duskin Philadelphia. $40-55.

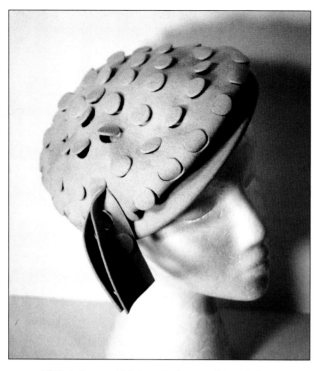

1950s beige wool felt beret is decorated in a circle design, which is created by piercing the felt. $50-65.

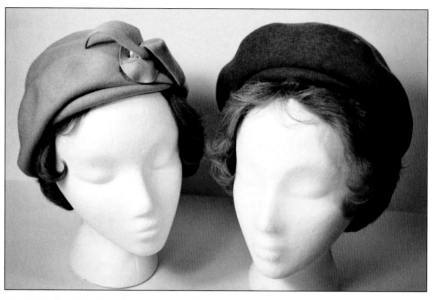

Two 1950s wool felt close fitting berets with front visor effect. *Courtesy of Mildred Quigley.* $20-30 each.

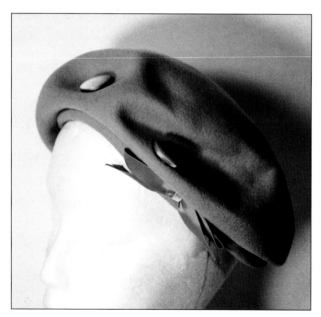

1950s beige beret style is stamped 100% wool felt Glenover Henry Pollak, Inc. New York with satin covered buttons and bow. Dents are hand stitched. Designer: A Jonquil Original. $30-45.

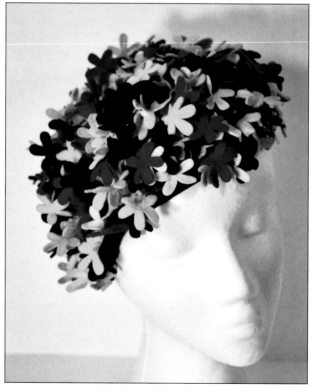

1950s beret is covered in tiny six petal felt flowers of orange, yellow, brown and beige. Designer: Jackwill Originale. Label: Union made in USA. $30-45.

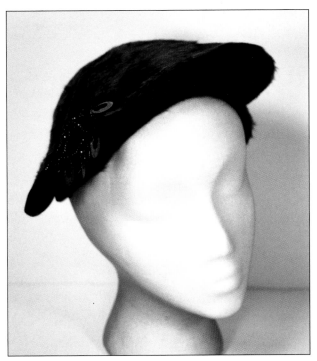

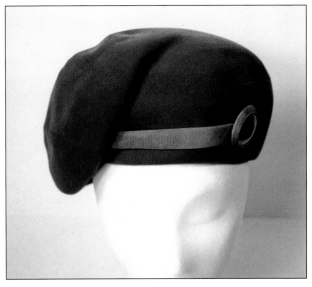

Front view of 1950s lavender felt turban beret trimmed with grosgrain, button, and rows of machine stitching. $65-90.

1950s handmade brown fur felt plush dish style hat with seed bead and sequin side trim with self-hatpin. *Courtesy of Josie V. Smull*. $40-65.

Label of turban beret made in Basel, Switzerland by Jean Hess.

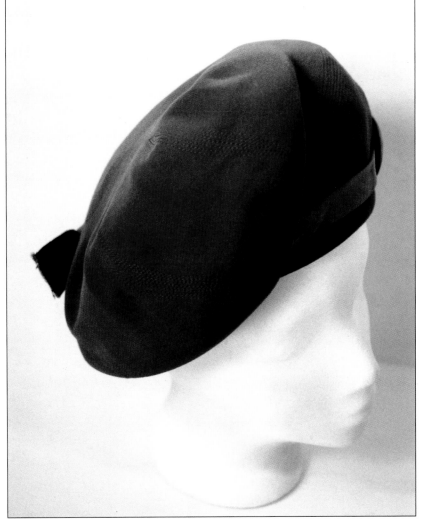

1950s side view of Swiss lavender felt turban beret. The trim is grosgrain ribbon, back bow, front button, and many rows of machine stitches. $65-90.

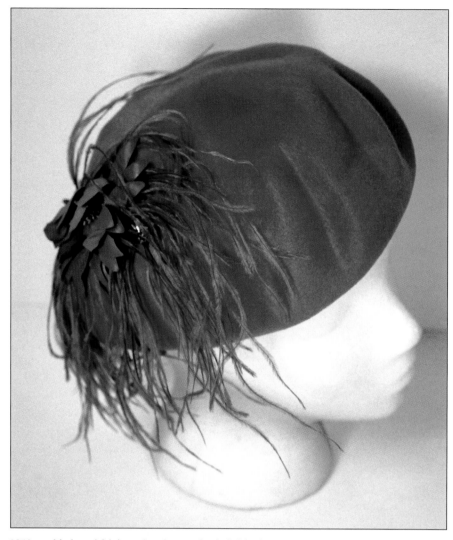

1950s molded wool felt beret in salmon color is finished with matching marabou feather and flower. Label: Glenover. *Courtesy of Josie V. Smull.* $50-75.

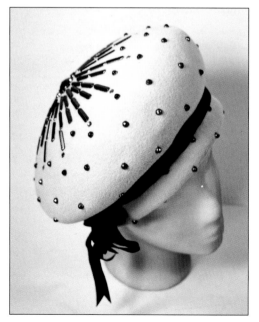

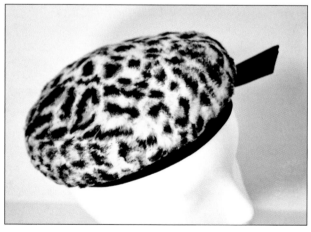

1957 faux fur printed leopard beret with black grosgrain band and bow was made by Mr. Milton. $35-60.

1950s winter white felt beret with hand riveted decoration, half beads, and brown velvet band and bow. Label: Fur felt. Michi, Haddon Heights, New Jersey. $75-85.

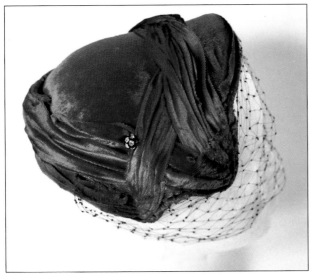

1950s raspberry crushed velvet hat is trimmed with rhinestone ball and nose-length veil. Store label: L. Bamberger and Co., Newark, New Jersey. $60-75.

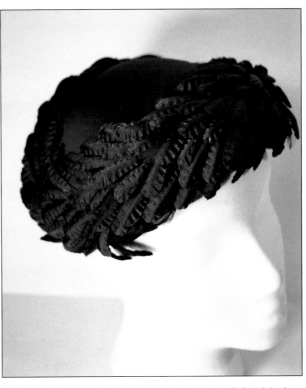

1950s royal blue satin hat has embossed petal trim. Label: Original Roberta Bernays. $50-65.

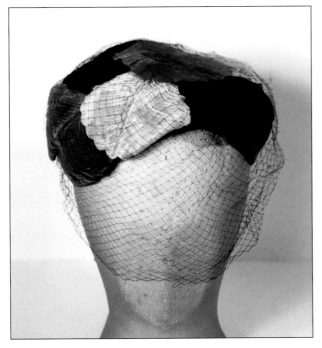

1950s half crown is made of crushed velvet leaves in shades of blue and is covered with full-face veil. $40-55.

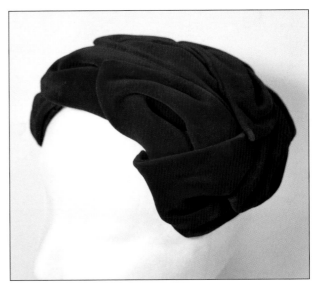

1950s bandeau style hat is made of fuchsia velvet petals draped over a mesh frame. Mr. Moyer liked this hat very much, because his wife's long hair could be seen in the back. *Courtesy of Jane Shaneberger Moyer.* $45-65.

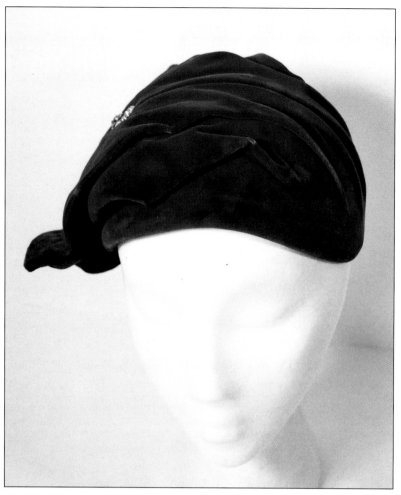

1950s inside view showing label of Lucilla Mendez Exclusive New York and gold lamé lining. *Courtesy of Joanne E. Deardorff.*

1950s front view of Lucia Mendez Exclusive. *Courtesy of Joanne E. Deardorff.* $50-65.

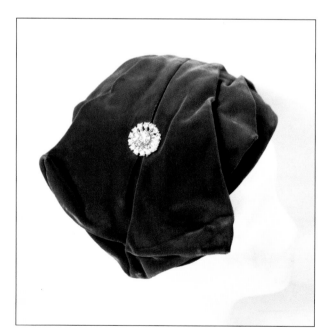

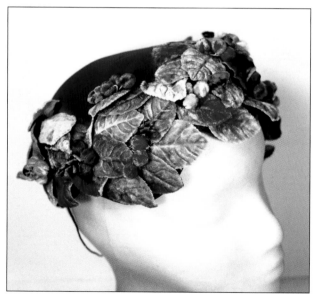

1950s side view of royal blue velvet draped and hand sewed hat with Aurora Borealis pin. *Courtesy of Joanne E. Deardorff.*

1950s raspberry velvet hat is made with embossed velvet leaves and berries. It is held on with a back elastic band. Label: Helen Joyce Original New York. *Courtesy of Josie V. Smull.* $60-75.

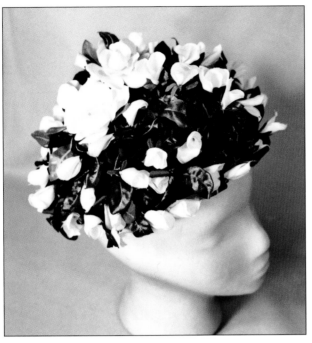

1950s gardenia hat, formed over mesh frame, was a most elegant hat. $45-70.

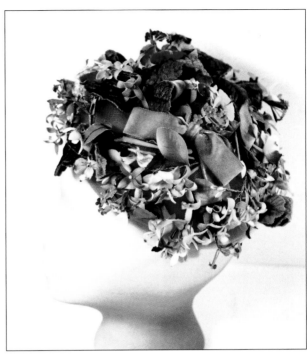

1950s Mr. Kurt Original made over a mesh frame covered with lavender tulle, a variety of early spring flowers, and velvet ribbon. Sold by Hess Brothers, Allentown, Pennsylvania. $45-75.

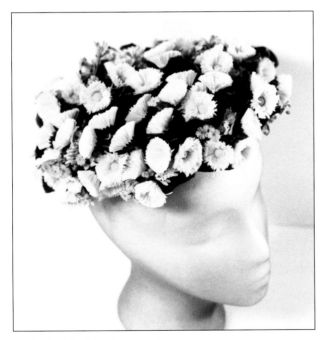

1950s Gottleib daisy flower hat is formed over a green mesh frame. $45-70.

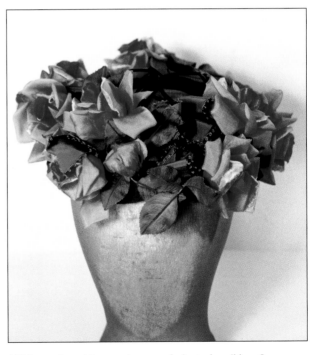

1950s rose hat with green leaves and picot edge ribbon from Orbach's, Newark, New Jersey. $65-75.

1950s hatbox is from Peck and Peck, Fifth Avenue, New York. $20-35.

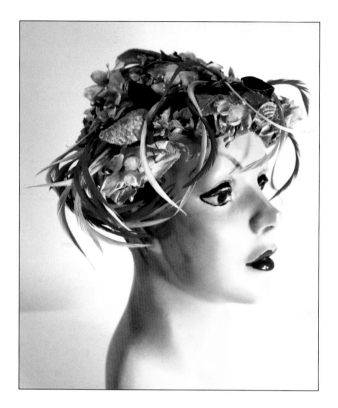

1950s half crown trimmed in fuchsia and pink feathers, silk flowers, and embossed leaves. *Hat and mannequin courtesy of Barbara Kennedy.* $75-90.

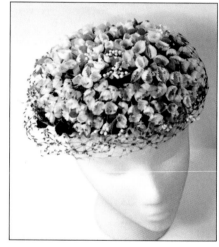

1950s Peck and Peck shallow pillbox hat covered with lilies of the valley and veiling and is held on with two tortoise shell combs. $25-35.

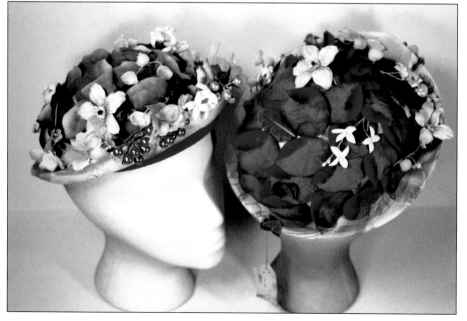

Early 1950s two small fully lined hats have up-turned brims. Crowns are completely hand covered with artificial cherries, flowers, and leaves. Hats are held on with back elastic. Original price tag hangs on hat on the right. Label: Hatitques. *Courtesy of Josie V. Smull.* $50-75 each.

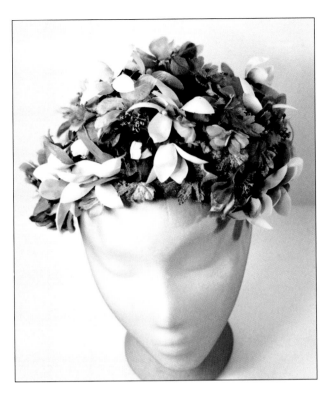

1950s flower hat constructed over mesh with white flowers and green velvet ribbon. $30-45.

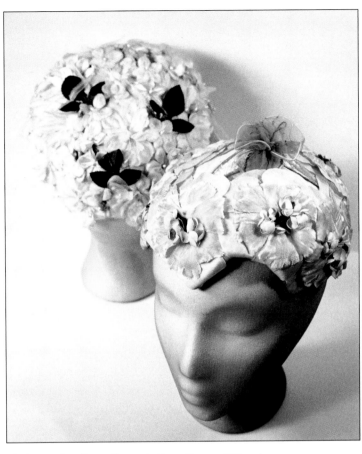

1950s popular all-over flower shallow pillboxes. $25 each.

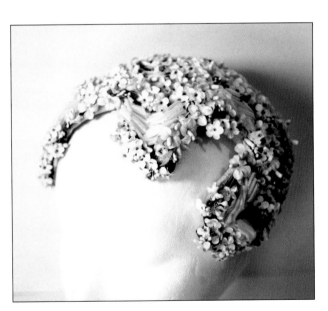

1950s scalloped head-hugging helmet is completely covered in delicate pink flowers and silk petals. $50-65. The scalloped edge is the popular eggshell design in broken form.

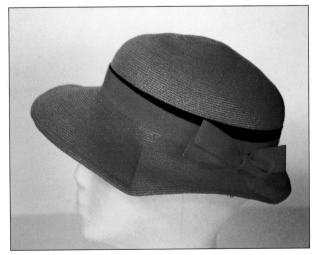

1950s orange straw hat trimmed with orange and black grosgrain ribbon and bows on each side. Fluted brim is made by four rows of stitching. Designer: Lucilla Mendez Exclusive New York. *Courtesy of Fae Shaffer*. $50-65.

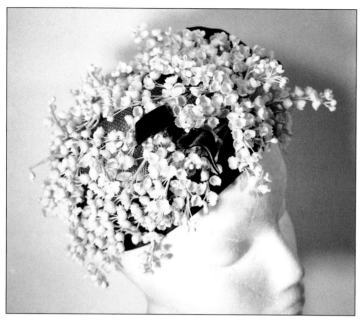

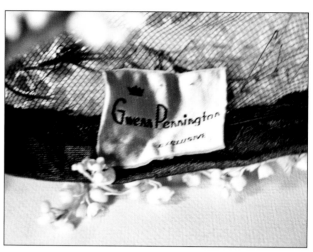

1950s Gwenn Pennington Exclusive bubble toque made over net frame covered with lilies of the valley and green velvet ribbon band and bow. Flowers are hand sewed in place. $20-30.

Label: Gwenn Pennington Exclusive made over moss green net frame.

1950s lampshade hat constructed over a wire frame is covered with net and silk roses. Label: Gigi New York, Hess's Allentown, Pennsylvania. *Hat and mannequin courtesy of Barbara Kennedy.* $95-125.

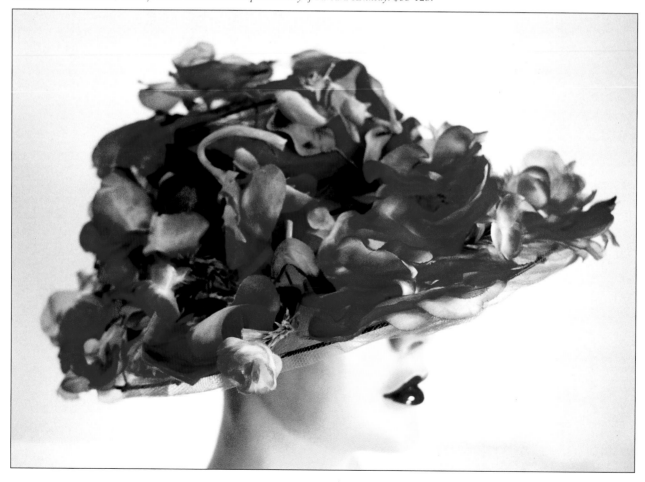

Feathered Hats

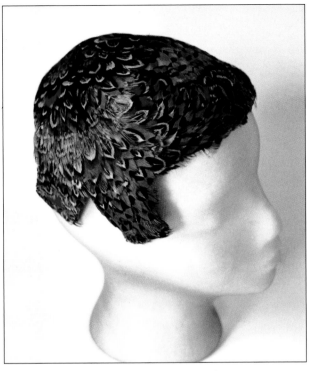

1950s handmade pheasant feather half crown hat has hand sewn thick flannel lining. *Courtesy of Jacki and Robert Jiorle, Eclectibles*. $40-65.

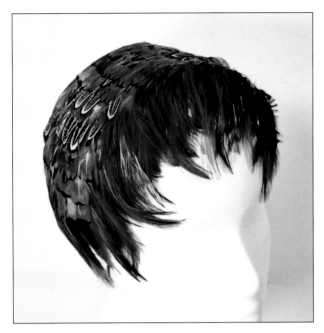

Late 1950s into 1960s clip band, covered in natural order pheasant feathers and tendrils, which frame the face. $30-45.

1950s half crown bandeau is completely covered in feathers that frame the face. Feathers were applied by hand, one at a time. $40-55.

Late 1950s black hackle feather (rooster) cocktail bandeau frames the face. $40-55.

1950s purple and pink feather bandeau has nose length veil. $40-55.

1950s feather bandeau with scalloped front line and nose length veil has iridescent taffeta lining. Label: Best & Co., Fifth Ave., New York. *Courtesy of Josie V. Smull.* $40-50.

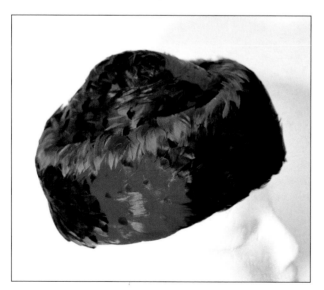

1950s felt form deep brim and pointed crown toque hand covered with feathers of fuchsia, turquoise, green, and purple. $50-65.

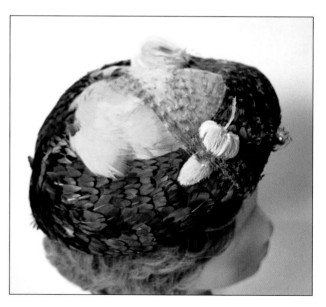

1950s pancake beret covered with pheasant feathers, veil, and pearl trim. $40-60.

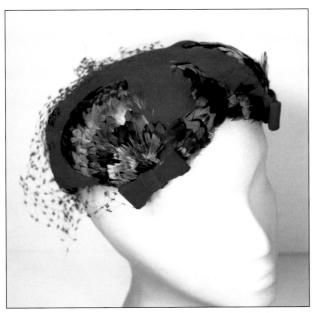

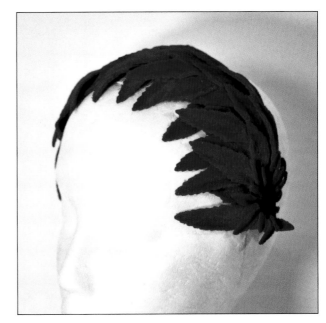

Late 1950s clip band of red embossed velvet leaves frames the face. $15-20.

1950s hand made feather bandeau with bows and veil. Label: Hess Brothers. *Courtesy of Josie V. Smull.* $45-65.

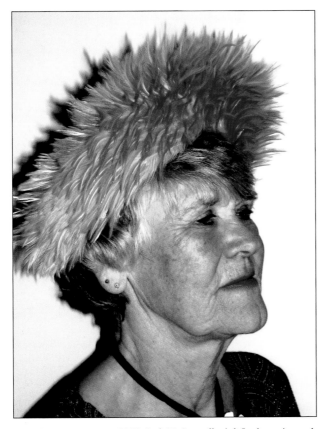

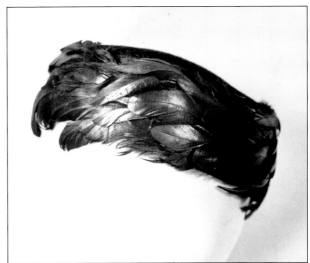

1950s shallow pillbox covered with iridescent coq feathers. $20-30. *Courtesy of Mildred Quigley.*

Betty Carpenter wears a 1950s Jack McConnell, pink feather-trimmed hat to a fancy tea. $90-125.

1950s small oval hat made of fine blue mesh with black lining and hand sewed grosgrain band inside. Hat is made of aqua embossed velvet feathers, which cover the hat form, and are a front decoration. Full-face veil covers entire hat. $30-45.

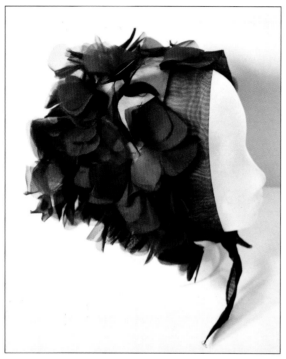

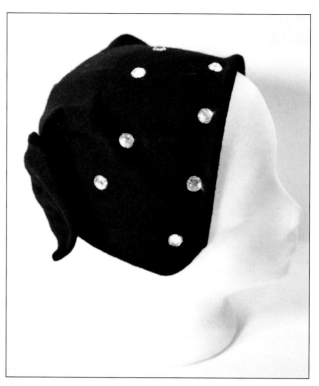

1950s black wool jersey knit cape hat attached to a bicycle clip. Rhinestone decoration is hand riveted in place. $10-15. *Courtesy of Marguerite Grumer.*

1950s black nylon triangular scarf with headband is completely covered with cut petals and ties under the chin. It may also be worn tied in back. Good for riding in open convertible cars. $15-25.

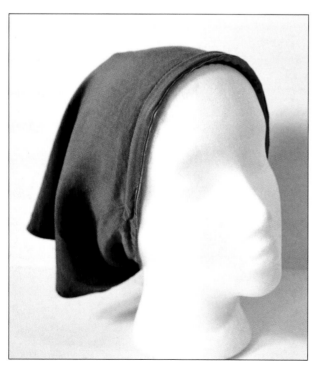

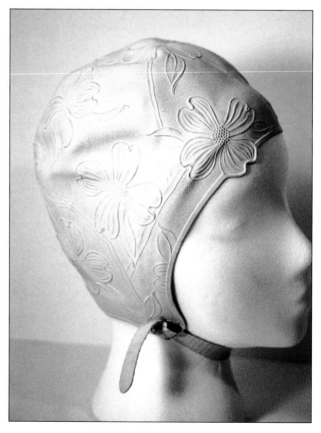

1950s reversible gold and popular olive green rayon bicycle clip cape hat tied in back of head. *Courtesy of Marguerite Grumer.* $10-15.

1950s rubber bathing cap, decorated with a popular dogwood pattern, is held on by an adjustable chin strap. Label: Sea Siren by Pretty Products, Made in USA. $15-20.

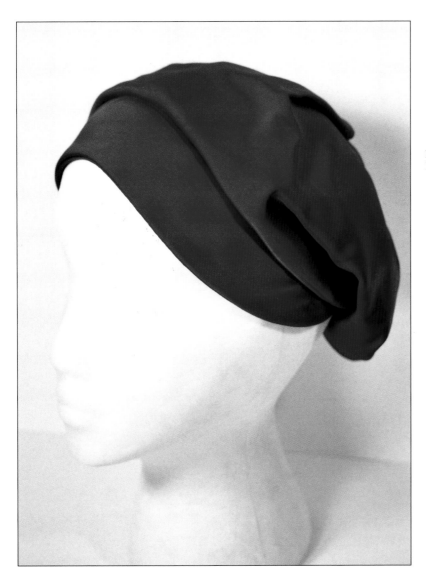

1950s fancy red satin open back cap style hat has visor. Label: DiPinna Fifth Ave. and Miami Beach. *Courtesy of Bea Cohen.* $50-65.

1950s back view of red satin cap by DiPinna. *Courtesy of Bea Cohen.*

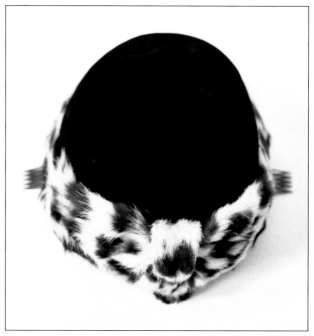

1950s fully lined chignon cap made of black velvet and leopard. Hat is held on with two tortoise shell combs and completely covered the chignon. $25-30.

1950s leopard printed silk chignon hat tied in bandana style has hand rolled edge. Hat is by Emme. Pictured with the hat are two chignon forms from the 1950s worn by Rose Jamieson. $20-30.

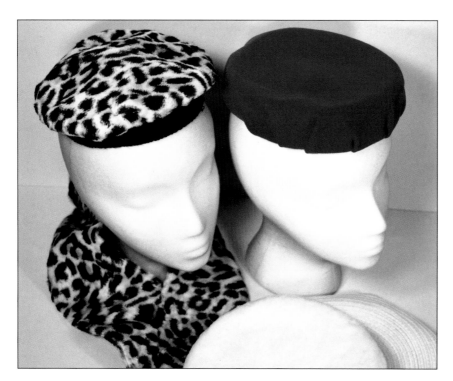

1950s faux fur beret style chignon hat with matching collar, left, and royal blue jersey pillbox, right. Two other chignon hats are in foreground. Dior designed a pillbox chignon hat that was worn to cover a large chignon. *Courtesy of Josie V. Smull*, who wore them. $25-30.

Pill Boxes

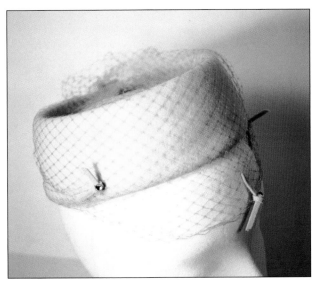

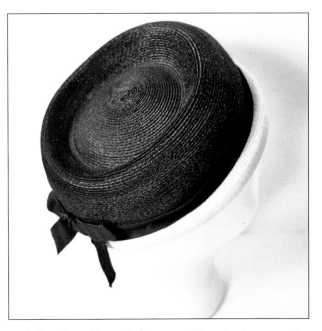

Back view of navy blue and white straw pillbox showing grosgrain band tied into a back bow.

1950s winter white pillbox with forehead length veil held on by two tortoise shell combs. Stamped label: Ritz 100% Wool. Henry Pollak, Inc. $45-55.

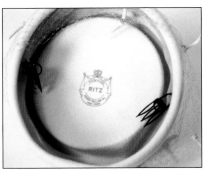

Inside view of winter white Henry Pollak pillbox showing green stamped label: Ritz 100% Wool and two combs that hold hat in place.

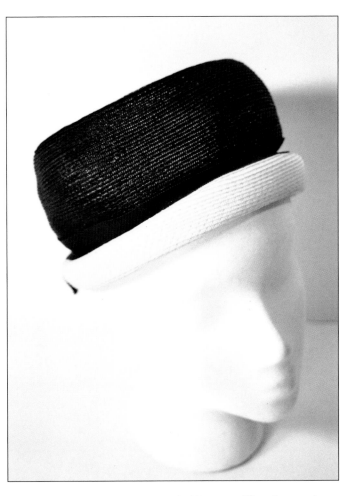

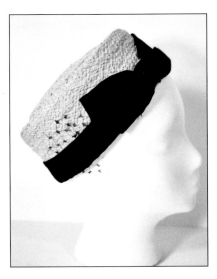

1950s woven straw pillbox has wide black velvet band and front bow. Remains of veil can be seen. Straw and velvet were a popular 1950s combination. $50-65.

Late 1950s front view of navy blue and white straw pillbox decorated with grosgrain band that is tied into a back bow. $50-65.

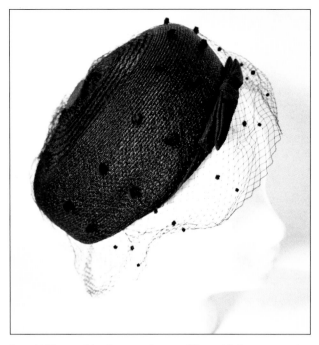

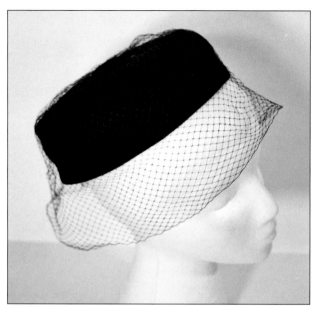

Late 1950s navy blue lacquered straw pillbox with front grosgrain bow has faille-covered button to hold graduated chenille dotted eye-length veil in place. Label: Clover Lane. $45-65.

1950s black velvet pillbox is covered with black eye length veil, which is attached at center back by a black velvet button. $50-65.

1950s genuine leopard skin pillbox by Mr. Marc is made of three pieces of skin. It is held on with two small tortoise shell combs. $50-65.

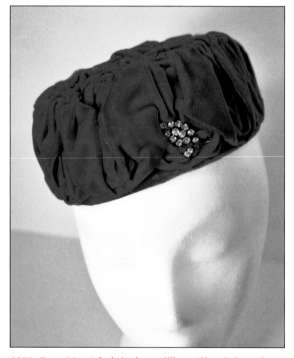

1950s Dana Marté fuchsia deep pillbox of hand-draped velvet is decorated with rhinestone pin. $50-75.

Inside view of pill box showing label: Made by Mr. Marc New York for John Wanamaker.

Label of Chapeau Dana Marté Originale.

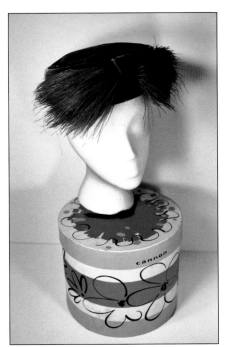

1950s royal blue velvet pillbox with primary color blue feather trim photographed sitting on its original hatbox. *Courtesy of Josie V. Smull.* $75-95.

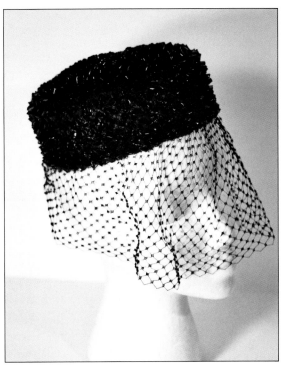

1950s black twisted cellophane tape pillbox has a tapered nose length coarse veil. Designer: Norman Durand Original. $65-85.

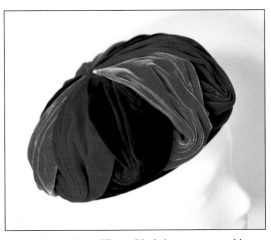

1950s nine-section pillbox of fuchsia, maroon, and hot pink velvet is hand draped over capenet frame, which is an open mesh foundation fabric. Label: An Original Mr. Stanley, New York. $50-65.

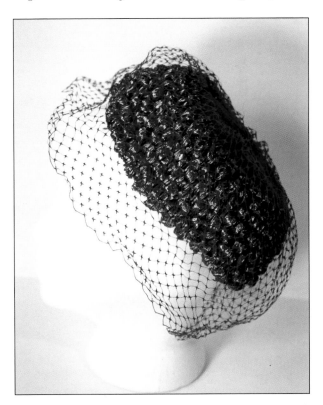

1950s black shallow pillbox is made of cordet yarn with sequin trim. A black veil covers hat and is held on by a tiny velvet bow. $25-35.

1950s red shallow cellophane straw pillbox is completely covered with red veil. $25-35.

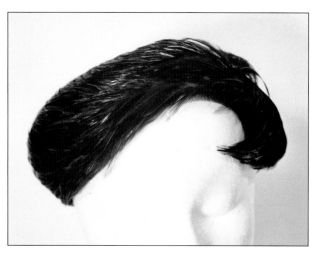

1950s marabou feather pillbox has original designer tag. Designer: Kurt Jr. *Courtesy of Mary Ann Faust.* $95-125.

1950s handmade, one-by-one feather-covered pillbox in black that was such a popular design it was made in many other colors. *Courtesy of Mildred Quigley.* $20-30.

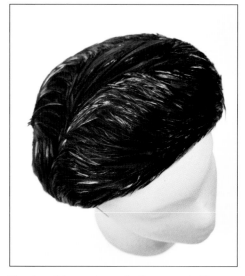

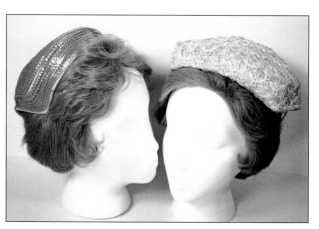

Two shallow hats – pink hat on left is covered with a string of sequins and beige hat on right is covered with ribbon trim and held on with elastic back band. Both were simple, but popular styles. $15-20.

Top view of the one-by-one feather covered pillbox above, showing the feather design. *Courtesy of Mildred Quigley.* $20-30.

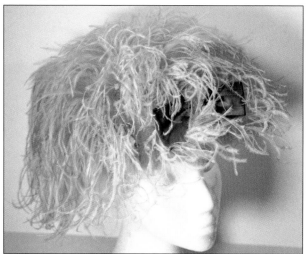

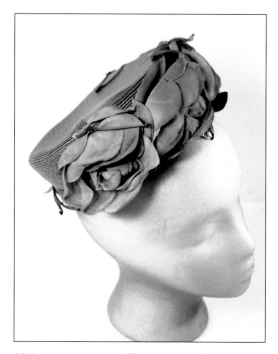

1950s champagne silk satin pillbox is covered with pink marabou feathers and a tailored bow. Label: Giovanni Made in Florence Italy. $75-125.

1950s pea green straw pillbox is trimmed in green silk flowers. Designer: Janeth Roy New York. $50-65.

Late 1950s Bonnet Styles

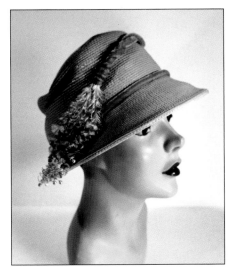

1958's pea green straw bonnet style hat with narrow brim has a velvet and feather trim. Tuck in brim was hand sewn in place. Hat was worn far back on the head. $55-65. *Mannequin courtesy of Barbara Kennedy.*

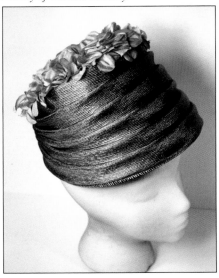

Late 1950s pleated lavender bonnet style hat is decorated with pink flowers at crown. Hat was worn at back of head. $40-55.

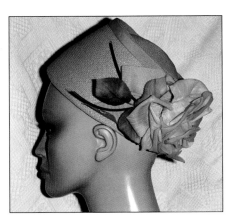

1950s peach straw Coralee bonnet style hat trimmed with grosgrain ribbon and large rose. *Courtesy of Kimberly Kirker, Kimberly Kirker Antiques.* $50-65.

Shell Hats

Page 153 of 1952 *Alden Catalogue* features shell bonnets in piqué, straw cloth and velvet, and popular button motif.

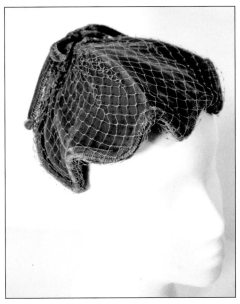

1950s brown velvet shell hat, constructed over a wire frame, is trimmed with large mesh brown veil and velvet bow. $20-30.

Yellow straw shell Easter bonnet was worn by Rose Jamieson in 1951. Edge of hat is bound in navy blue velvet ribbon. Crown is trimmed with a wreath of miniature daffodils, green leaves, and three navy velvet bows. Nose length veil also covers front of the brim. $40-50.

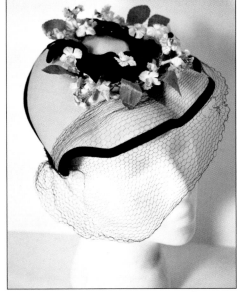

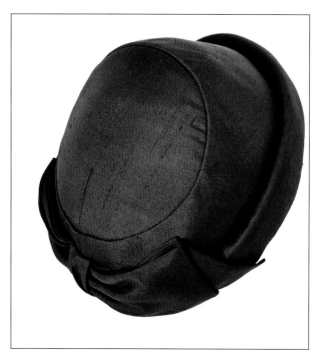

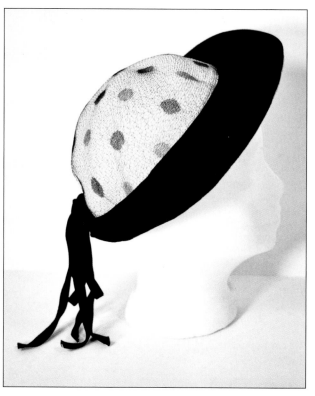

1950s black silk shantung dressmaker hat constructed over hat frame having deep crown and rolled up brim finished with large bow at nape of neck. The hat is fully lined with black taffeta. Manufacturer: Betmar Paris New York. $50-75.

1950s lacquered straw bonnet has a velvet-covered brim with a polka dot net covering the crown. Black velvet bow and streamers fall from back. Velvet and straw were a popular 1950s combination. $75-95.

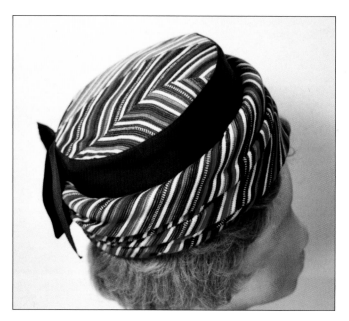

Inside view of bonnet showing hat maker Bernice Charles label, 711 Fifth Ave., New York. Also showing are large hand-made catch stitches. Bonwit Teller, Philadelphia, sold hat.

1950s striped pinwale corduroy dressmaker hat has brown grosgrain band, bow and full satin lining. $30-40.

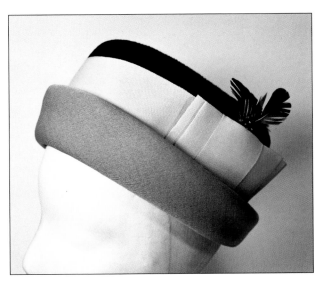

1950s black velour small style hat has camel color jersey knit covering the brim. Yellow grosgrain band, tailored bow, and feather trim the hat, which is fully lined. Label: Body made in Italy. Styled by Quaker Maid. Hat was made over by a milliner. $30-40.

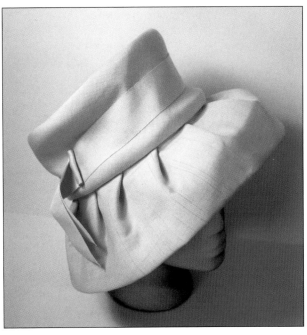

Late 1950s pink silk shantung dressmaker lampshade hat is trimmed with matching grosgrain ribbon. Hat is fully lined with heavy, hot pink faille. Hat made by sewing techniques. $50-65.

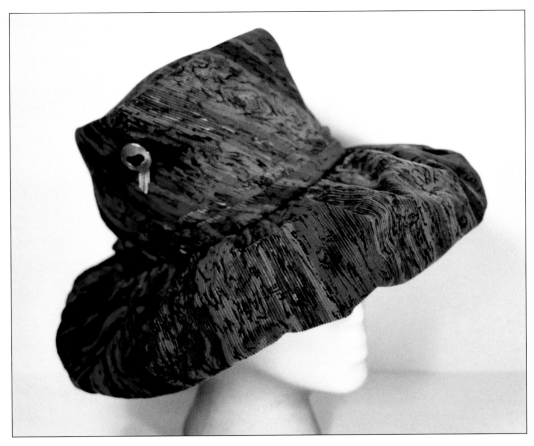

1950s dressmaker hat was made of printed pinwale corduroy. The brim was cut on the straight of the grain; the crown and band were cut on the bias. These were usually made to match an outfit using dressmaker sewing techniques. *Courtesy of Josie V. Smull.* $60-75

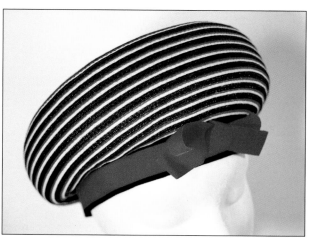

1950s bubble toque of red, white, and blue straw is trimmed with red grosgrain ribbon bow in front. Store label: Gladys & Belle 30 West 57th Street, New York. $75-95.

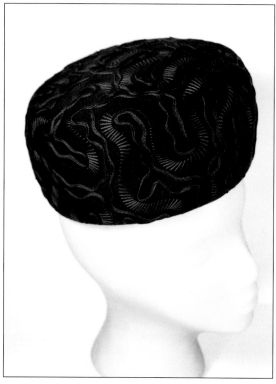

1950s hatbox from Gladys and Belle, 30 West 57th Street, New York. $25.

1950s bubble toque of navy blue wool felt is trimmed with vermicelli embroidery and tape. Hat is held on with a three-inch long front clear plastic comb. Designer: Don Anderson. $60-75.

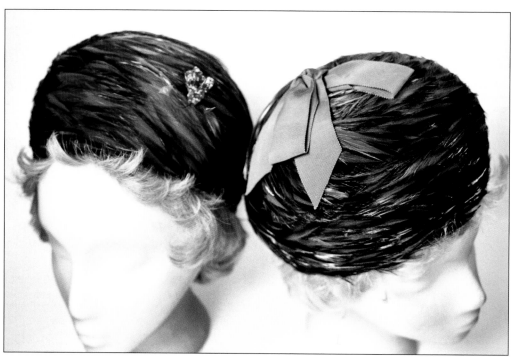

1950s two of Fran's hand made bubble toques are fully lined and hand decorated with feathers. Left hat is decorated with amber pin and right hat has a large green grosgrain bow. $85-95.

Winter Fashions

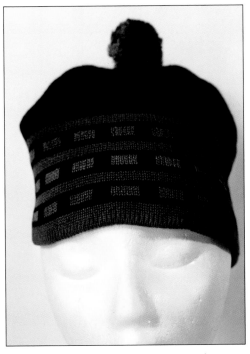

1950s cap has 100% cotton lining. Label: Hanna Made in Sweden, hand wash lukewarm, no bleach, shape and dry flat. $15-25.

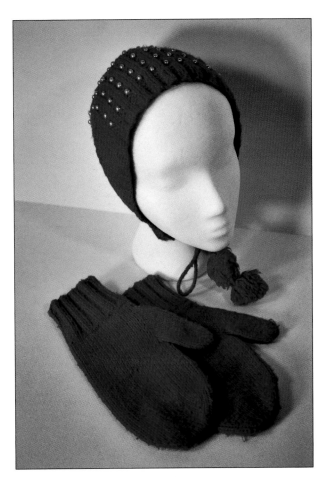

Hand knit in 1958 by Jane Quigley for her high school age niece, this red acrylic biggonet has white pearl trim hand sewn in place and matching red mittens.

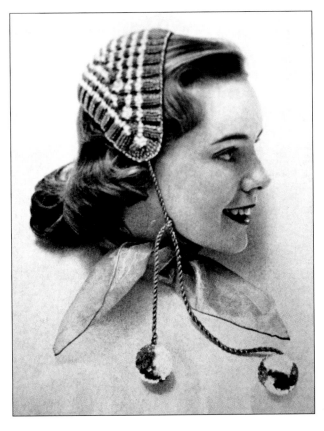

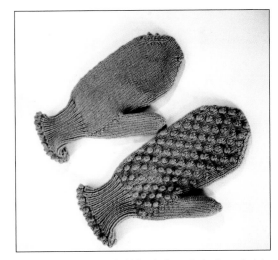

1950s gray mittens in bobble stitch made by Jane Quigley.

1950s knit hat (Biggin) by American Thread Company. Model is wearing a neckerchief, the popular 1950s accessory.

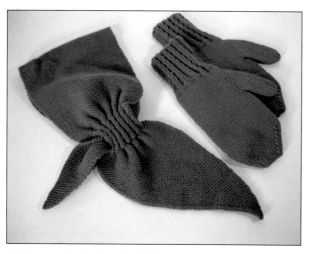

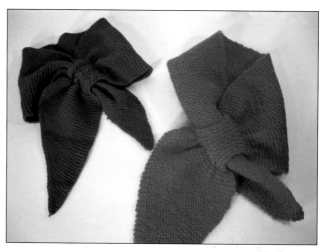

1950s mauve knitted scarf and mittens were made by Jane Quigley for sister-in-law Mildred Quigley. Cuff of mittens is worked in miniature cable stitch. Scarf is worked in garter stitch and miniature cable with a pull-through slot.

1950s two knitted scarves have pull through or slot. Left is red with garter stitch and open work lace. Right is orange garter stitch with 1 by 1 rib pull through area.

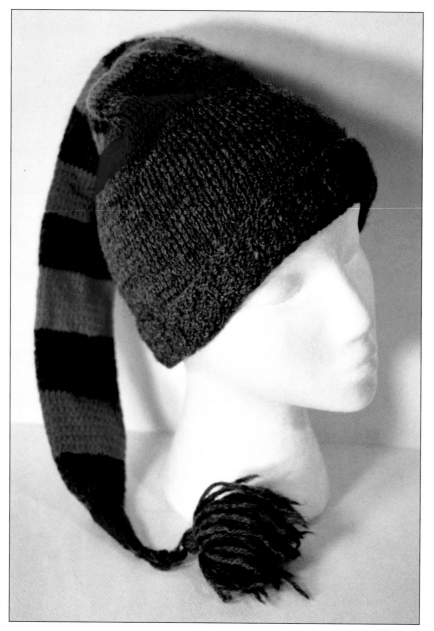

1950s hand knit wool stocking cap completed in stockinette stitch. $25-30.

Women's Hat Boxes

1950s John Wanamaker hatbox showing famous John Wanamaker eagle. $15-20.

1950s Strawbridge and Clothier hatbox. Their stores were in Philadelphia, Ardmore, Jenkintown, Wilmington and Cherry Hill. $15-20.

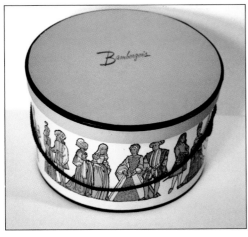

1950s Bamberger's hatbox. $10-20.

1950s vinyl hatbox. *Courtesy of Josie V. Smull*. $15-20.

1950s hat stand from a store millinery department. *Courtesy of Josie V. Smull*. $100-125.

A group of 1950s golfers poses in their fedoras and "v" neck sweaters.

1950s man's hat has brand stamped Desmond's Southern California, Beaver 20, Los Angles. The soft Western style has a rolled brim and the crown is trimmed with band and bow. $45-55.

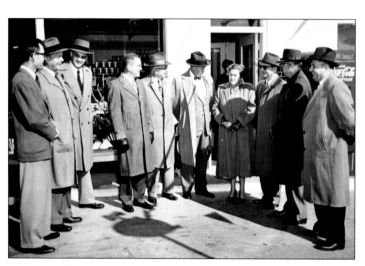

1950s photo showing a group of men in suits and overcoats wearing the popular Fedora. The only woman is "hatless."

1950s man's brown velour alpine style hat has a rolled brim, cordet yarn band and a silver Edelweiss pin holding a bouquet of pheasant feathers. Store label: Bricker, Easton, Pennsylvania and was worn by Paul Jamieson. $40-55.

1950s man's brown wool felt "Cross Country" hat has grosgrain ribbon trim. Manufacturers: Dobbs Fifth Avenue, New York. Sold by Hackett, Easton, Pennsylvania. $40-55.

1951 Seaman style scarf hand knit by Mildred Quigley for her son Nelson. Chest area ends are basket weave stitch and neck area is 4 by 4 ribbing. This variegated wool sport weight yarn was popular in the 1950s. The scarf is reversible.

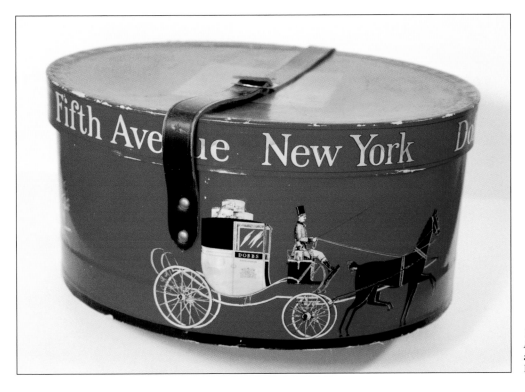

1950s hatbox from Dobb's, 5th Ave., New York showing horse and driver delivering hats in Dobb's coach. $60-90.

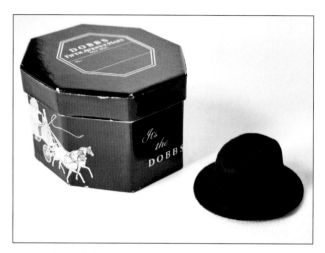

1950s Dobbs miniature hatbox and black felt hat used for gift giving. $25-35.

Easter 1950. Georgette Wolf wears a typical baby bonnet and her mother, Anna Freed, holds a bunny. *Courtesy of Paul and Georgette Wolf.*

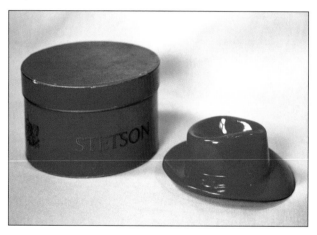

1950s miniature Stetson hatbox with red plastic Fedora snap-brim was given as a gift; then recipient would go to the store and select a hat. *Courtesy of James and Rene Stoufer*. $25-35.

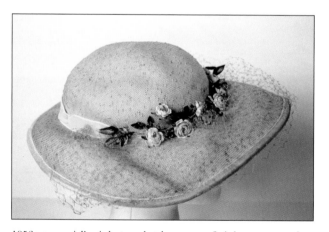

1953 young girl's pink straw hat has a row of pink roses around crown and net over front brim. $25-40.

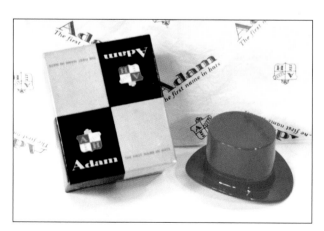

1950s Adam miniature gift hat box with original Adam tissue paper and red plastic top hat. Belonged to Carroll Robbins Bird. $25-35.

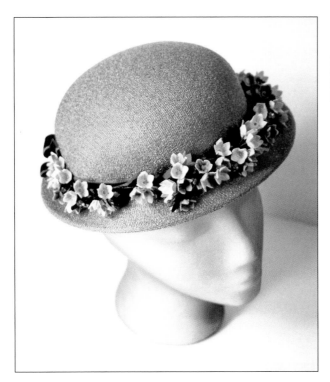

1950s tan derby style hat with low, wide crown is trimmed with wreath of small flowers and brown velvet bow. *Courtesy of Vangie and Donald Shweitzer*. $50-75.

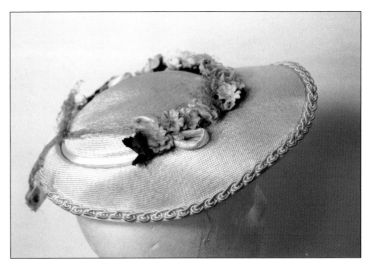

1952 pink Dior style hat belonged to Rose Jamieson as a young girl. The crown is trimmed with flowers, ribbon and veil. Brim is edged with braid. This hat is being held in the photo below. $35-50.

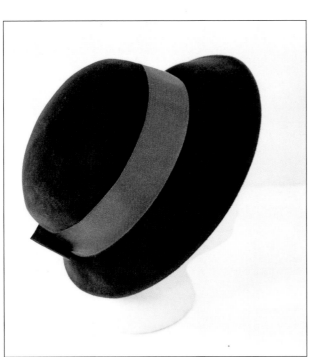

1950s very fine quality navy blue felt hat by Borsalino Antica Casa, Rome, Italy. Trim is wide grosgrain band and back bow. $50-75.

1950s inside view of navy blue bonnet style felt hat showing Borsalino Antica Casa stamped label, Rome, Italy.

Easter 1952 sisters Rose and Antoinette Quigley pose with friend. A Dior style hat is held by Rose (right) and a straw bonnet is held by Antoinette (front).

The 1960s
Youth Revolution

Historical Events of the 1960s

January 20, 1961, John F. Kennedy was inaugurated as President of the USA.

Jackie Kennedy became a new, youthful fashion icon.

South Vietnam was given assistance to fight communism, Vietnam War.

African American and white "Freedom marchers" gathered in Washington, DC, August 28, 1963, with Reverend Dr. Martin Luther King, Jr., who gave his "I Have A Dream" Speech.

President John F. Kennedy was assassinated November 22, 1963.

Lyndon Baines Johnson became President of the USA.

Bobby Kennedy was assassinated June 5, 1968.

Martin Luther King, Jr. was assassinated March 4, 1968.

Young hippies struggled to overthrow "the establishment" and rejected American values.

Women wore pants suits and men wore long hair to show personal freedom.

Neil A. Armstrong and Edwin E. Aldrin, Jr. walked on the moon July 20, 1969.

Fashions of the 1960s

In the 1960s there was a youth revolution. This new emphasis on youth led to styles designed for young people. By the mid-sixties the mini skirt, short shorts or hot pants, tapered leg pants, and denim clothing were popular. Many older women, who had been the fashion establishment, followed the trend of youthful dressing.

There were still many women who refused to wear the miniskirt, and they could wear pants as an alternative. When the new pants suits became fashionable, women were accepted wearing them at work, in theaters, at restaurants, and on city streets. When women elected to wear pants outfits, there were many philosophical discussions about its correctness by the few who considered it improper.

Paris fashion was always made for the older, well-established, wealthy woman who could afford the custom made clothing from the designer houses.

Young English fashion designer Mary Quant caused a fashion revolution when she started to design clothing with teenagers and young women in mind. Her clothes were fun, affordable, youthful, and simply cut. Quant brought out the miniskirt, mini dress, tights, thigh high boots, wide belts, and large size purses. Her clothes were ready-to-wear and fun to mix and match.

Young high-fashion designers in Paris learned from the popularity of the youth movement; Courreges designed miniskirts and the trouser suit in 1964. They were worn with a large helmet-like hat called a wastebasket. Cardin designed miniskirt ensembles with clean, severe lines. Yves Saint Laurent designed the still very famous Mondrian geometric sheath dress and the maxi skirt. In 1962 he opened his own ready-to-wear business called *Rive Gauche* ("left bank" in French).

In 1960 well-established Pairs designers showed dresses, suits, and coats made of two contrasting colors in the same garment. The colors were lime green and turquoise, orange and pink, and bright yellow and green. The accessories were made in the brighter of the colors. Deep pillboxes, large bubble toques, and deep crowned hats with soft floppy brims topped these designer outfits.

Hairstyles of the 1960s

The revolutionery "hippies" of the 1960s wore their hair long and used headbands to keep it back. They wore necklaces of beads, clothing with fringes, and prairie style clothes. Hairstyles of the 1960s were long. The 'flip' was a popular style worn down to the shoulder and it turned up at the ends, giving it its name. To make the hair flip, it was set in fat rollers, teased for fullness, and sprayed with plenty of hairspray. Jackie Kennedy wore a flip. It was topped with the famous deep pillbox worn back on her head.

The "beehive" was another popular hairstyle designed for long hair. It had to be sprayed with hairspray during the teasing process to give it more fullness or volume. The hair was smoothed

and arranged with fullness at the sides and with hair piled high on top. Teasing was popular into the 1970s. Tall crowned hats were designed to go over the beehive.

Wigs and hairpieces were an important accessory and became very big business in the sixties. They were styled at the beauty parlor to fit the woman's face. Hair coloring and bleaches were technically improved and became another big part of the beauty parlor industry.

In 1964 long, straight hair was a hairstyle, which symbolized youth. Starting in 1968 and into the 1970s, the "Afro" style was popular among all groups of people. The beauty parlor sold permanent waves for the new "Afro."

Hat Information for the 1960s

John F. Kennedy did not wear a hat to his presidential inauguration. This was a severe blow to the dying fashion of wearing a hat, giving men more courage to go hatless. The Danbury, Connecticut hat makers blamed Kennedy for the decline of the Danbury Hat Making Center and for the subsequent unemployment.

By the mid-1960s the wearing of beautiful hats was on the decline. The emphasis on youth added to the decline as the popular, long-haired musical band The Beatles had become style setters for the young.

Popular hats of the early 1960s include the lampshade hats, crocheted bangle hats, turban style hats, small cone hats, deep pillboxes worn at the back of the head, and helmet style hats (called cloches by Sears). As hairstyles became bigger, crowns of hats became larger to accommodate the hair.

There were the large flowered hats, bonnet styles, bubble toques, and large two-section berets. With the popularity of the movie "Dr. Zhivago," hats in Russian style, made of both genuine and faux fur, become popular. Other hats with deep crowns and wide brims were in fashion with the masculine styles: derbies, top hats, fedoras, and helmets. As the hairstyles became bigger and there was more interest in hair, hats by the end of the sixties turned into whimsies worn on top of the hairstyle. Whimsies were made in all kinds of materials in interesting designs, until they were finally almost nothing. To wear a whimsy meant you were still proper and well-dressed. You weren't going hatless!

Designer Halston

Roy Halston Frowick was born in Des Moines, Iowa, and studied art at the Chicago Art Institute. In 1961 Halston, known as H to his friends, designed the pillbox for Jackie Kennedy. He learned millinery with Lilly Daché in New York.

Jackie Kennedy needed a hat to wear to John F. Kennedys inauguration in 1961. Jackie and Halston agreed on a pillbox, which became her fashion trademark throughout the western world. She and Halston had the same head size and he always tried on the hats before he sent them to her. She always knew they would fit. She had pillboxes made in colors and fabrics to match each of her outfits. The pillbox was a youthful style that she wore back on her head. Having no large brim, her face could be seen in photographs from all angles, which greatly pleased the photographers.

1960s white fur toque by Halston.

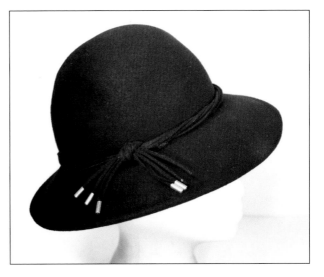

1960s tailored deep crown hat with wide brim trimmed with three groups of two ply twisted cords tied around crown. Label: Halston 100% wool felt. *Courtesy of Louise Sanita.* $50-75.

Designer Oleg Cassini and Jackie Kennedy

Oleg Cassini was born in Paris, France in 1913. He graduated from the English Catholic School and then the *Accademia delle Belle Art* in Florence in 1934. He worked in his mother's dress shop in Florence until he left for New York in 1936. There he worked on Seventh Avenue for various manufacturers and finally joined 20th Century Fox in 1940. After WWII he became head of the wardrobe department at Eagle-Lion Studios. In the 1950s he returned to Seventh Avenue in New York and designed glamorous sheath dresses, knitted suits, jackets, and cocktail dresses. He was also designing for television and theater.

Back view of Oleg Cassini Registered bubble toque showing champagne fur felt plush with brown satin band and petal decoration on back. $75-95.

Label for Oleg Cassini Registered hat showing inside of completely finished hat. He designed hats for Jackie Kennedy.

In 1961 he was appointed by Jacqueline Kennedy to be her official wardrobe designer. Together they worked to develop a personal style for her, which became her trademark. She was a young and attractive First Lady and brought charm and elegance to the White House. Many of her outfits were copied. One of the most famous outfits he designed for her was the suit with short jacket and three-quarter length sleeves. The skirt had a slight "A" line and was just below her knee. The outfit was accessorized with Chanel-type beads, long gloves, and, of course, a pillbox hat designed by Halston worn back on her head. She wore this suit to accompany President Kennedy to Paris in June 1961. Oleg Cassini died in March of 2006.

Designer Adolfo

Adolfo Sardina was born in Havana, Cuba in 1933. His mother died in childbirth and his wealthy aunt who took him to Paris on shopping trips raised him. There he was introduced to Balenciaga and Chanel who were his Aunts favorite designers. He eventually became an apprentice to Balenciaga. When he left Paris for New York, his first job was as a designer of millinery for Bergdorf Goodman. Then he designed hats for Emme and his label was Adolfo of Emme.

In 1962 he borrowed $10,000 from Bill Blass in order to open his own business. He was so successful, the debt was paid off in six months. He designed for First Lady Nancy Reagen.

He wanted to design dresses and would design the dresses his models wore when they modeled his hats. When he made hats for women, he always asked the ladies to stand up for their hat fittings. He thought standing gave an accurate picture of fit. His later label was Adolfo II.

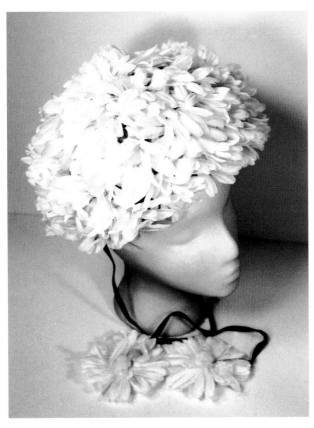

Early 1960s daisy wig hat constructed over a coarse mesh frame. Black decorative ties from back tie under the chin, ending in single daisies. Daisies were a popular 1950s motif. Designer label: Adolfo II New York Paris. *Courtesy of Josie V. Smull*. $50-60.

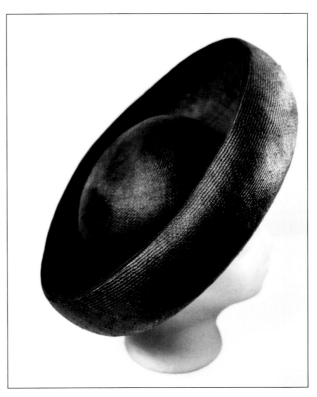

1960s Adolfo II side view of rolled wide brim Breton forming a halo is made of finely woven navy blue straw. In the 1960s it was worn at the back of the head, Jackie Kennedy style. $95-110.

Label: Adolfo II Paris New York.

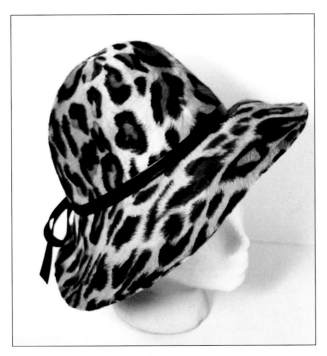

1960s faux fur leopard with tall, five-section crown has wide brim trimmed with narrow vinyl band and bow. Hat is fully lined with brown faille. Designer label: Adolfo Realities, New York and Paris. $75-95.

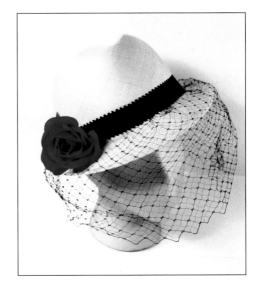

1960s fine Italian natural straw fedora style with sculptured crown has narrow brim. Trim is grosgrain ribbon with picot edge, full-face veil and red rose. Label: Adolfo II. $70-85.

Designer Yves Saint Laurent

YSL was born in 1931 in Oran, Algeria. He entered one of his fashion sketches in a contest judged by Dior. Laurent won the contest and was offered a job as a design assistant to Dior. From 1954 to 1957 he worked at the House of Dior. When Dior died in 1957, Yves Saint Laurent became the top designer. He left Dior and opened his own business at age 23 with Pierre Berge. By 1966 Laurent had opened the ready-to-wear boutique called *Rive Gauche*. His YSL initials were used on licenses for all types of merchandise including hats. Laurent is remembered for his trapeze dress in 1958 in his first Dior Collection. He also designed pea jackets, blazers and the famous dress inspired by artist Modrian. In 1963 he was honored by The Metropolitan Museum of Art.

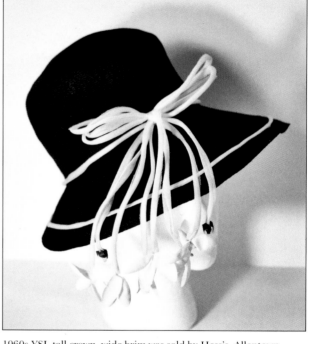

1960s YSL tall crown, wide brim was sold by Hess's, Allentown, Pennsylvania. The navy blue straw is trimmed with beige silk bands, bows and flowers. Streamers are so long that they trail down to the face of the wearer. Designer: Yves Saint Laurent. $95-110.

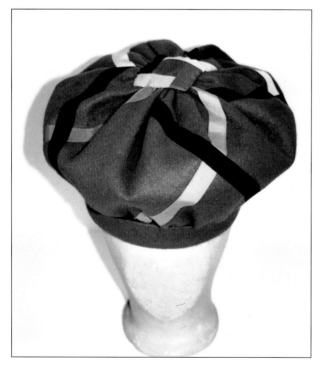

1960s brown felt tam is trimmed with beige and black grosgrain ribbon. A top square was hand stitched in place. Label: Yves Saint Laurent Paris – New York. $95-110.

Label: Yves Saint Laurent Paris – New York, and original hangtag.

Lampshade Hats

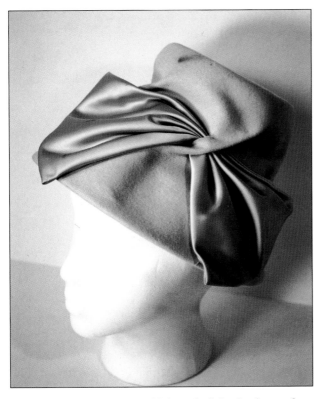

Early 1960s champagne beige felt lampshade hat has large soft champagne beige satin bow placed through the slash in felt. Store label: Arnold Constable, New York. $50-70.

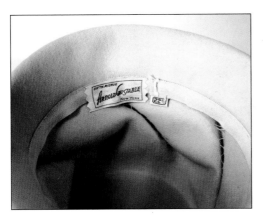

Inside view of the hat showing Arnold Constable Fifth Avenue, New York label and hand stitching.

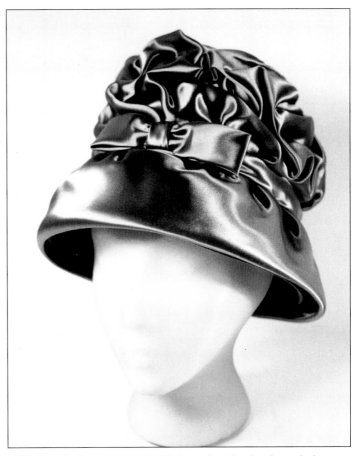

1960s lampshade style hat made of beige satin with a hand-smocked crown. Band and bow set off hat. *Courtesy of Helen Jiorle.* $50-70.

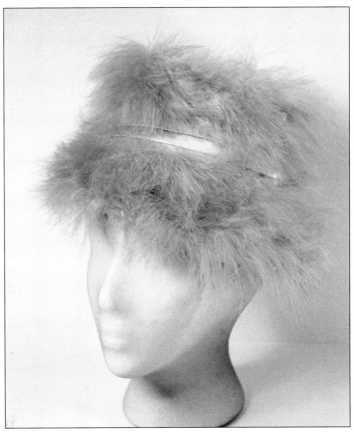

1960s feminine beige satin lampshade has pleated self-satin band and is covered with soft marabou feathers. *Courtesy of Helen Jiorle.* $50-75.

Wig Toques

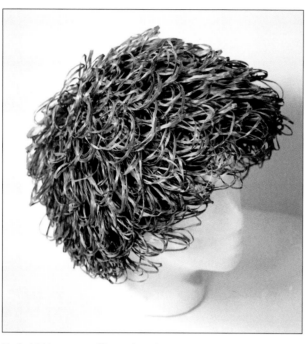

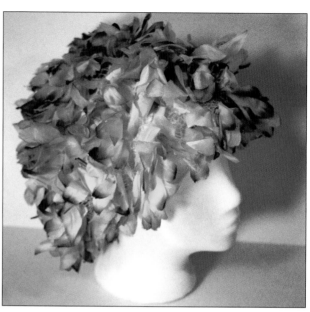

Early 1960s flower wig toque is covered with yellow silk petals. Grace Kelly wore a similar soft toque decorated with silk flower petals, but her toque had a band, which framed her face. $40-50.

Early 1960s green raffia crocheted wig toque with long loops. Store label: Best and Co., Fifth Ave., New York. $35-45.

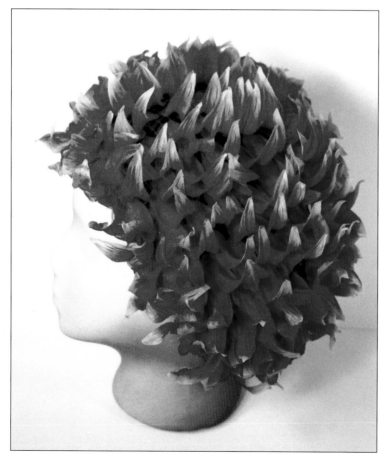

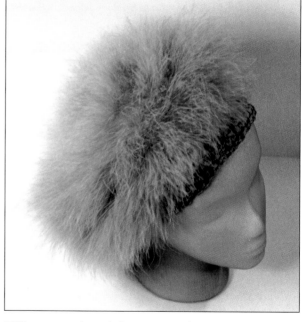

1960s aqua marabou wig hat constructed over crocheted rayon tape. *Courtesy of Jeanne L. Call, Facet Designs.* $30-45.

Early 1960s hot pink petal hat is formed over a rayon mesh net. Phyllis Blanchfield remembers the bright orange petal hat her sister wore to her wedding in 1967, and she looked beautiful! Label: Original Design by Nibud. Stamped label: 100% Rayon made in Japan 3955/Item No. 164. $45-65.

Mad Hatter's Hat

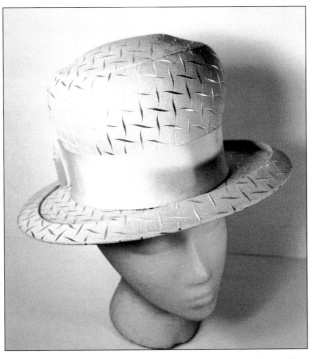

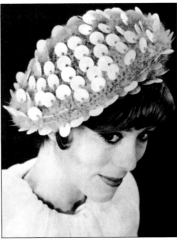

1960s Mohair Beret No. 23 in booklet *Instructions for Bangle Hats 10* uses imported mohair, 200 Walco bangles and size G hook. *Gift of Virginia Van Doren.*

1960s winter white tailored style tall crown hat wide at the top has a wide brim with a folded edge. Trim is wide grosgrain band and bow. Fabric is acrylic with embroidered design. Designer label: Lucilla Mendez Exclusive, New York. $70-95.

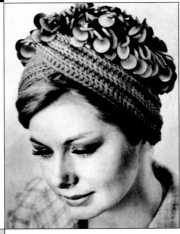

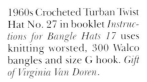

1960s Crocheted Turban Twist Hat No. 27 in booklet *Instructions for Bangle Hats 17* uses knitting worsted, 300 Walco bangles and size G hook. *Gift of Virginia Van Doren.*

Bangle Hats

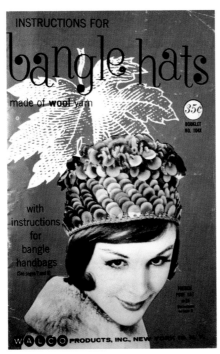

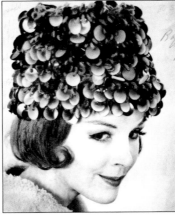

1960s Bangle Hi-Fashion High Hat No. 5 in booklet *Instructions for Bangle Hats 4* uses knitting worsted, 500 Walco bangles and size H hook. *Gift of Virginia Van Doren.*

1960s cover of *Instructions for Bangle Hats made of Wool Yarn* showing crocheted bangle toque. Published by Walco Products, N.Y. *Gift of Virginia Van Doren.*

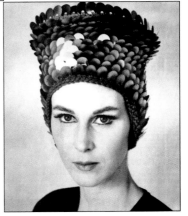

1960s Cleopatra High Hat No. 16 is a crocheted bangle toque in booklet *Instructions for Bangle Hats 12* covering the ears using knitting worsted, 500 Walco bangles and size G hook. *Gift of Virginia Van Doren.*

105

Turban Styles

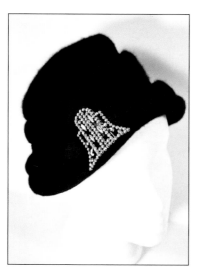

1960s black fur felt turban style toque has a cut steel pin. $45-65.

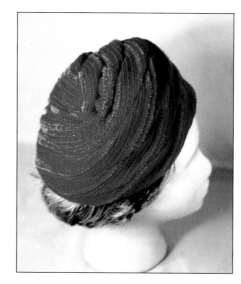

1960s side view of raspberry color turban style hat. Label: Union Made. $35-50.

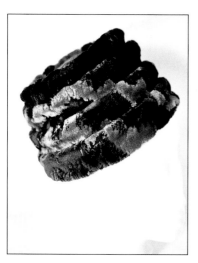

1960s rust, brown, and black pile fabric turban style toque is Union made by Cap A dors, USA. $45-65.

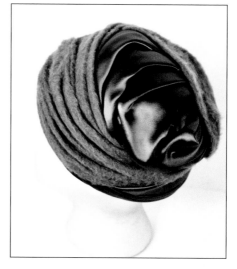

1960s hand draped and sewn turban made of Sunback, a popular lining fabric for coats, suits, and skirts. The satin side was worn outside and the plush side was the backing. Here both sides were used as fashion fabric. This hat would have matched the coat lining. Label: Mr. John. $60-75.

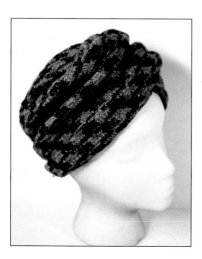

1960s draped turban made of wool in large hound's tooth check of brown and gray. This hat was made to be worn with a matching coat. The large hound's tooth check was a popular 1960s fabric. $40-65.

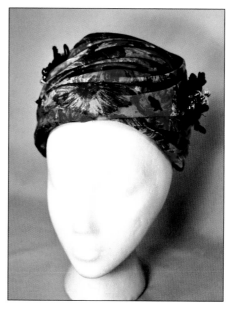

Late 1960s mesh turban frame is hand draped with multicolored printed silk. Hand stitches are visible. Black velvet bouquets decorate each side. *Courtesy of Marianne Meyer-Garcia, The Rose Cottage*. $40-60.

Bonnet Style Tall Crowns

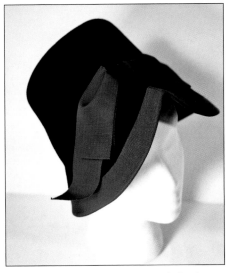

1960s black velour scoop bonnet style hat has a scalloped front brim. Brown grosgrain ribbon binds brim and large floppy bow is placed through slash in body of hat. Self-covered hatpins were made to compliment hat. Label: Steigers. $70-85.

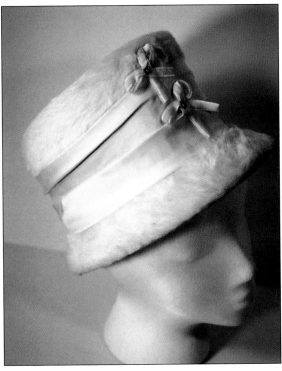

1960s winter white fur felt plush bonnet style is trimmed with satin bands and two velvet bows. The plush is made to imitate sheared ermine. $25-30.

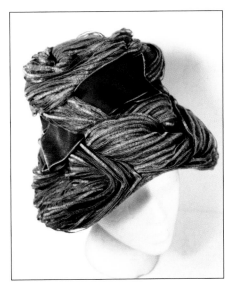

1960s blue bonnet style deep crown, wide brim is draped with twists of nylon fabric. Velvet ribbon is placed around the crown and ends at a diagonal. Label: Frederics Millinery, Allentown, Pennsylvania. $50-60.

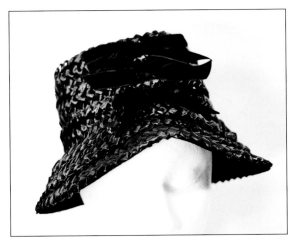

1960s black cellophane straw scoop bonnet is made over nylon mesh frame in bonnet style. Trim is a row of three velvet bows above peaked brim. $50-75.

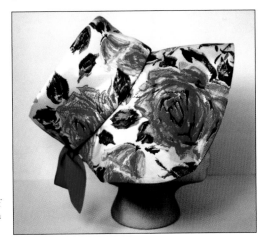

1960s dressmaker poke bonnet style hat made of rose printed taffeta is fully lined with white taffeta and trimmed with pink back bow. $40-50.

Cone Hats

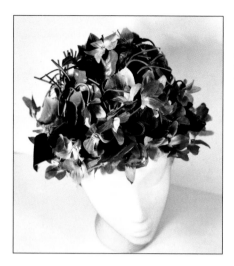

1960s cone hat made over a mesh frame is decorated with bouquets of violets and purple velvet bows. All are hand sewed in place. Store label: Hess's. $50-75.

Cone shaped hat is covered with pleated pink silk crepe and finished with a soft sculpture butterfly. $55-60. *Courtesy of Donna Hahn.*

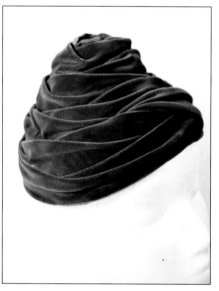

1960s taupe velvet draped cone hat designed by Miss Sally Victor, New York. $75-95.

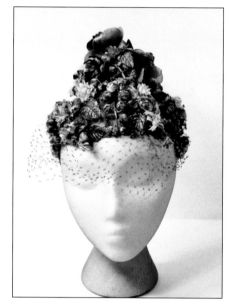

1960s cone hat constructed over velvet wire frame with side burns and fine net. Flowers are turquoise, pink, and lavender with pea green leaves. Eye length veil finishes hat. *Courtesy of Jeanne L. Call, Facet Designs.* $30-50.

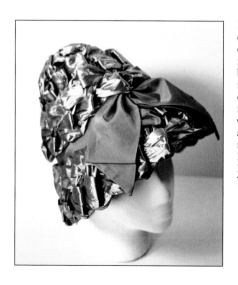

1965 taupe wide cellophane straw cone hat with matching taffeta band and large front bow was made over a lacy mesh frame. The hat was worn so forehead and hairstyle did not show. Label: Lucilla Mendez Exclusive New York. $60-75.

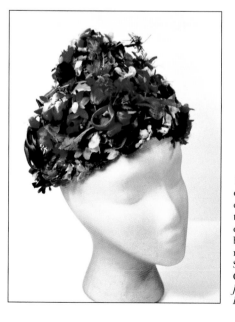

1960s cone hat made of rose colored crocheted raffia trimmed in rose colored flowers and buds with green and rose bows. Label: Strawbridge & Clothier. *Courtesy of Jeanne L. Call, Facet Designs.* $45-55.

Flower Pot Hats & Helmets

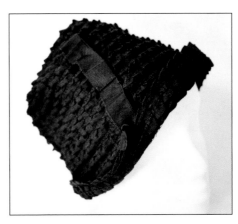

1960s navy blue straw helmet is trimmed with grosgrain band. Brim is a twisted rope effect. Label: Everitt. *Courtesy of Jane Shaneberger Moyer.* $30-40.

1960s Union made in USA dressmaker hat is made of black-coiled grosgrain in flowerpot shape and has a turned-up brim. *Courtesy of Shirley Kohr.* $30-40.

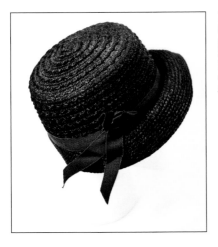

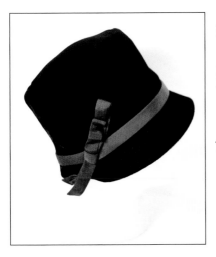

1960s black velvet helmet with narrow brim is machine stitched with 12 rows and lined with black faille and trimmed with grosgrain. Label: Lucille Mendez Exclusive, New York. *Courtesy of Jane Shaneberger Moyer.* $30-40.

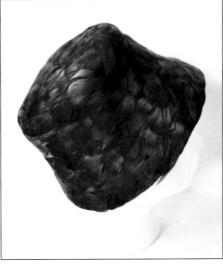

1960s purple feather flowerpot hat made over lace form. Label: Original Chapeaux Louise. *Gift of Dee Bouch.* $30-40.

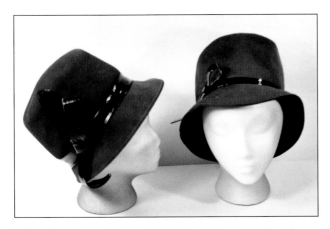

Left: 1960s brown velour made in Italy with brown leather trim. $20-30. Right: 1960s green felt tall crown with stamped label: TNLee 100% wool. Trim is black vinyl band and three rows of machine stitches. These tall crowns were tailored styles worn with suits. $20-30.

1960s royal blue velvet helmet hat trimmed in one by one-blue feathers. $40-50.

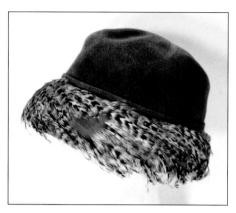

1960s adaptation of helmet hat in olive green felt body is completed with a hand applied feather covered brim. A touch of green in the brim unifies the design. $30-40.

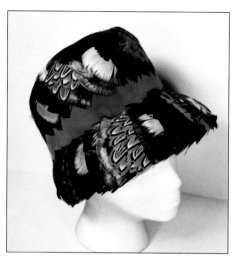

1960s hand "feathered" flowerpot hat with wide brown grosgrain band. Label: Union Made. *Courtesy of Kay Aristide.* $50-60.

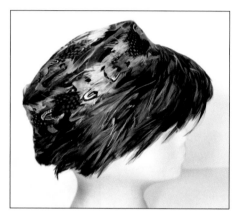

Side view of helmet style hat with feathers from various species of birds. Application of feathers was done by hand. *Courtesy of Josie V. Smull.* $50-60.

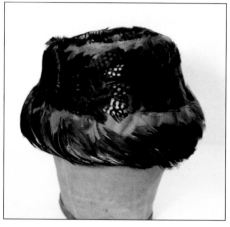

1960s popular helmet shaped hat is completely hand covered in "one by one method" in a variety of feathers. Label: Union made. $25-30.

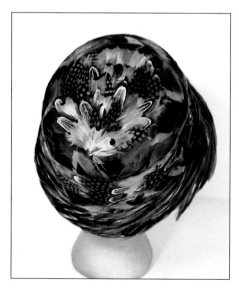

1960s back view of handmade helmet style hat with planned out design. *Courtesy of Josie V. Smull.* $50-60.

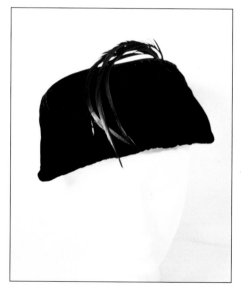

Late 1950-early 1960s black velvet swirled helmet hat with feather decoration. This was a popular style that was also available in royal blue and purple. $25-30.

Pillboxes

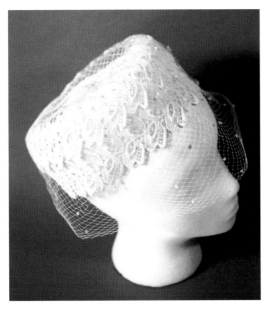

1960s white Venetian lace deep pillbox constructed over large mesh frame is covered with nose length veil. *Courtesy of Marguerite Grumer.* $20-25.

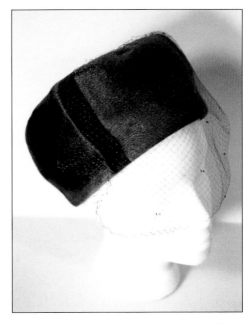

1960s Dana Marté made gray velour deep pillbox with nose length veil. $50-60.

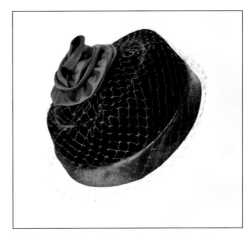

1960s black velvet pillbox trimmed with a bias cut black satin edge. Hat is covered with veil and a black satin rosette sits at top of crown. $25-35.

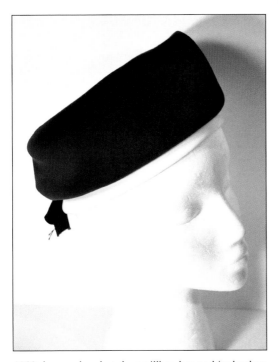

1960s burgundy velvet deep pillbox has a white leather (vinyl) band and back grosgrain bow. Label: Union Made in USA. $25-30.

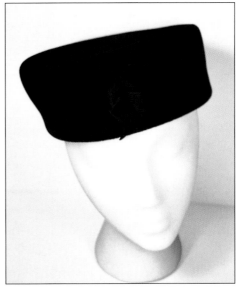

1960s well made black velour asymmetrical deep pillbox with front trim. Label: Leher Millinery, West 47th St., New York. *Courtesy of Josie V. Smull.* $50-60.

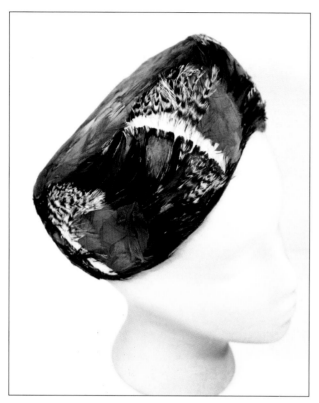

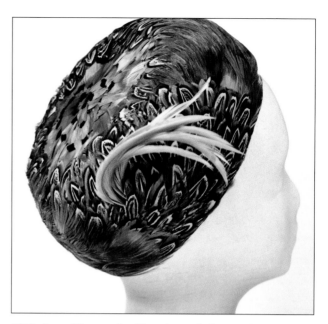

1960s deep pillbox made of "one by one" pheasant feather pattern designed over a good quality felt hat. $40-50.

1960s feather covered deep pillbox was sold by Anna Cubby Millinery, Haledon, New Jersey. Design on brim is made by hand placement of the feathers. $50-65.

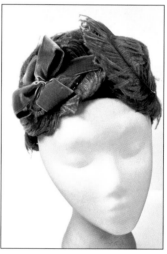

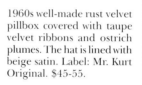

1960s well-made rust velvet pillbox covered with taupe velvet ribbons and ostrich plumes. The hat is lined with beige satin. Label: Mr. Kurt Original. $45-55.

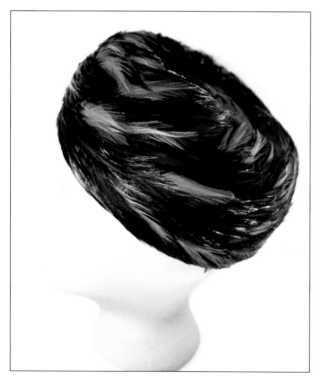

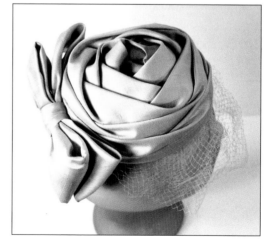

1960s one by one feather covered pill box is decorated with black, teal, and fuchsia feathers. Label: B. Altman & Co., Fifth Avenue, New York. $60-70.

1960s small pillbox constructed over mesh frame is draped in bias cut beige silk shantung. Back is finished with a large double bow; front has a double nose length veil. Hat is held on with clear plastic combs. *Courtesy of Jeanne L. Call, Facet Designs.* $30-45.

Bretons

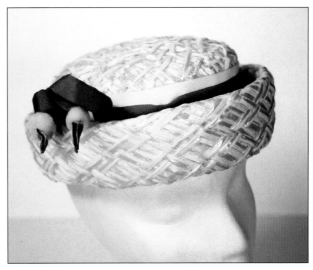

1960s Breton style in white cellophane diagonal weave straw trimmed with white and teal grosgrain ribbon has fur trim at end. Label: Union made. *Courtesy of Fae Shaffer.* $25-35.

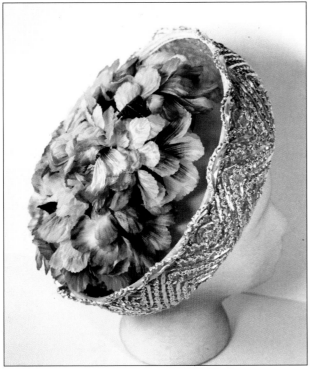

1960s side view of a lacy cellophane straw Breton with rolled brim and flower covered crown. $25-35.

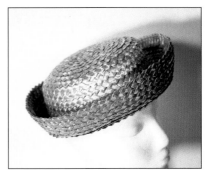

1960s coiled straw Breton. $20-35.

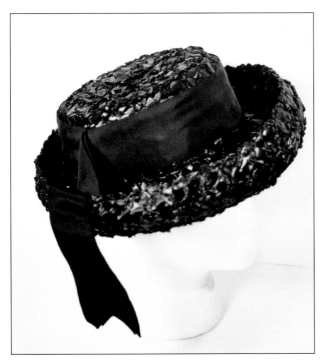

1960s black cellophane straw Breton has grosgrain ribbon decoration. *Courtesy of Jane Shaneberger Moyer.* $25-35.

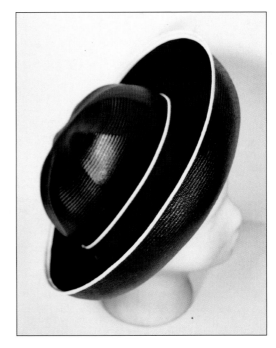

1960s black fine molded straw Breton outer brim trimmed in white piping. Hat forms a halo framing the face. Label: Winner Original. *Courtesy of Josie V. Smull.* $75-95.

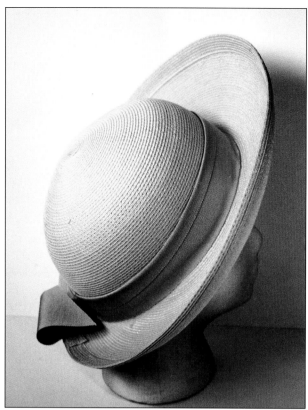

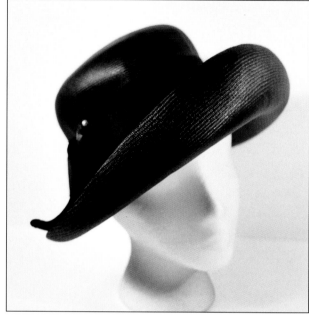

1960s side view of Breton.
Gift of Mary Frances O'Gorman. $40-60.

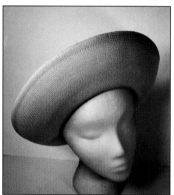

1960s beige pedaline straw Breton with matching grosgrain ribbon trim was worn by Mrs. O'Gorman who was a piano teacher in Phillipsburg, New Jersey. *Gift of her daughter Mary Frances O'Gorman*. $40-60.

1960s fine black Italian straw with wide crown and asymmetric rolled brim, forming a halo effect. Trim is grosgrain with original hat ornament. Label: Gwenn Pennington Original. $50-60.

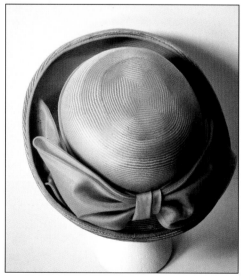

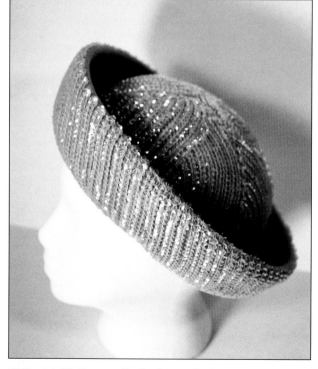

1960s back view of fine leghorn straw Breton, which is woven in intricate pattern. The trim is a band and large back bow of bias cut silk organza. Sold by Hess's, Allentown, Pennsylvania. *Courtesy of Jeanne L. Call, Facet Designs*. $45-55.

1960s pink felt Breton sailor hat is completely covered with aurora borealis sequins. Label: Glamour Felts 100% Wool Terry Sales Corp. New York. $50-60.

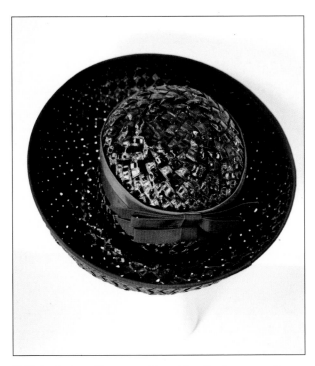

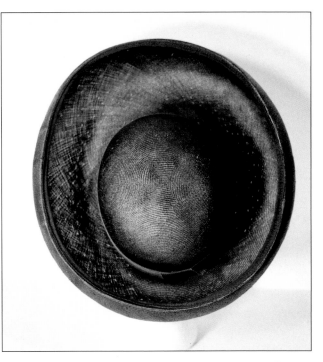

1960s back view of large navy blue wide cellophane straw Breton showing that the crown is trimmed with satin and grosgrain ribbon and two bows. $50-60.

1960s back view of navy blue finely woven Italian straw rolled brim. Designer: Adolfo II Paris New York.

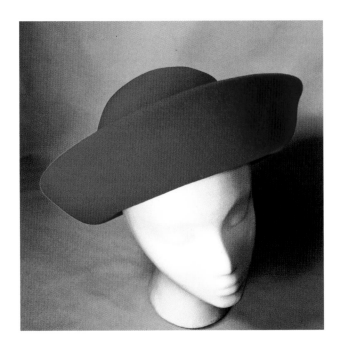

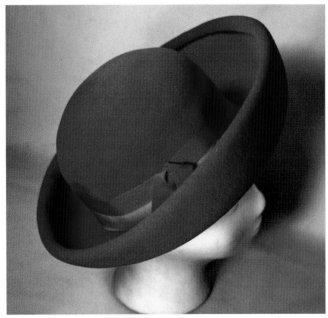

1960s red wool felt Breton worn by Eleanor Pinto. Label: Belle, Italy. Store label: Lord and Taylor. *Courtesy of Eleanor Pinto.* $60-75.

Side view of red wool felt Breton worn by Eleanor Pinto. $60-75.

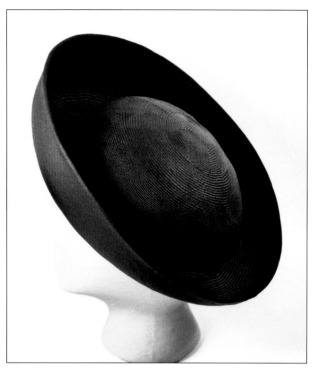

1960s back view of excellent quality finely woven Italian black straw Breton. Halo forming brim is covered with black silk shantung. Label: Gottlejb New York. $95-120.

1960s front view of Gottleib straw Breton.

1960s black beaver body with deep crown and very large curved up brim. Label: Voila! Paris. $75-85.

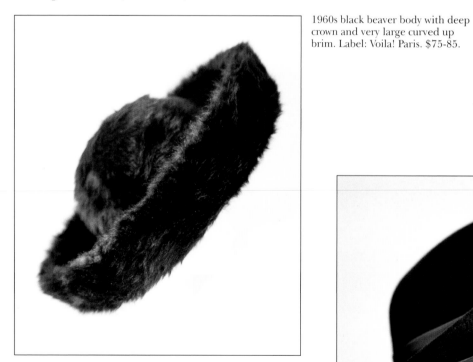

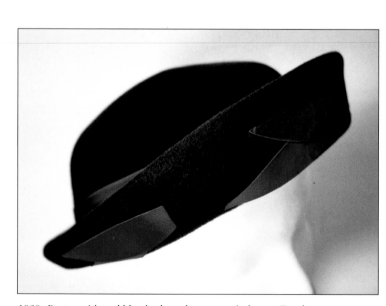

1960s Breton with teal blue body and mauve satin leaves. Band was stamped: Delux Velour Merrimac Body made of Imported Fur. $40-50.

Label of hat by Voila! Paris.

Flowered Hats

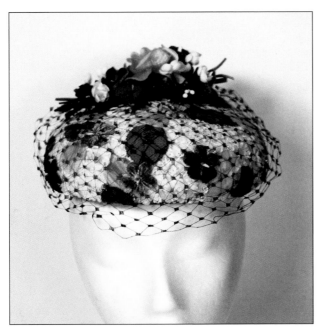

1960s Easter hat of white cellophane straw is decorated with spring flowers and leaves, covered with veil. Hat was made by Chanda. *Courtesy of Fae Shaffer.* $60-75.

Photo showing inside of completely finished hat with hand stitches, Chanda label, and H. Leh & Co. store label. *Courtesy of Fae Shaffer.*

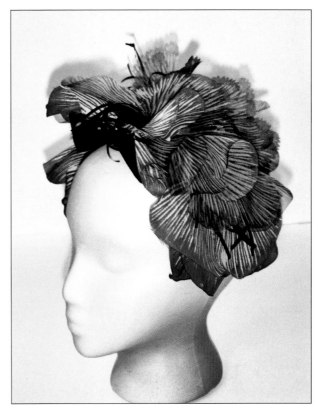

1963 half hat covered with gray and white striped, printed silk petals is trimmed with black velvet front bow and black vinyl strands. $18-25.

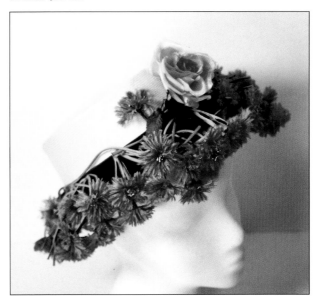

Late 1960s fine straw boater style hat decorated with a green velvet band. Bachelor buttons and large rose were hand sewed onto hat. Store label: Sold by Gimbles. $50-60.

Fae Shaffer and her friend at Rebers Restaurant in Barryville, New York, May 1960. Fae is wearing a black suit, mink fur scarf, and little flowered hat; her hair is pulled back into a fashionable chignon. Her friend is wearing a coat with a funnel neck and a straw flowered hat. *Courtesy of Fae Shaffer.*

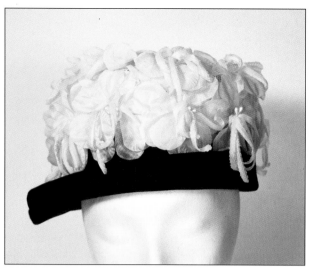

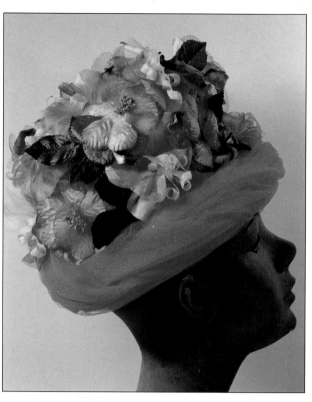

1960s black velvet Mr. Lewis hat has crown covered in white silk flowers, pearl buds, and soft ribbon. *Courtesy of Fae Shaffer.* $25-30.

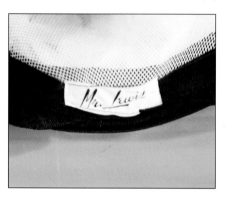

Mr. Lewis label with capenet. *Courtesy of Fae Shaffer.*

1960s tall crown formed over mesh frame is trimmed in hot pink net and flowers. $85-125.

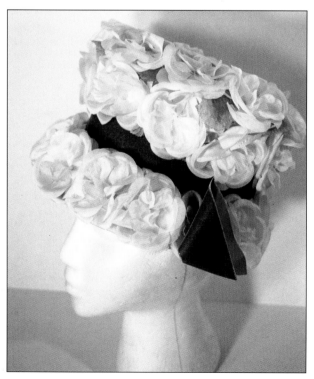

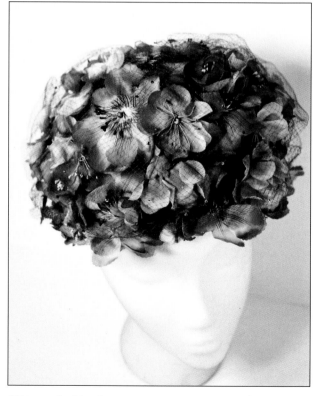

1960s white roses cover mesh lampshade frame. Leaves are green embossed velvet. Crown is encircled with wide green velvet band ending in diagonal cut ties. In the 1960s Sears called this a flower cloche. $45-60.

1960s powder blue flower toque covered with veil by Frederics Millinery, Allentown, Pennsylvania. $50-60.

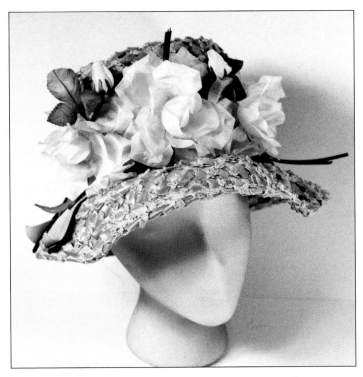

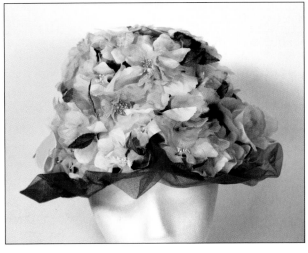

1968 spring high crown hat of pea green yellow straw trimmed with pea green grosgrain band and large white roses. The bonnet was worn to a confirmation when Helen became godmother. *Courtesy of Helen Jiorle*. $50-65.

1960s Spring Easter hat completely covered with tulle, flowers, and a velvet bow. Fae remembers these hats were worn forward covering hair and forehead. *Courtesy of Fae Shaffer*. $60-75.

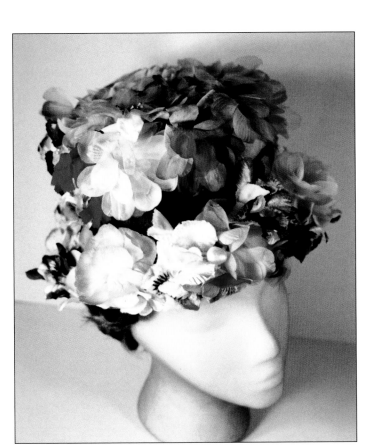

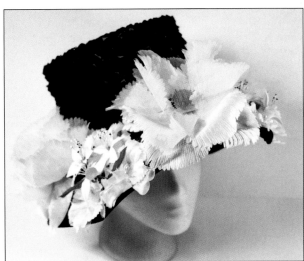

1960s navy blue Easter bonnet with square deep crown is formed over a cape net frame with a large scalloped brim and large white silk flower trim. *Courtesy of Helen Jiorle*. $50-65.

1960s spring high crown flowered hat with green velvet bow. $40-50.

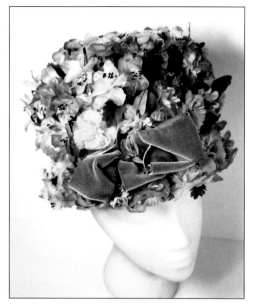

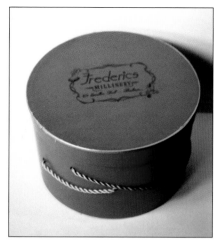

1950s hot pink hatbox from Frederic's Millinery, 819 Hamilton St., Allentown, Pennsylvania. $15-20.

1960s deep crown cloche formed over a mesh frame is covered with flowers and trimmed with velvet butterfly bow. Label: Frederics Millinery, Allentown, Pennsylvania. $50-65.

Two different style hatboxes from Frederics Millinery, 819 Hamilton Street, Allentown, Pennsylvania. The 50s hatboxes were round and constructed at the factory; whereas, the 60s boxes were square and delivered flat to be assembled at the store. Fredericks had models walking throughout the store and ladies could ask them to model a hat to see how it looked, Fae Shaffer tells us.

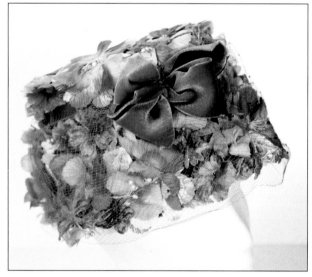

1960s hat handmade over mesh frame has lace lining. Hat is covered with embossed velvet leaves and flowers and has a focal point velvet butterfly bow. Eye length veil covers hat. Hat is made by Frederics Millinery, Allentown, Pennsylvania. *Courtesy of Fae Shaffer*. $40-65.

Inside of hat showing workmanship and Frederics Millinery, Allentown, Pennsylvania label. *Courtesy of Fae Shaffer.*

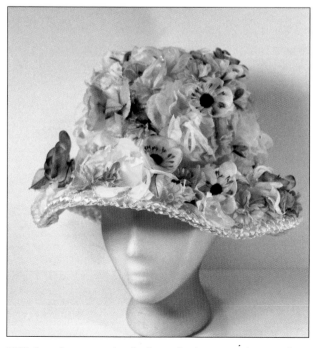

1960s large bonnet made of yellow cellophane straw is covered with colorful spring flowers. *Courtesy of Helen Jiorle*. $50-75.

The Oversized Flower

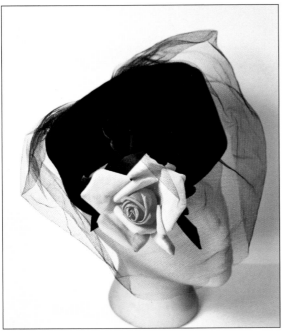

1960s black velvet deep pillbox with large pink muslin rose placed at edge of hat has full-face veil, which is held in place with self-covered button at crown. $50-75.

1960s inside view showing Gibbe Hat label New York and Paris with Union Made label USA. Hat is fully lined with rose printed taffeta.

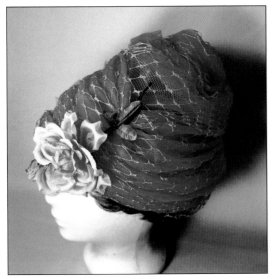

1960s large hot pink beehive hat is made over a net frame which is covered with tulle and coarse mesh veiling and trimmed with a large rose. *Courtesy of Marianne Meyer-Garcia, The Rose Cottage*. $50-75.

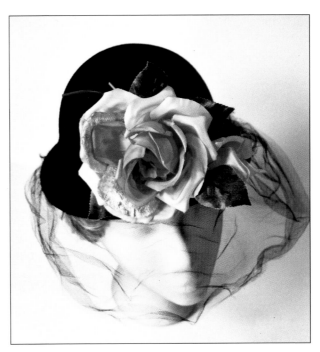

1960s ladies black velvet derby has a huge pink silk and velvet rose and a full-face veil. *Courtesy of Vangie and Donald Shweitzer*. $40-60.

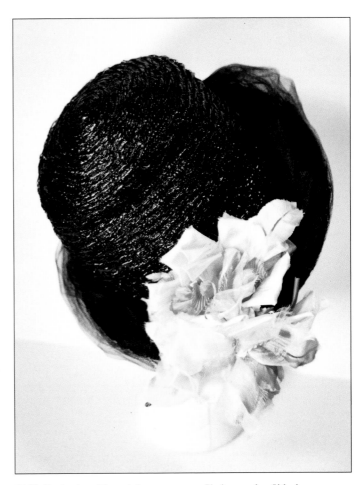

1960s Be An Angel brand deep crown profile hat made of black cellophane straw. Black net encircles brim and large pink satin roses sit at side of hat. $50-60.

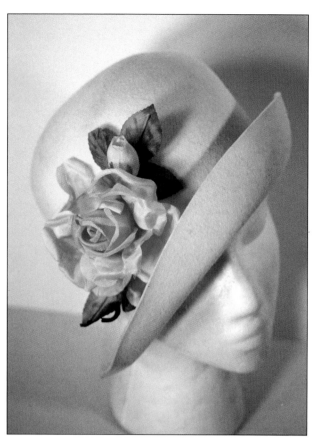

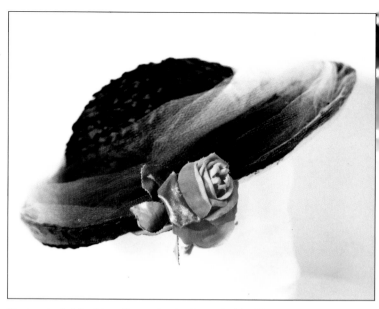

Black satin finish wide coil straw hat is trimmed with white net and large pink rose. Label: Adjustable Head Size. *Courtesy of Dave and Sue Irons, Iron's Antiques.* $45-55.

1960s off white wool felt profile cloche has wide deep crown and narrow turned up brim. The decoration is a large silk, peach rose. Label: Union Made in USA. $40-50.

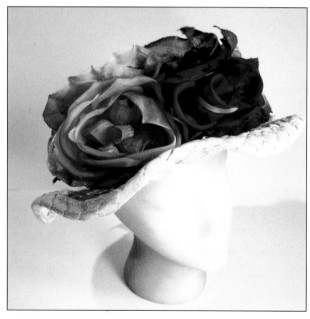

1960s hat is made of wide white cellophane straw woven on a diagonal and covered with oversized pink and fuchsia silk roses. *Hat and mannequin courtesy of Barbara Kennedy.* $75-95.

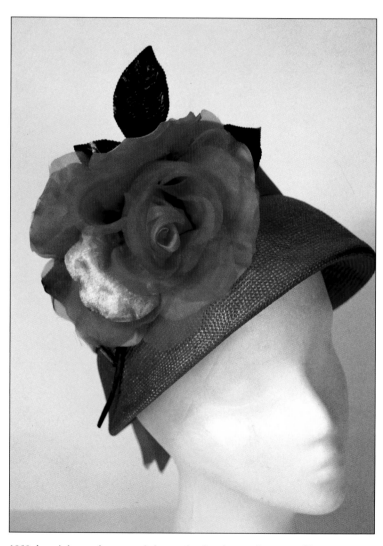

1960s hot pink straw bonnet style has a velvet band around crown and large silk and velvet rose at side. *Courtesy of Fae Shaffer.* $40-55.

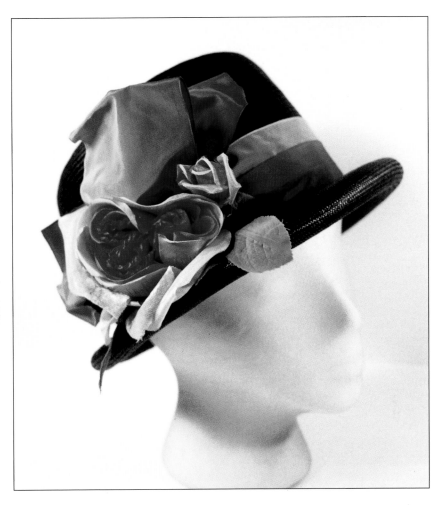

1960s navy blue fine Italian straw with tubular brim is trimmed with wide band of light pink and rose colored silk. Large rose and bud set off the hat. Label: Danziger Original. *Gift of Theresa Grassi*. $50-60.

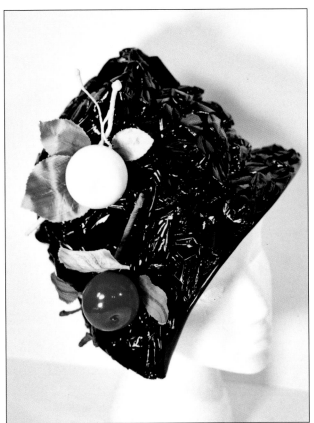

Inside of Lucy Long Hat with fully lined crown has a patent leather (vinyl) brim inside.

1960s wide, black cellophane straw is woven into a deep crown profile hat with narrow brim. Red and white fruit and leaves set off hat. Label: Lucy Long. $50-65.

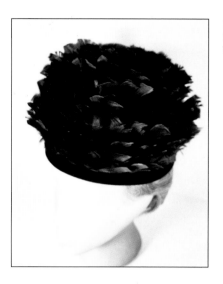

1960s black feather toque with black velvet band. $50.

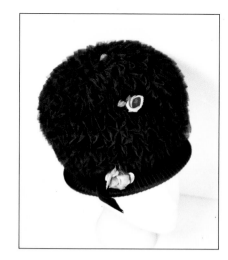

1960s very dressy top hat is constructed over a capenet frame with zigzag black net, pink roses, and finely pleated brim. *Courtesy of Josie V. Smull.* $60.

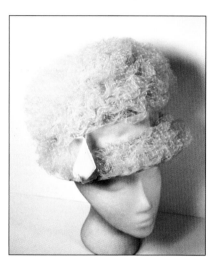

1960s tall crown, narrow brim, top hat is formed over a mesh frame and covered with stiff nylon ruffle and velvet ribbon. $60.

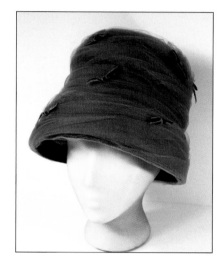

1960s label: original Pay Topper beehive hat to be worn over the high hair style is made over a capenet frame and draped in blue tulle with tiny bow trim. It was worn for a wedding. *Courtesy of Helen Jiorle.* $40.

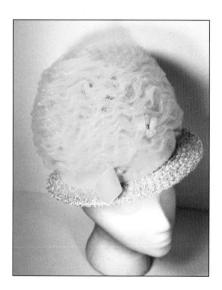

1960s yellow top hat made over mesh is trimmed with coiled net glued on from top of crown to brim. Trim is velvet ribbon and butterflies. *Courtesy of Josie V. Smull.* $60.

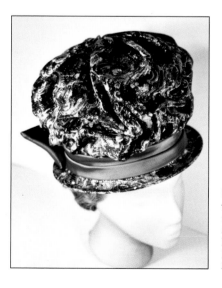

1960s top hat style is made of brocade with a gold metallic yarn, tan satin band and large back bow. Label: Kilton. $50-60.

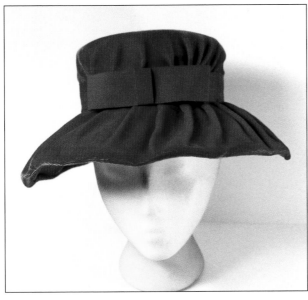

1960s hot pink picture hat draped with velvet has flat crown and scalloped brim. Grosgrain band is trimmed with tailored bow. *Courtesy of Helen Jiorle.* $50-75.

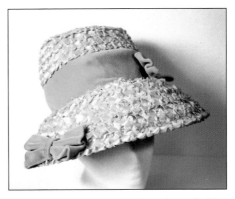

1960s coiled straw tall crown hat trimmed with a wide yellow velvet band and bows. The hat was worn by Agnes DiBella. Designer label: Gwenn Pennington Exclusive. *Courtesy of Antoinette DiBella.* $50-65.

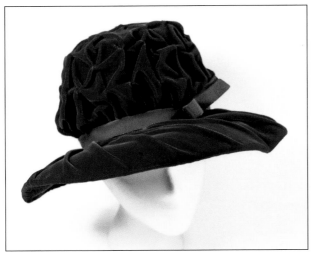

1960s luxurious royal blue velvet picture hat with high smocked crown has draped brim forming radiating pleats. Helen wore this hat to a wedding. *Courtesy of Helen Jiorle.* $60-80.

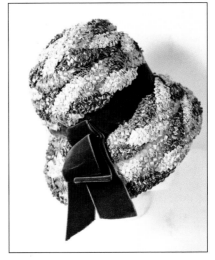

1965 mesh frame tall crown hat of orange, taupe and beige straw, a popular '65 color combination. Brown velvet ribbon trims this Gwenn Pennington Exclusive. The hat was worn by Agnes DiBella. *Courtesy of Antoinette DiBella.* $50-65.

1960s tall crown is in two-tone straw of beige and white with flower and cherry trim. Label: H. Leh & Co., Allentown, Pennsylvania. *Courtesy of Josie V. Smull.* $50-60.

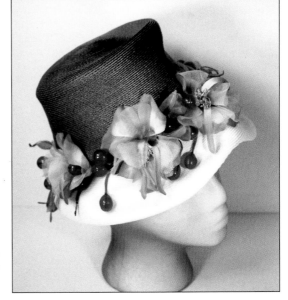

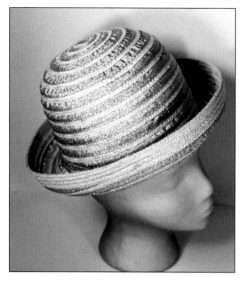

1960s tall crown derby style made of a coil of metallic and natural straw. Label: Made in Italy Platina. *Courtesy of Josie V. Smull*. $50-60.

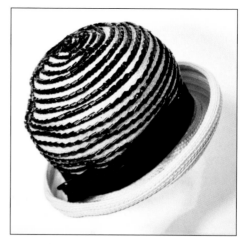

1960s yellow straw modified derby has tall crown and is trimmed in black vinyl twist simulating black patent leather. Black grosgrain band and bow finish off crown. Store label: Hess Brothers, Allentown, Pennsylvania. $50-65.

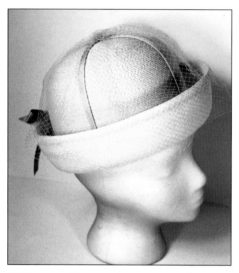

1960s straw wide crown in two-tone tan is trimmed with grosgrain, veil, and satin back bow. Label: Suzy Michelle Original. Hess's sold hat for $5.91. *Courtesy of Kay Aristide*. $45-60.

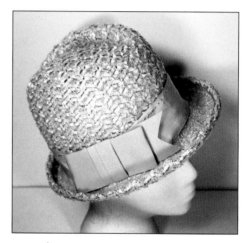

1960s man's style beige tall crown derby made of nylon and zigzag cellophane straw with wide grosgrain band and tailored bow. *Courtesy of Josie V. Smull*. $50-65.

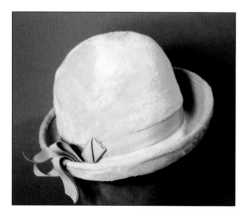

1960s Gwenn Pennington Exclusive with tall crown and rolled, shallow brim is made of beige fur felt. Beige grosgrain ribbon and bow trim crown. Stamped: Empress body, Made in Western Germany. $40-50.

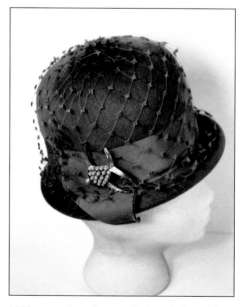

1960s turquoise tall crown derby style has wide grosgrain band, veil and fish pin. $50-75.

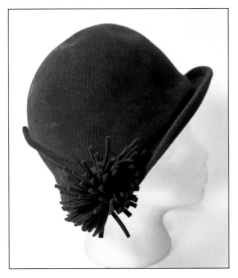

1960s maroon felt, tall crown cloche has a narrow brim and self-flower. Label: Genuine Cloud Imported Velours. $50-65.

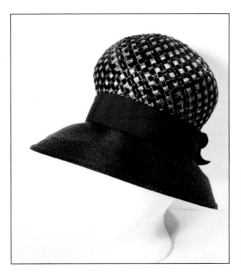

1960s tall crown lampshade hat of diagonally woven cellophane straw has wide turned down brim. Trim is a wide grosgrain band with back bow. Designer: Gwenn Pennington. $45-60.

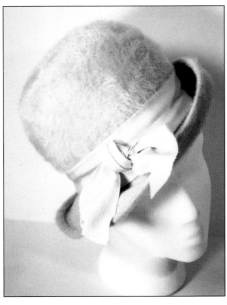

1960s beige fur felt tall crown derby style has narrow brim rolled down over eye, forming a profile. Beige grosgrain band and bow trim hat. $50-65.

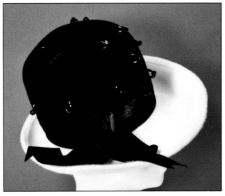

1960s black and white fur felt Mr. Dennis tall crown is trimmed with beads. Label: Mr. Dennis body made in Italy. $50-65.

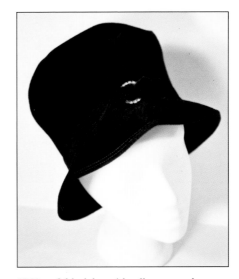

1960s soft black hat with tall crown and narrow brim is stamped Genuine Imported Velour. Edge stitched brim, band and rhinestone buckle trim complete the hat. Designer: Toby of London. $50-60.

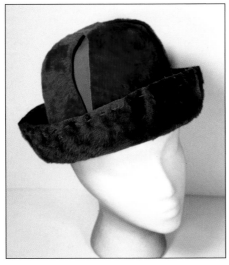

1960s plush derby style hat of magenta and teal blue has insets of grosgrain behind cutouts. Brim is hand stitched. Label: Union label. *Courtesy of Josie V. Smull.* $50-65.

Label for Toby of London.

127

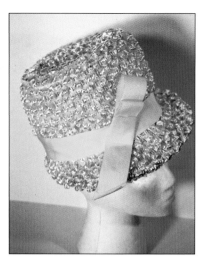

1960s yellow cellophane straw hat has tall crown and narrow brim with yellow grosgrain band and double loop ribbon trim. $40-50.

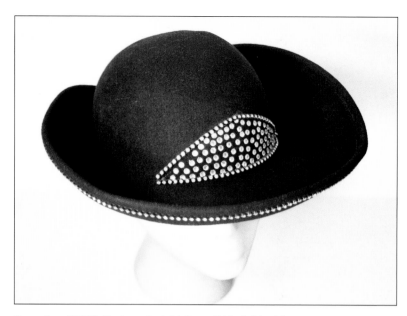

Front view of 1960s Designer Jack McConnell black felt wide curled hat. $110-125.

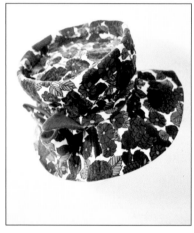

1960s printed cotton dressmaker hat with tall crown is fully lined and decorated with numerous rows of machine stitches. Designer/maker label: Catherine Jackson, Haddon Hall, Atlantic City, New Jersey. $50-65.

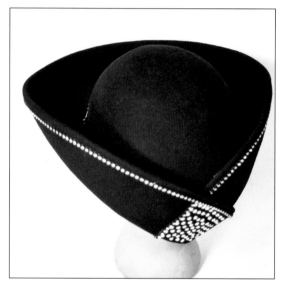

1960s back view of black felt wide curled brim folded in back and decorated with riveted rhinestones. Hat is held on with back elastic band. Designer: Jack McConnell. $110-125.

Inside view of the Catherine Jackson hat showing lining, lace-edged grosgrain band, and stitched brim. A tremendous amount of work went into making this hat.

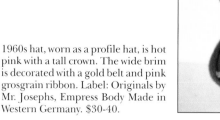

1960s hat, worn as a profile hat, is hot pink with a tall crown. The wide brim is decorated with a gold belt and pink grosgrain ribbon. Label: Originals by Mr. Josephs, Empress Body Made in Western Germany. $30-40.

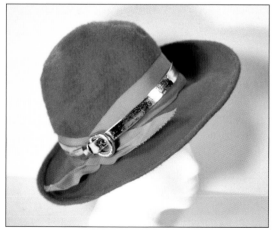

128

Bubble Toques & Berets

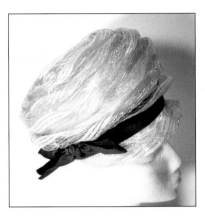

1960s beige, wide-crown, bubble toque with visor effect is made over a faille base. A tube of nylon and satin stripe is coiled around the hat form to create the delicate effect. The crown is trimmed with a brown grosgrain band and bow. Designer: Reggie of Wilshire Paris New York. $65-75.

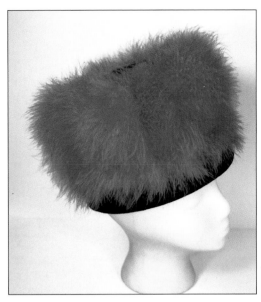

Dramatic black velvet and fuchsia marabou feather toque is made over a capenet frame. *Courtesy of Josie V. Smull.* $75-85.

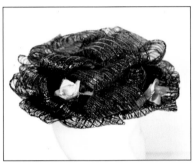

1960s ruffle toque is constructed over large mesh frame using two-inch wide vinyl tape. Trim is pink roses. Worn by Josie V. Smull. *Courtesy of Josie V. Smull.* $45-55.

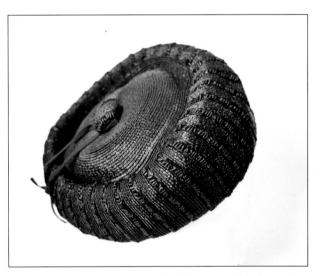

Late 1950-early 1960s asymmetric bubble toque of black straw has a center button to hold the streamer. Hat was worn at back of head. Label: Herbert Bernard Original, New York. $50-65.

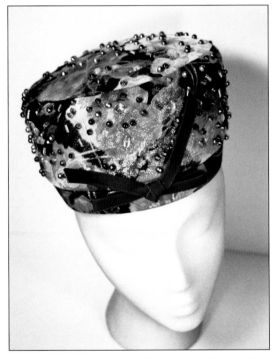

1960s multicolored printed silk toque has a band and velvet bow. All over decoration is riveted beads and stones. *Courtesy of Josie V. Smull.* $65-75.

Late 1950s label and inside of Herbert Bernard Original New York asymmetric bubble toque.

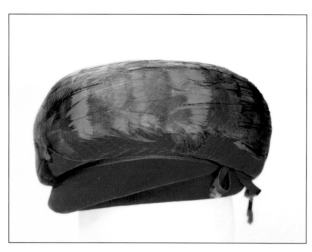

1960s royal blue velvet toque hand decorated with green and blue feathers and veil. Royal blue and green was a popular color combination in the 1960s. Designer label: Dana Original. *Courtesy of Fae Shaffer*. $50-60.

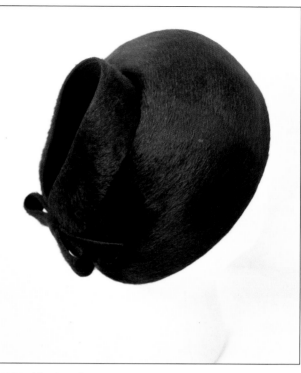

Inside view of Dana Original hat completely lined with paisley print silk. *Courtesy of Fae Shaffer*.

1960s side view of navy blue fur felt bubble toque has back band and bow. Stamped: Body Made in West Germany. Designer label: Don Anderson. $60-75.

1960s inside view of Don Anderson hat showing label and hand stitches used to fasten trim.

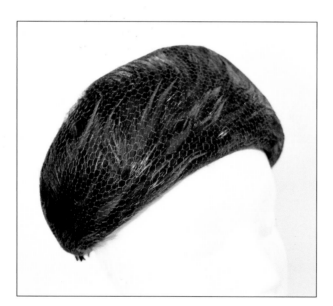

1960s brown wool felt toque is trimmed with one by one feathers and covered completely with netting. $15-25.

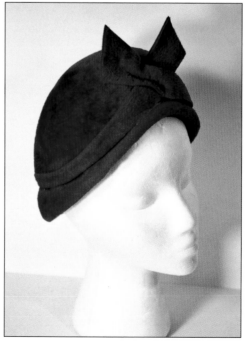

1960s red pure fur felt cloche style with wide crown and shallow rolled brim has self-fabric ties that encircle the crown, stand up, and cross in front. $50.

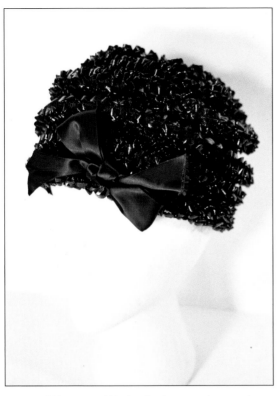

1960s bubble toque of black cellophane crochet yarn is worked over mesh frame with satin bow in front. Designer: G. Howard Hodge, Jr. $50-75.

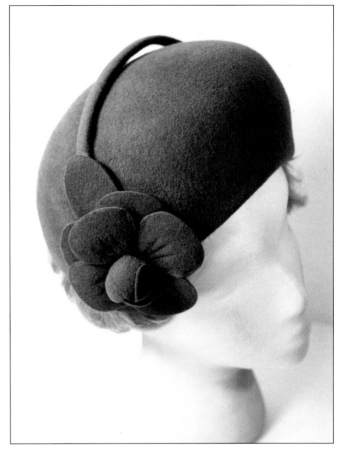

1960s brown felt bubble toque with large self flower and stem. Label: Exclusively Cath. $65-75.

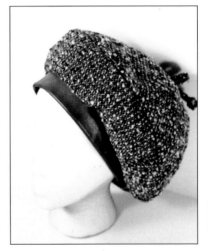

1960s reversible large two-section beret showing tweed with vinyl band. $80-90.

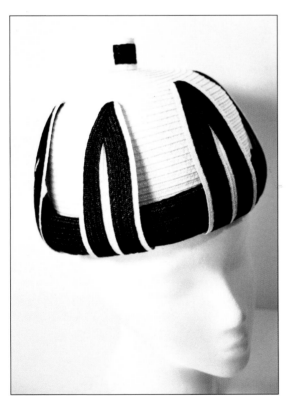

1960s navy blue and white straw bubble toque with narrow brim and six upturned petals on crown. Rolled straw coil finishes top of hat. Label: Styled by Coralie. $50-60.

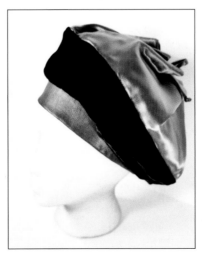

The reverse side of this two-section beret is brown velvet and beige satin.

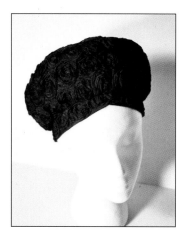

1960s bubble toque made over net base is completely covered with black tape rosettes. The hatband frames the face. Fully lined hat is made by Lilli California. $90-125.

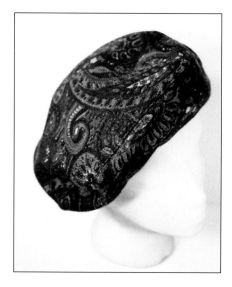

1960s dressmaker beret made in four sections from printed acrylic paisley fabric is fully lined with aqua taffeta. Label: Designed for Arnold Constable, Fifth Avenue, New York. Hat was made by Leneo Any New York. $50-65.

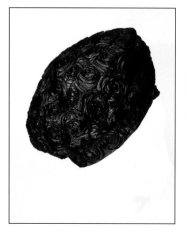

1960s side view of Lilli California bubble toque showing close-up of rosettes made from narrow tape.

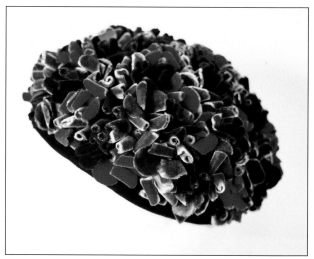

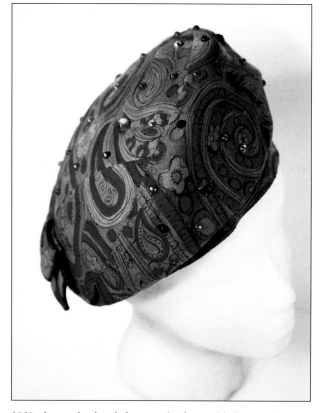

1963 small beret style made of five-petal velvet flowers hand stitched into the mesh frame. Hat edge is covered with velvet ribbon. Store label: Best and Co., Fifth Ave., New York. $40-50.

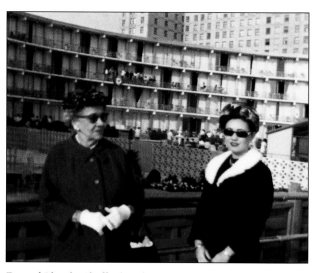

1960s dressmaker banded two-section beret with three-section crown. Fabric is a printed acrylic paisley design. Hat is trimmed with riveted jewels and back bow, and is fully lined with beige taffeta. Label: Fifth Avenue, Arnold Constable, New York. $60-75.

Fae and Blanche Shaffer in Atlantic City, November 1963. Both ladies wear fancy hats to set off their outfits. *Courtesy of Fae Shaffer.*

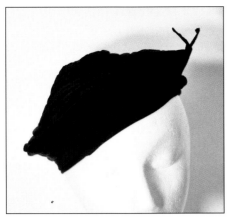

1960s dressmaker beret made of a continuous coil of narrow black grosgrain ribbon sewed together and decorated with a cockade at the side. *Courtesy of Shirley Kohr.* $30-40.

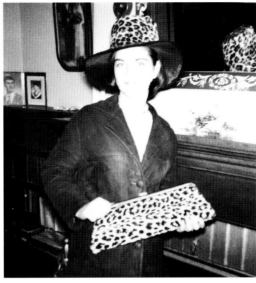

1962 Antoinette Quigley models a brown suede coat and matching faux leopard fur tall crown picture hat with matching clutch purse. Photo by Rose Quigley.

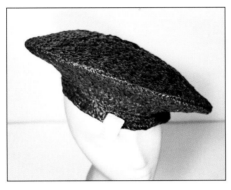

1960s large brown straw beret in diagonal weave with original tag. Label; Made in Switzerland. Store label: Madeline of Easton, Pennsylvania. *Courtesy of Josie V. Smull.* $50-60.

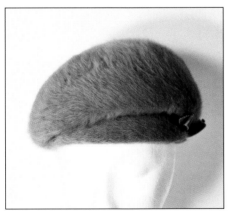

1960s powder blue banded angora beret has a blue grosgrain bow tucked in at side of brim. Designer: Kangol Registered Design. Label: Made in England. Today Kangol is part of Bollman. $30-40.

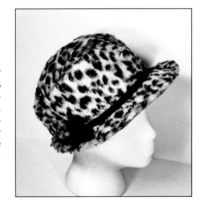

1960s printed faux fur wide crown hat is trimmed with black velvet band and flower. Stamped label: Imported Velour Body Made in France. *Courtesy of Josie V. Smull.* $35-55.

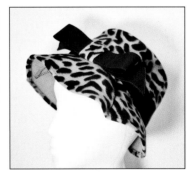

1960s hat stamped Jacquar Mélange Blend 100% wool printed felt by Henry Pollak, Inc., New York is trimmed with grosgrain ribbon and tailored bow. Brim is fluted with two rows of hand stitches. *Courtesy of Jeanne L. Call, Facet Designs.* $35-45.

Late 1960s to early 1970s plain beige beret style with hand stitched indentation. Stamped: 100% Shagfelt by Terry Sales Co. $20-30.

1960s printed faux fur deep pillbox, left, and faux fur flowerpot shaped hat, right. *Courtesy of Josie V. Smull.* $45-60 each.

133

1960s Mr. John Classic Paris New York was stamped: 100% Wool Faun Finish. Hat is beige felt with light fox fur trim around deep, wide crown derby. It is designed to cover large hairstyle. $95-135.

1963 black velvet brim with white rabbit fur crown has a grosgrain bow in front. Rose Jamieson wore this hat. It was purchased at Meyer Bros. store in Paterson, New Jersey. $45-60.

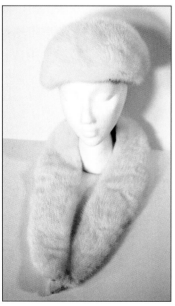

1960s Halston white fur toque and collar. Label: Halston – USA. $125 for toque, $75 for collar.

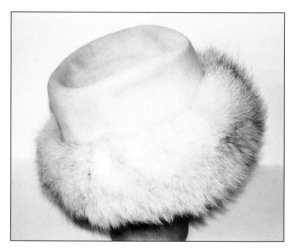

1960s Mr. John, Jr. cream felt fedora style hat has a large fox fur band. The hat shows the Russian style that was popular in the 1960s. $100-125.

1960s deep brown mink bubble toque has a dark brown satin band. Back of band is trimmed with a satin bow. A matching mink collar is also pictured. Label: Bachrach's Registered, Washington, D.C. $75-95 each.

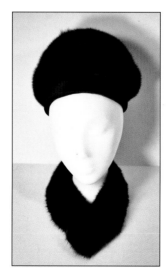

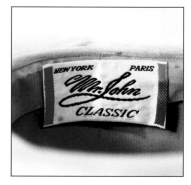

Label: Mr. John Classic New York Paris.

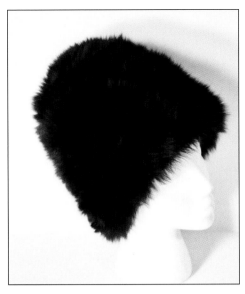

1960s black lamb Cossack style was made in Italy. $60-75.

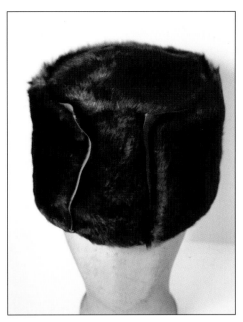

1960s fur felt toque has silk faille trim. Designer: Miss Dior Created by Christian Dior. $95-110.

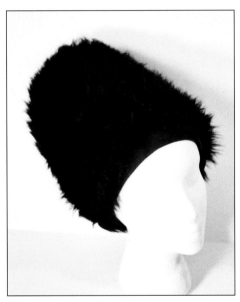

Black acrylic fake-fur tall toque, worn by Rose Jamieson in the 1960s, was made popular by the movie "Dr. Zhivago." Rose remembers well that Paul was amazed she had the courage to wear this hat. It was shown again for winter, 2005. $30-40.

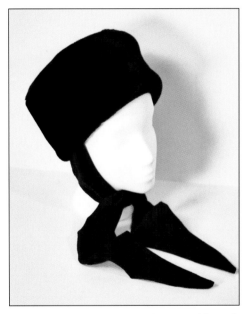

1960s black fake fur Cossack style toque with acrylic ties covering ears and tying under the chin. $50-65.

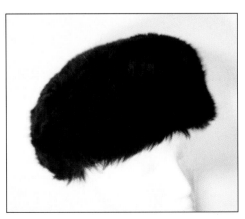

1960s black lamb's wool toque. $35-45.

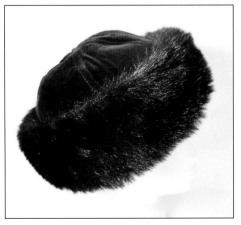

1960s faux fur trimmed velvet hat has six-section crown for winter wear. Fully lined with faille. $30-40.

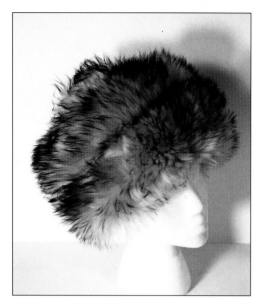

1960s Stamped: Genuine Tuscan Lamb Skin fur toque Made in Italy. Care instructions: "Shake it vigorously. It will become beautiful. Store it inside out." Toque is constructed in three graduated tiers. $75-95.

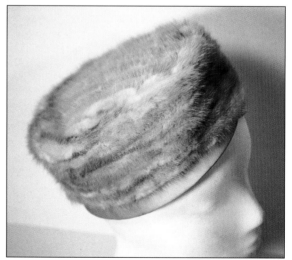

1960s beige acrylic faux fur pillbox of Russian Cassock influence. *Courtesy of Marguerite Grumer*. $30-40.

1960s three tier fox toque with gray faille lining was a popular 1960s style. Label: Mr. D. $30-50.

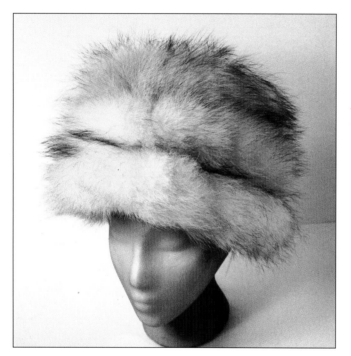

1960s champagne beige mink pillbox made with matching satin band. Label: Union Made. This was a very popular style. $25-35.

1960s winter white lambskin three-tier toque showing 1960s influence of the movie "Dr. Zhivago." Store label: Marché. Stamped: Made in Italy, Fur Origin in Italy. $75-85.

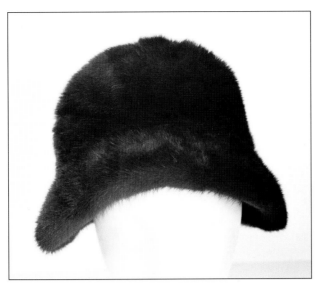

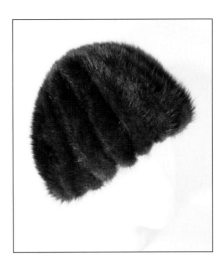

1960s fur toque is made from mink tails. *Courtesy of Fae Shaffer*. $45-55.

1960s ranch mink hat with tailored back bow. *Courtesy of Fae Shaffer*. $80-95.

1960s inside view of ranch mink hat showing silk satin stripe lining. Owner's initials are embroidered inside. Designer label: Adolfo II New York and Paris. *Courtesy of Fae Shaffer*. $80-95.

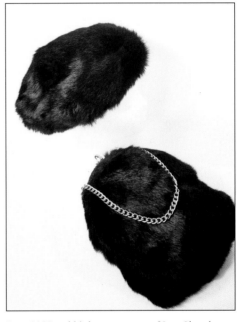

Late 1960s rabbit beret, *courtesy of Jane Shaneberger Moyer*. Rabbit purse was worn by Agnes DiBella. *Courtesy of Antoinette DiBella*. $30 each.

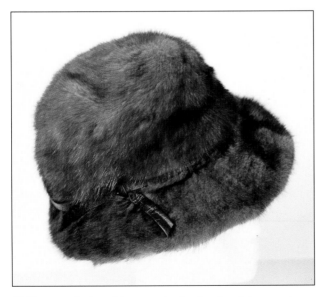

1960s sporty fur hat with narrow leather band and tie around crown. *Courtesy of Fae Shaffer*. $50-60.

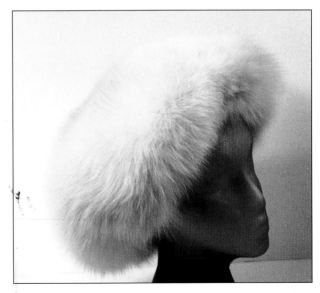

1960s large luxurious white fox fur toque is made of Brightened Fox from Norway. Lining is black acrylic jersey knit. Labels: Don Anderson. Fox Fur from Norway. Sold by Saks Fifth Ave. $125-150.

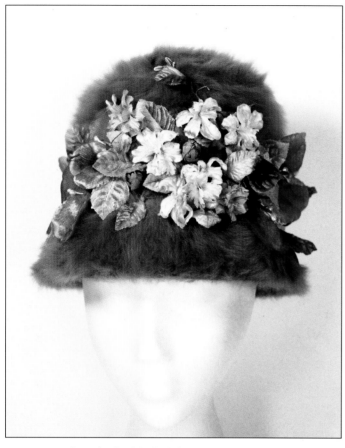

1960s lavender fur felt plush deep crown hat decorated has embossed leaves and flowers. Hat was worn forward with no hair or forehead showing. Designer label: An Original by Mr. Joseph New York. Stamped: Housse HB. *Courtesy of Fae Shaffer*. $55-65.

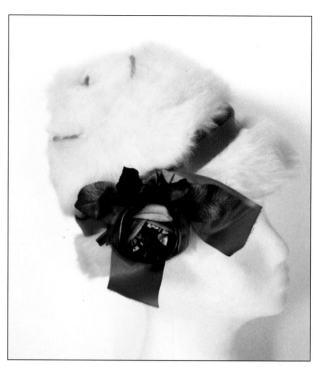

1961 white fur felt plush deep crown hat with brown satin ribbon and brown rose was worn by Fae at Atlantic City, New Jersey boardwalk. Label: Lily of France. *Courtesy of Fae Shaffer*. $50-65.

Label: Lily of France, Quebec, P. Q.

Fae Shaffer and her friend on the Boardwalk in Atlantic City, NJ, 1961. Fae is wearing the plush hat with a brown trim, that is pictured above, to match her fur coat. Both women wear wrist-length white gloves. *Courtesy of Fae Shaffer*.

Wedding Hats

1964 wedding photo of bride Bobbie Bushnell and groom Ernest Hemphill. Bridesmaid is Josie Bushnell. Bride and bridesmaid wear simple wire headdress. Best man is brother of groom, James Hemphill.

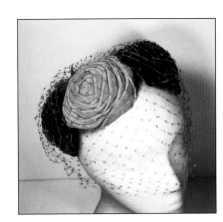

1960s beige and brown velvet hand made rosettes form this bandeau with nose length veil. Label: Pinehurst, Fifth Ave., New York. *Courtesy of Josie V. Smull.* $25-35.

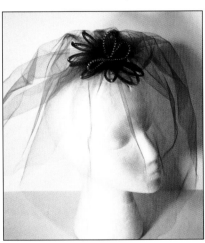

Josie Bushnell wore 1964's bridesmaid headdress of turquoise wire and pearls with full-face veil. $25.

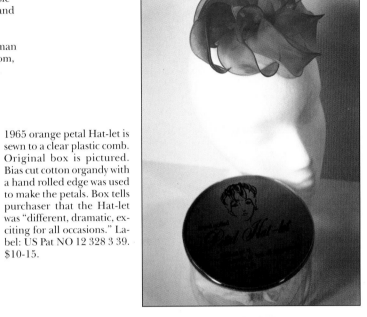

1965 orange petal Hat-let is sewn to a clear plastic comb. Original box is pictured. Bias cut cotton organdy with a hand rolled edge was used to make the petals. Box tells purchaser that the Hat-let was "different, dramatic, exciting for all occasions." Label: US Pat NO 12 328 3 39. $10-15.

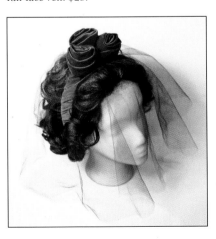

1960s bridesmaid headdress made of wrapped turquoise velvet band with three rosettes and generous circular veil. $25-35.

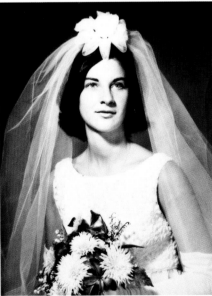

June 1965 bride Antoinette Quigley wears a Hat-let headdress and veil made by one of her college friends. Photo by Village Studio, Main St., Manville, New Jersey.

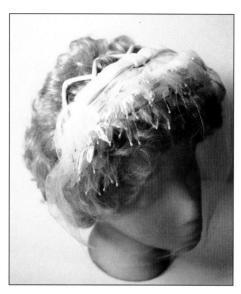

1960s bridal headdress made over a covered wire frame with velvet ribbon, petals, and seed pearls. Veil is full face. $25-30.

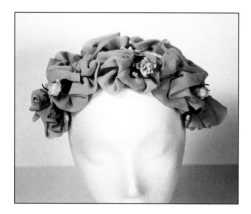

1960s handmade bride's maid headdress of powder blue bias cut silk chiffon rosettes, which were placed over a hand-covered frame. *Courtesy of Fae Shaffer*. $30-40.

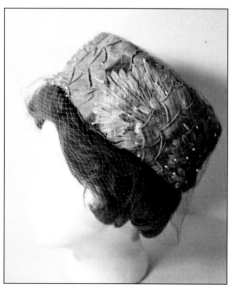

1965 turquoise deep pillbox with veil was worn by Mildred Quigley to her daughter's wedding. This color was very popular in 1955 and revived in 1965.

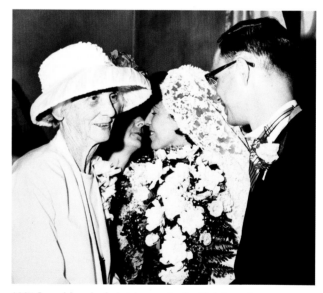

1965 bride Rose Quigley wears an Alençon lace mantilla with silk illusion veil. Priscilla of Boston designed the gown and headpiece. Photo by Village Studio, Main St., Manville, New Jersey.

1965 fancy lampshade hat is worn by Iva Quigley at her granddaughter's wedding. Photo by Village Studio, Main St., Manville, New Jersey.

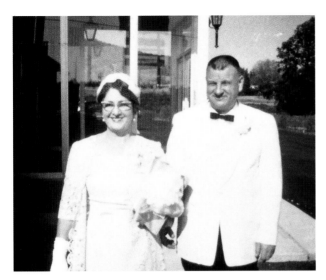

1965 Mildred and George Quigley dressed for wedding of their daughter.

1960s wide bandeau formed over cape net and is made of bundles of folded champagne beige net. Delicate hat is covered with eye length veil. Hat was worn by Mildred Quigley for her daughter's wedding in the photo above. $20-35.

August 1965 Josephine Avella is just coming out of church after the wedding of her niece. She wears a yellow lampshade hat.

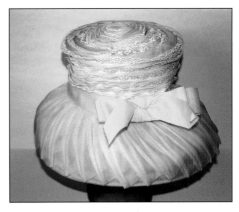

1965's yellow lampshade hat has a brim covered with pleated silk organza. The crown is trimmed in lace edging and the grosgrain ribbon around crown is tied in a large bow. Josephine Avella wore the hat to her niece's wedding. $50-60.

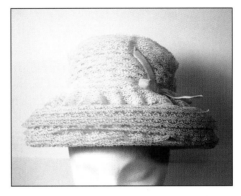

1965 nylon framed lampshade hat completely trimmed with concentric rows of 1/2" lace edging was worn by Agnes DiBella. Courtesy of Antoinette DiBella. $50-60.

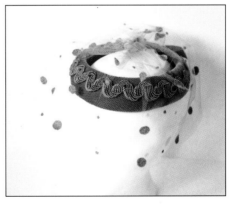

August 1965, turquoise velvet whimsy trimmed with cord and back bow. Veil is decorated with flocked dots. Marguerite Grumer wore this hat to her son's wedding. $20-25.

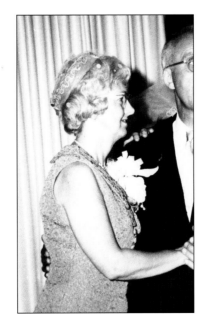

Marguerite Grumer wearing turquoise whimsy and dress at her son's wedding in 1965. Turquoise was a popular 1960s color.

Masculine-style Hats for Women

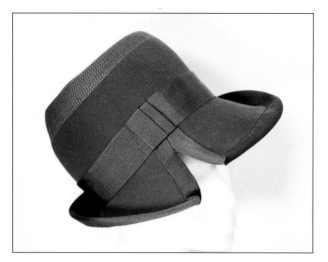

1960s lady's royal blue fur felt with grosgrain ribbon trim was made in Switzerland. Twenty-one rows of machine stitching decorate top of crown. Designer: Schiaparelli, Paris. $95-120.

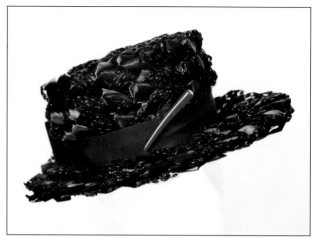

1960s black wide cellophane straw boater has grosgrain trim and tailored back bow. Hat is set off with a red plastic pin. *Courtesy of Fae Shaffer.* $50-65.

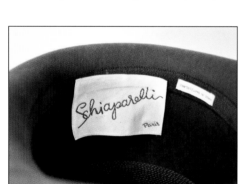

Label: Schiaparelli Paris.

Inside view showing store label: H. Leh & Co., Allentown, Pennsylvania. Established 1850. *Courtesy of Fae Shaffer.*

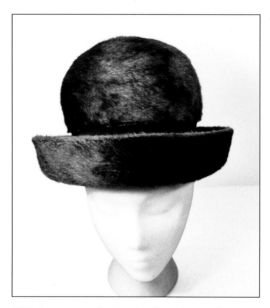

1960s large crown derby style adaptation made in Italy. Label: Mr. John. $45-60.

1960s hatbox from H. Leh & Co., Allentown, Pennsylvania. $15-20.

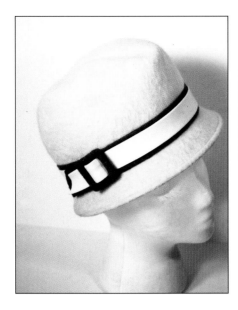

1960s winter white deep crown dented front to back trimmed with gray wool and white vinyl belt style band. Label: Genuine Beaver Union Made. *Courtesy of Bea Cohen.* $25-40.

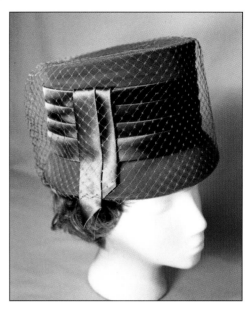

1960s tall turquoise velvet top hat is decorated with purple pleated satin band and matching veil. $65-75.

1960s red fur felt fedora style hat is trimmed with matching grosgrain band and bow. Label: Musketeer Imported from Austria. $40-55.

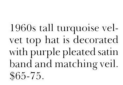

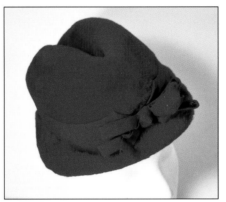

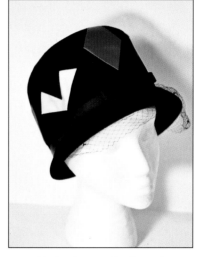

1960s black velour top hat has satin diamonds in coffee, black, and peach. The stain band and bow trim the crown and short veil covers the eyes. $50-65.

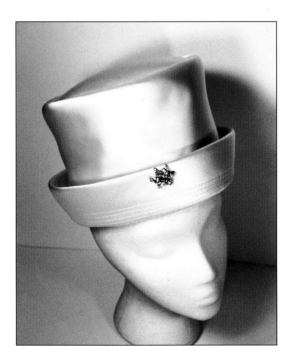

1960s woman's powder blue felt fedora trimmed with grosgrain ribbon and machine stitched edge imitating hand picking, a tailoring technique. Stamped: 100% Wool, Made in Italy. $50-65.

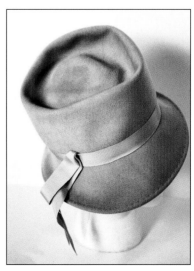

1960s winter white satin ladies' top hat style is fully lined with beige faille and trimmed with an Aurora borealis pin. *Courtesy of Josie V. Smull.* $50-65.

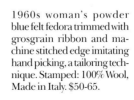

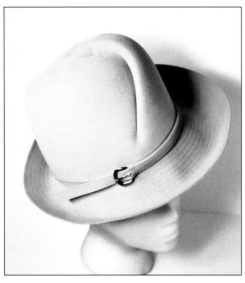

1960s beige felt deep crown with curved seam has stitched brim. Trim is fine band and buckle. Designer label: Mr. John Classic, New York, Paris. Stamped label: Mr. John Faun Finish. $60-75.

1960s black felt lady's Alpine style fedora has a narrow turn-down brim and simple brown band. Label: Hed-Bute by Dorothy Biak.

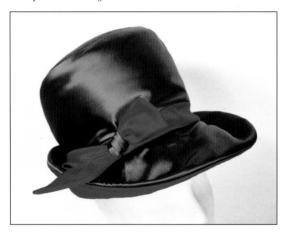

1960s red and green satin Christmas deep crown Fedora style was designed by Mr. John Jr. Fae Shaffer wears this hat every Christmas. *Courtesy of Fae Shaffer.* $75-95.

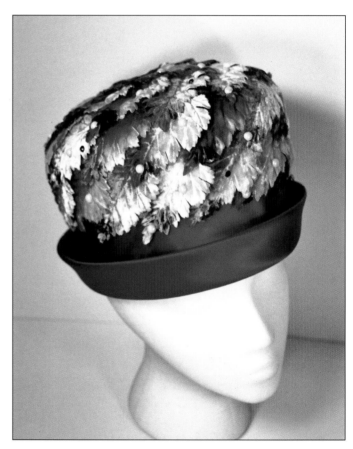

1960s tall crown derby style is constructed over a capenet frame. Fashion fabric of red satin is covered with embossed velvet variegated leaves and pink pearl beads. *Courtesy of Josie V. Smull.* $40-50.

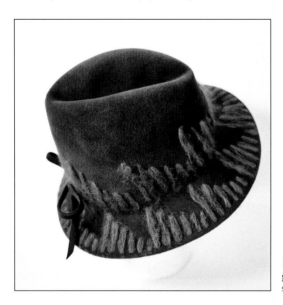

1960s Mr. John Jr. green Fedora is trimmed in purple and green angora yarn groups of hand sewn graduated stitches. *Courtesy of Jeanne L. Call, Facet Designs.* $50-75.

1960s hand woven fine panama straw visor cap with an open weave pattern for coolness was made in Ecuador. Stamped label: Montecristi. *Gift of Marie Claus Danko*. $125-160.

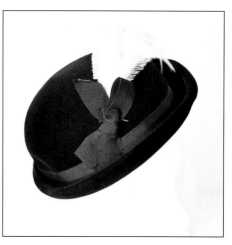

1960s ladies' black velvet derby adaptation is made in Firenze, Italy. Crown is trimmed in black grosgrain band. Bow holds the white feathers in place. $40-50.

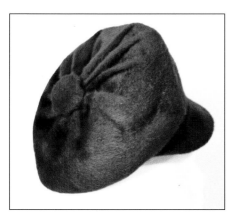

Inside view of Panama straw visor cap with stamped label showing the Montecristi label. $125-160.

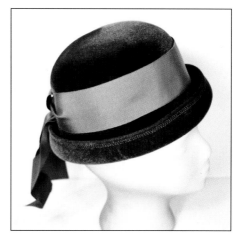

1960s deep crown gray derby is trimmed with wide grosgrain band and three rows of machine stitches. Stamped: Morica Mélange Blend felt of 90% wool 10% fur. Designer label: Henry Pollack Inc. New York. *Courtesy of Josie V. Smull*. $50-65.

1960s visor beret of blue mohair with pleated crown held in place under self-covered button was the popular unisex look of the 1960s. $40-60.

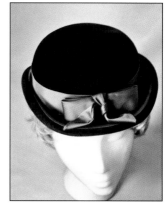

1960s brown felt low crown derby is trimmed with brown satin band and bow. Stamped: Firenze Body Made in Italy. $50-60.

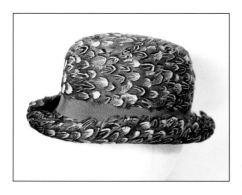

1960s lady's derby is completely hand covered in pheasant feathers and is trimmed with grosgrain band. The hat is fully lined with taffeta and is held in place with two clear plastic combs. *Courtesy of Bea Cohen*. $75-95.

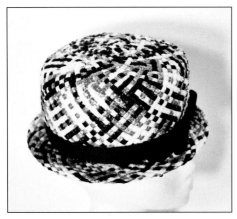

1960s black, white, and gray diagonally woven cellophane straw masculine derby style has grosgrain ribbon trim and tailored front bow. $40-50.

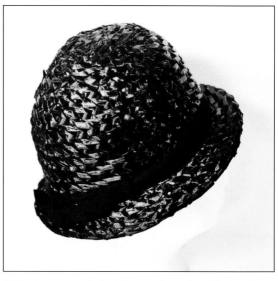

1960s deep crown ladies' derby style made of black cellophane straw with grosgrain ribbon band. $25-35.

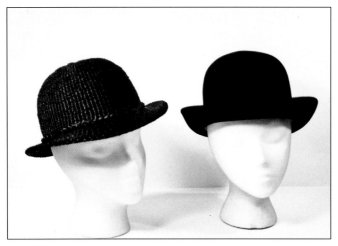

Right: 1960s ladies' black fur felt derby has whip stitched velour band around wide crown. This popular mannish look for the 1960s was designed by Mr. K Originals and was also popular after "Sweet Charity" in the 1970s. $40-50. Leftt: 1960s black, man-made straw lady's derby is stamped 60% chlorevynil and 40% viscose Made in Italy. $40-50.

1960s Persian lamb hat with visor is lined with heavy black satin. *Courtesy of Bea Cohen.* $50-65.

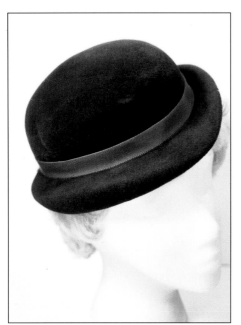

1960s blue derby style with grosgrain band. Label: Jacomet HB. Made in France. $50-60.

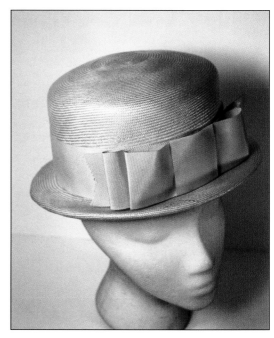

1960s pink fine Italian straw boater has wide pink grosgrain band and tailored bow. $60-75.

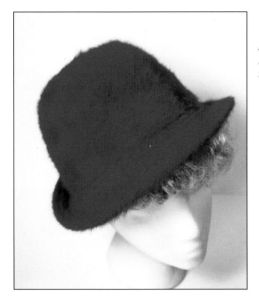

1960s red angora sporty swagger brim worn with stitched brim turned up in back and down in front. Label: Made in France. Sold by Sak's Fifth Ave. $50-60.

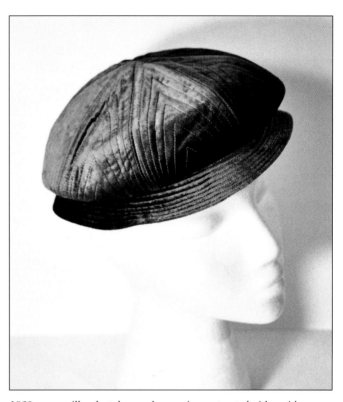

1960s green silk velvet dressmaker cap is constructed with a wide crown of eight sections and narrow brim. The crown and brim were decorated with repeated rows of machine stitches, a very tedious sewing operation, done perfectly. *Courtesy of Shirley Kohr*. $30-50.

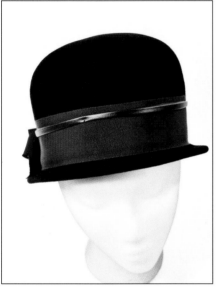

1960s lady's derby style hat with narrow brim is trimmed in grosgrain ribbon and leather in a tailored back bow. Stamped: Peachbloom Velour (made with rabbit fur), Merrimac Body Made of Imported Fur. Label: Union made UHC & MWIU. $40-50.

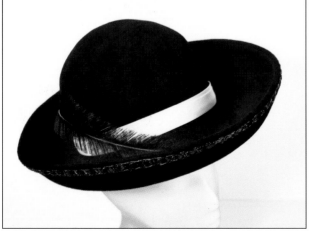

Inside of hat showing label of Kurt Jr. by Tom Hann and the green grosgrain band.

1960s black velour asymmetric hat with large deep crown is trimmed with beige satin band and black feather. A row of large, black sequins edges brim. Designer: Kurt Jr. by Tom Hann. $50-75.

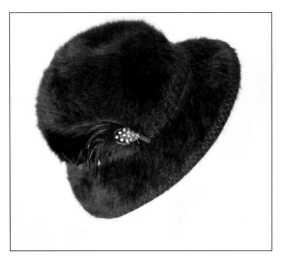

1960s ladies blue sport cloche with feather pin made in England by Kan Gol Registered Design. Stamped 45% rabbit hair/angora, 30% chlorofibre, and 25% nylon. Hat crown and brim are decorated with fancy machine work. $35-45.

1960s label for Kan Gol Registered Design. Made in England and is held in place by fine elastic band.

Helmet Hats

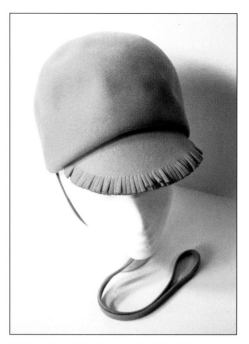

1960s yellow felt jockey style hat has fringed visor and adjustable chinstrap. Stamped: 100% wool Mauchoir Mélange Blend – Felt Henry Pollack. Designer label: Mr. John Classic. *Courtesy of Robert and Jacki Jiorle of Eclectibles.* $50-65.

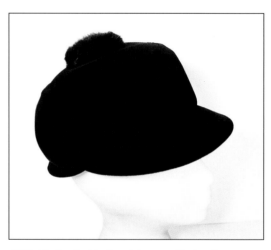

1960s black velvet jockey style cap with visor has pompom made from man-made yarn. The hat is fully lined with red acetate moiré. Designer: Adolfo II New York Paris. $50-65.

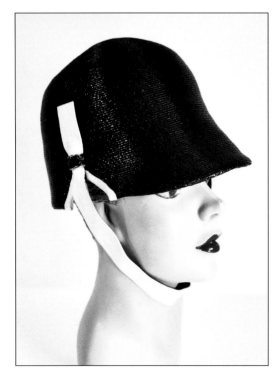

1960s navy blue straw helmet style hat with white chin strap. *Hat and mannequin courtesy of Barbara Kennedy.* $90-125.

1960s black fur felt helmet hat with tailored grosgrain bow in front stamped made in France and labeled Marie Schwarztrefz, Stuttgart, Alexanderstr. 8B. $50-65.

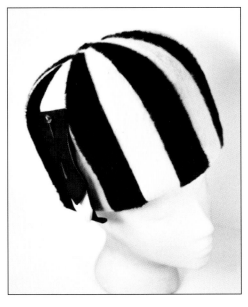

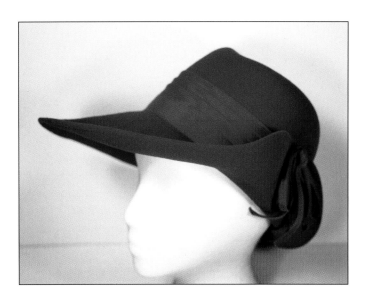

1960s masculine style black and white felt stripe helmet with grosgrain ribbon and original pin is constructed by sewing strips of felt together. Label: Gwenn Pennington Exclusive. $65-75.

1960s red felt Western style hat with pinned up side brim held in place with two bows. A wide pleated silk band trims the crown. Label: Gwenn Pennington. *Courtesy of Josie V. Smull.* $75-95.

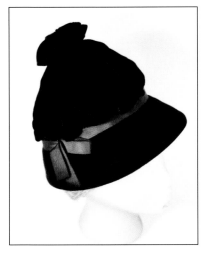

1960s black velvet brimmed hat has a four section deep crown, which is gathered into a pom-pom. Grosgrain band and bow trim the crown. $50-65.

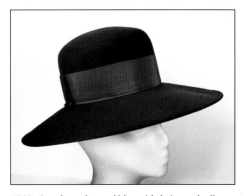

1960s Gaucho style royal blue wide brim and tall crown hat is trimmed with wide grosgrain band and back bow. Stamped: 100% wool Ritz Henry Pollak, Inc., New York. $40-50.

Tall Crown Picture Hats

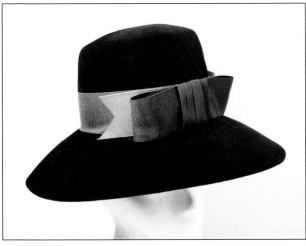

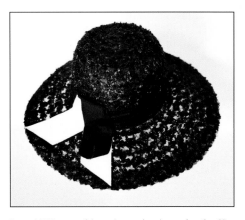

Late 1960s navy blue picture hat is made of raffia straw over nylon mesh. Navy blue and white grosgrain trims the hat. $50-70.

1960s tall crown hat with wide brim is made of felt and trimmed with wide grosgrain band and tailored bow. Designer: Lucilla Mendez Exclusive New York. Stamped: Unc @ MWIU Merrimac Body Delux Velour Made of Imported Fur. $40-50.

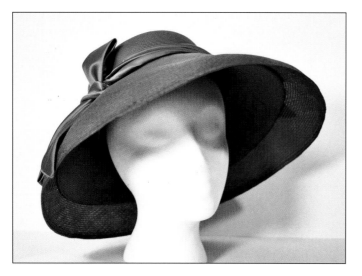

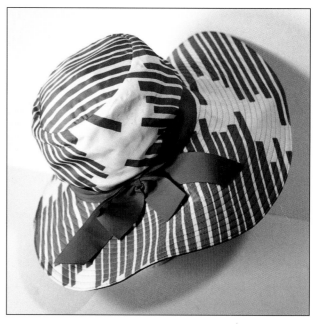

1960s custom made by Laddie Northridge, New York is a sun hat, which is constructed of two hats, one is raspberry straw and the other is turquoise faille. Crown is trimmed with a long, bias cut satin tie. A "hat inside of a hat" was a usual technique used by Laddie Northridge. $80-95.

Inside of Laddie Northbridge hat showing label and construction. Crown is lined with taffeta.

1960s turquoise and white silk serge dressmaker picture hat has a tall crown and soft floppy brim. Eighteen rows of machine stitches decorate brim, grosgrain band and bow trim crown. Hat is by Henry Margu.

Inside view of hat showing white lining and label of Henry Margu Original Creations. $45-55.

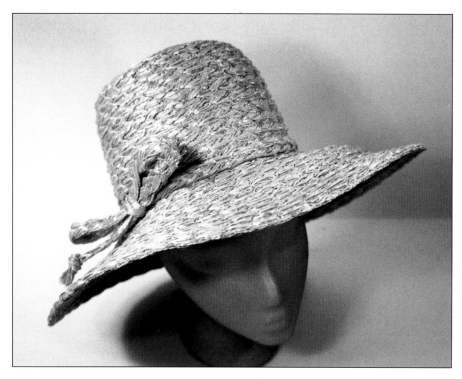

1960s tall crown, large floppy brim sun hat is made of cream-colored cellophane straw. Label: Leslie James, California. $60-75.

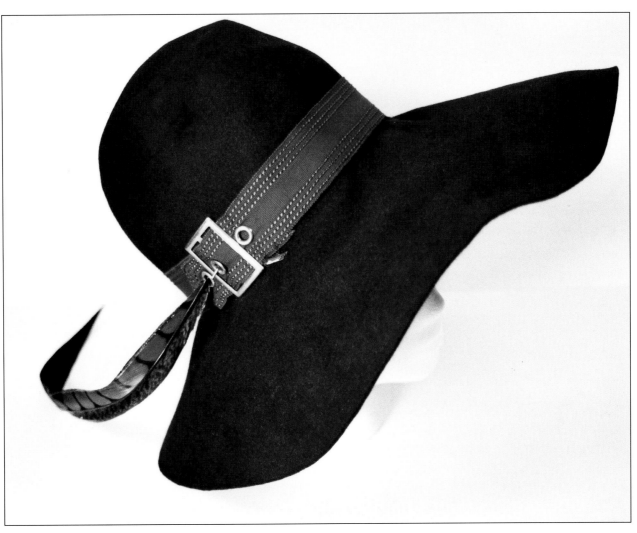

1960s large brown felt 10-gallon hat with tall crown and soft floppy brim was made by Adolfo. Hat is trimmed in a belt and buckle effect with pheasant feather placed in an eyelet. $75-95.

Inside showing Adolfo New York label. Hat sold by The French Room, Marshall Field and Company.

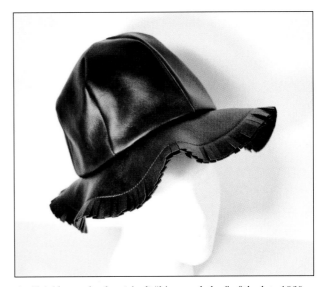

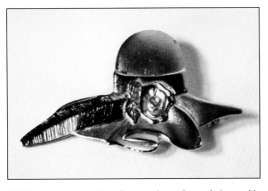

1960s costume pin with tall crown, large floppy brimmed hat decorated with band, rose, and long feather. $25.

Artificial brown leather (vinyl) "hippy style hat" of the late 1960s is made of a six-section tall crown and machine stitched double fringed brim. $30-40.

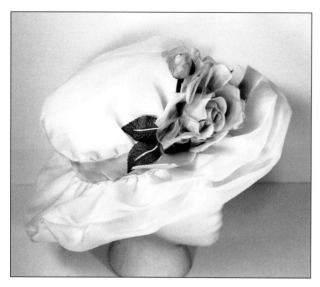

1960s white silk organza dressmaker hat has double brim. Trim is pea green velvet band with large silk rose, based on mobcap style. *Courtesy of Josie V. Smull.* $65-75.

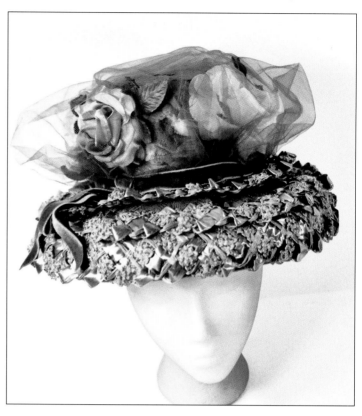

1960s romantic lampshade straw wide brim is trimmed with large roses, green velvet ribbon and veil. $50-70.

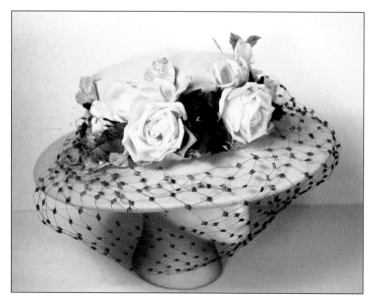

1960s yellow doeskin wide brim boater s trimmed with large matching roses, green leaves, and green large mesh full-face veil. *Courtesy of Josie V. Smull.* $90-110.

Class of 1963 dink is from Albright College, Reading, Pennsylvania and was worn by Rose Jamieson when she was a student there.

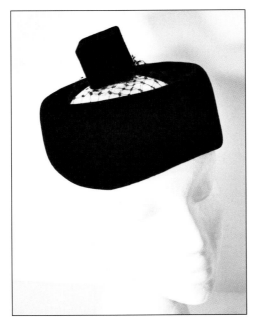

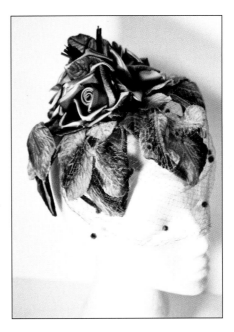

1960s hat constructed over green velvet frame with three green satin roses and embossed velvet leaves at top of crown. Chenille dotted nose length veil completes the hat. $45-55.

Late 1950s-1960s black velvet open crown pillbox supports a cube over veil. Two tortoise-shell combs hold hat in place along with two self-covered hatpins. Designer: Emme. Store label: Lewis, Philadelphia. $50-60.

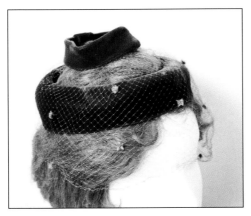

1965 taupe velvet two-circle whimsy covered with chenille dot veil. Label: Union Made. $20-25.

1960s wide bandeau or half crown is covered with dressmaker brocade artichoke petals in royal blue and olive green with a gold metallic yarn. Remains of the veil can be seen. Royal blue and olive green were a popular 1960s color combination. $20-30.

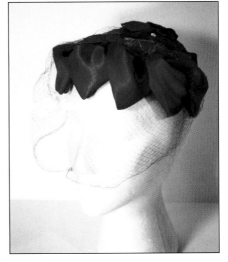

1960s wide dressmaker bandeau is constructed over a velvet covered wire frame with rose-colored satin petals and embossed velvet leaves. A fine mesh nose length veil finishes hat. $25-30.

1965 off white circular tube whimsy is covered with nose length veil and three small velvet bows at top of crown. $15-20.

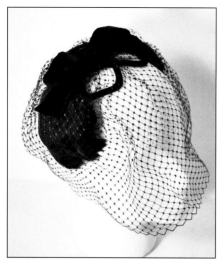

1960s navy blue feather bandeau is constructed over velvet wire frame and trimmed with side feather pads, large velvet bow and full-faced navy veil. $30-35.

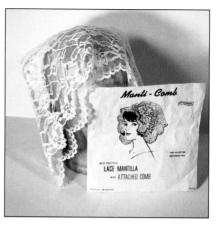

1960s Manti-Comb Lace Mantilla with attached comb is a blend of 65% nylon and 35 % acetate. "The accepted new head veil" is by Franshaw Exclusive. Jackie Kennedy made this style popular in the early 1960s. Empress Eugenie brought the mantilla to France in the 1860s. $10-15.

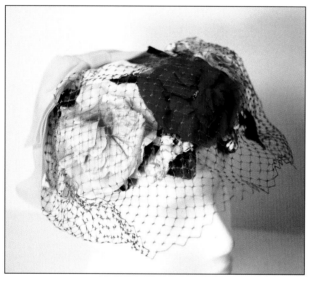

1960s half crown hat with pink and red roses and large peach back bow is covered with eye-length veil. $25-30.

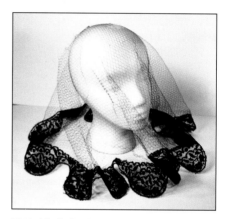

1960s black circular veil with scalloped lace edge was used for church in place of a hat. Made popular by Jackie Kennedy. $10-15.

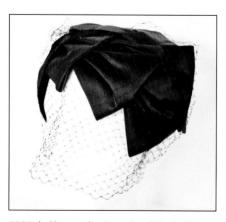

1960s half crown hat is made of black silk satin bows placed over a large mesh frame. Nose length veil finishes hat. $20-30.

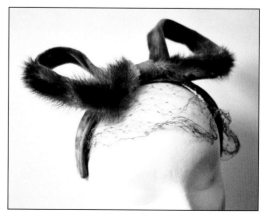

Late 1960-1970s headband made of taupe velvet and mink tails is trimmed with veil. $20-35.

154

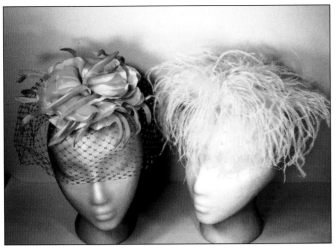

1960s two veil hats. The left hat is trimmed with large silk turquoise flower and the right one with marabou feathers. *Courtesy of Josie V. Smull.* $30-40 each.

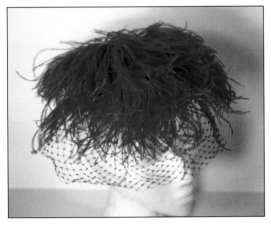

1960s whimsy, which is made on 6" felt base, is decorated with pink marabou feathers and nose length veil. $30-40.

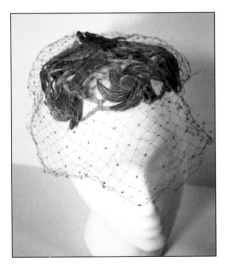

1960s whimsy made over a large open mesh uses a Juliet type frame and is covered with gold velvet embossed pinwheel flowers. Nose length veil covers entire hat. $15-20.

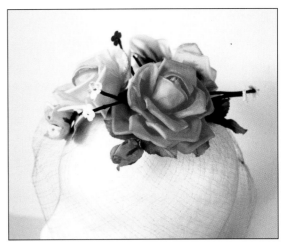

1960s whimsy with yellow, orange, and green roses made over a delicate veil. Designer: Mr. John Caprice, New York, Paris. $30-45.

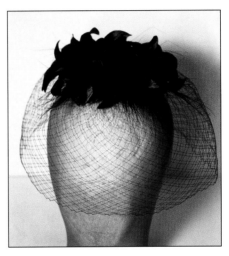

Brown veil hat completely covers face and head and is decorated with brown feathers. Anna Freed wore hat for a December 1969 wedding of her daughter. Designer: Mr. John Caprice, New York, Paris. *Courtesy of Joanne E. Deardorff.* $45-50.

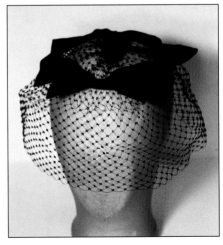

1960s black veil whimsy decorated with four silk organza bows arranged on a circle form. *Courtesy of Joanne E. Deardorff.* $45-50.

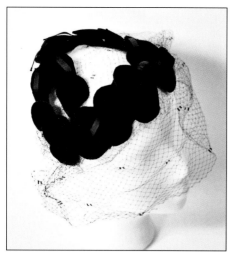

1960s black velvet whimsy made of circles trimmed with satin ribbon and full-face veil. $20-25.

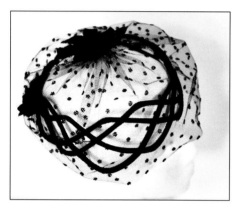

1960s black four-strand wire frame whimsy is covered with nose length veil and spider bow. Veil is chenille style made with flocked dots. $20-25.

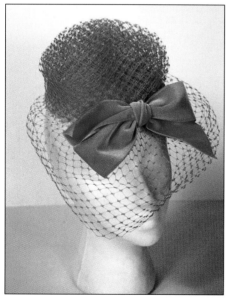

1960s peach bride's maid hat constructed completely from veiling set off with a large velvet front bow. Hat is held on with two clear plastic combs. *Courtesy of Fae Shaffer.* $25-35.

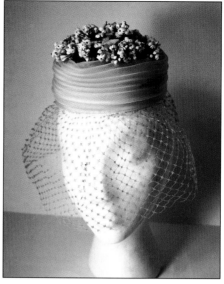

1960s small confection is made of bias cut pleated beige silk organza with small flowers on top. Veil forms a cage around wearer's head. $40-50.

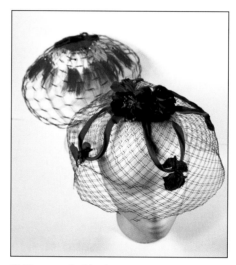

1960s two red whimsies, rear one is made over large mesh chicken wire and front one is made over veiling. $10-15.

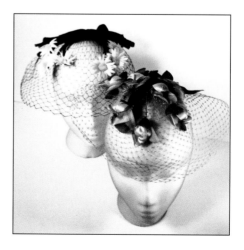

1960s two whimsies made over veiling with daisies and roses. $10-15.

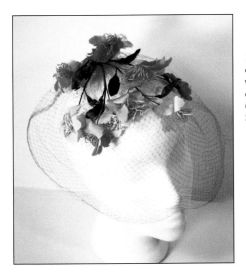

1960s whimsy is constructed over a nose length veil, covered with salmon miniature carnations and green leaves. *Courtesy of Marion Kingsbury.* $10-15.

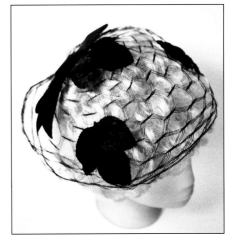

1960s large mesh black chicken wire veil hat decorated with black velvet leaves and bow. $5-10.

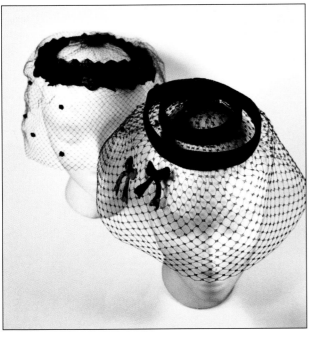

1960s two whimsies for dressy occasions made over veiling. $10-20.

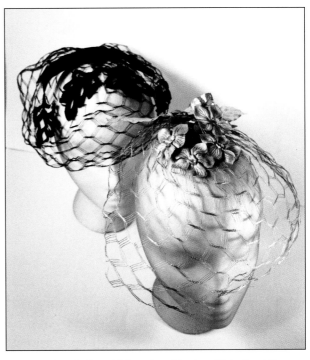

1960s black and silver chicken wire whimsies with leaf and flower decoration. $10-15.

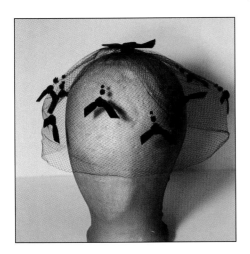

1960s whimsy made of navy blue net with velvet bows and chenille dots. $10-15.

1960s whimsy is constructed over headband with brown veil, velvet bow and feather tendrils. Graduated chenille dots cover nose length veil. $10-15.

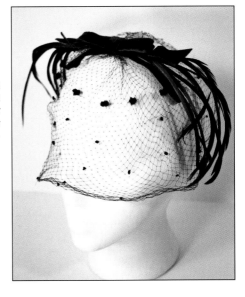

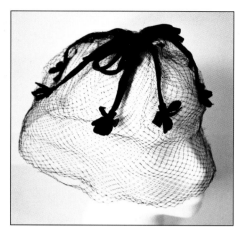

1960-70s whimsy is constructed with navy blue full-face veil. The velvet top bow ends in six flowered streamers. $10-15.

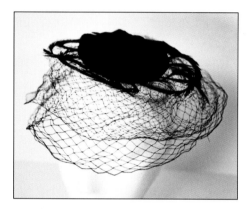

1960-70s whimsy is made to look like 1940s doll hat with double black veil in fine and coarse mesh. Body is black velvet with black feathers. $10-15.

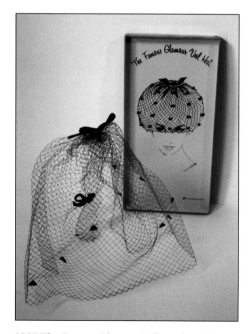

1965 The Famous Glamour Veil Hat in original box sold for $1.29. $6-12.

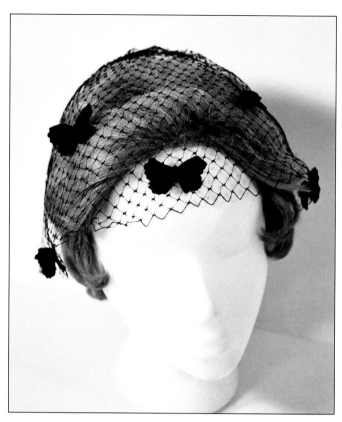

1960s black veil whimsy has black felt butterflies applied to veil. $5-10.

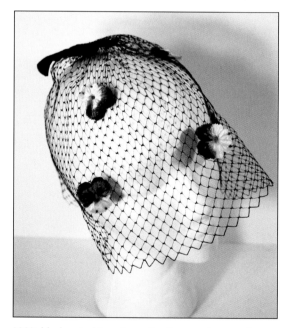

1960s black net whimsy has velvet bow on the top of crown and embossed velvet pansies. Bouffant hairstyle makes the veil end at the eyes. $5-10.

Square Hat Boxes

1960s hatbox from Kresge – Newark. $10-15.

1960s two hat boxes from Grollman's "Where Quality Reigns." Joseph Grollman said he assembled hundreds of these hats boxes for Easter when he was a child. *Courtesy of Bea Cohen*. $10-15.

Hatbox from Zallinger's, Allentown, Pennsylvania. Courtesy of Fae Shaffer. $10-15.

1960s square hatbox is from Hess's, Allentown, Pennsylvania. $6 in poor condition.

1960s hatbox from Sigals, Easton, Pennsylvania. The store was known for its better dresses, coats, hats, and bridal and prom gowns. $10-15.

The 1970s
Ethnic Influences

Fashions of the 1970s

In the 1970s fashion designers made the mid-calf midi skirt and the ankle length maxi skirt in an effort to keep women's styles feminine. Women rejected those styles and selected comfortable pants rather than the more feminine styles. Designer Frank Olive felt women became militant and did not want to be feminine. In 1977 Yves Saint Laurent brought out his Russian and rich peasant collections.

Hairstyles of the 1970s

The "punk look" of the 1970s made pastel color hair of pink or soft green popular. The hair was cut short so it could be worn in spikes. Hippies continued to wear their hair long and straight.

The "Afro" hairstyle was popular for African American youths, along with all other ethnic groups. The permanent wave business increased with the great number of perms sold to curl poker-straight hair for the fashionable Afro hairstyle. The "Farrah Fawcett look" led to long hair fashions, along with the rock music groups who generally wore their hair long.

Hat Information in the 1970s

Headbands in stripes were worn by people interested in sports and health-promoting activities. The hippies wore bandanas and block print scarves from India to hold their hair in place.

With the increased popularity in ethnic styles of dress, berets, turbans, and Gaucho styles were popular. The male fedora in felt and straw was popular for women. The crown of the fedora was tied with striped or paisley scarves.

1970s. Joseph Rath wearing his Russian sable fur hat. Earflaps can be let down for added warmth.

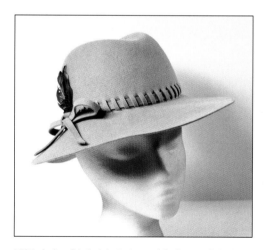

1970s beige felt lady's Fedora with diagonal slashes around crown holding band, bow and feather. Stamped: Astre 100% wool WPL 3137 Made in USA. $20-25.

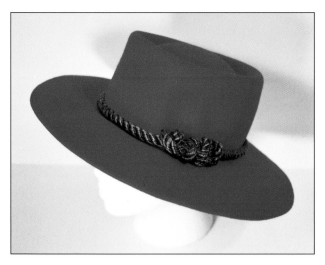

1970s red felt Gaucho style hat with pork pie crown is trimmed in twisted, multicolored silk rope and knot. Stamped: Made in Los Angeles, California USA by the Field Company. $50-65.

The movie "The Great Gatsby" created a renewed interest in hat styles of the 1920s and 1930s, with a revival of the cloche and slouch hat. Knitted and crocheted hats and granny squares were stylish along with felt hats.

1970s Women in Government

By the early 1970s, few women were wearing hats. Two famous women never stopped wearing their large hats: Bella Abzug and Shirley Chisolm. Congressional Representative Bella Abzug of New York was pictured on the cover of the June 9, 1972 issue of *Life* magazine wearing a red felt, wide brim hat with a tall crown. Shirley Chisolm ran for the New York Assembly in 1964 and won. She will always be remembered for her contributions to child care centers, school funding, and women's rights. In 1972, she ran as a "presidential candidate of the people." She passed away January 1, 2005. Besides her contributions to society, Shirley Chisolm will be remebered for her large and beautifully fashionable hats.

Sears Wish Book

On page 106 of the *Sears Wish Book for the Christmas Season, 1970* a Gaucho hat was selling for $6.00. It was available in navy blue, pale pink, and dark brown. The Gaucho was made of wool felt trimmed with a grosgrain ribbon band and bow with a chinstrap. The hat was pictured being worn with shorter skirts above the knee and with longer versions below the knee. The same hat was shown on page 126 being worn with slacks, a jacket and high-heeled boots.

A selection of men's hats was pictured on page 197. These included the All Fur Envoy cap of dyed mouton lamb selling for $9.99. The Tyrolean style hat was selling for $5.99 made of plush pile with a band and feather trim. A faux Persian lamb Cossack style cap sold for $4.99. Each of these models had a center crease crown and a wool Melton turn down band inside the hat called an inband, which could be pulled down for added warmth because the band covered the ears. The Tyrolean and Cossack style caps were both popular. Other styles available that year were a suede Fedora, ski mask and a 100% wool worsted sailor cap.

The June 18, 1971 cover of *Life* magazine pictured the radiant bride Tricia Nixon in her wedding dress, designed by Priscilla Kidder of "Priscilla of Boston." Her headdress was a jewel-encrusted pillbox worn at the back of her head, which held her full-length veil.

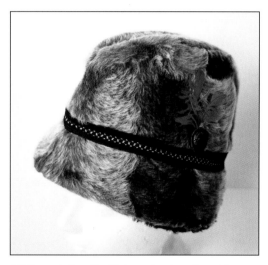

1970s man's faux fur Alpine style winter hat with tape and feather trim was worn by Paul Jamieson. $15-20.

Gayle and Gary Gorga were married in 1977. For her wedding gown, Gayle chose a Mexican style long white dress. The collar, bodice front and cuffs were hand embroidered with colorful flowers. Gayle's headdress was a garland of flowers matching the embroidery and the flowers in her bouquet.

The *JC Penny Catalog for Christmas 1976* had the following hats for sale for children:
A colorful girls' striped pull on washable acrylic cuff hat in sizes 7-16 sold for $2.27. The younger girls' matching hat in sizes 3-6X sold for $1.97. The hats were part of a coordinated outfit including matching scarves, sweater, and knee-high socks shown on page 210.

Also for little girls was a natural white rabbit fur beret with earflaps and chin tie selling for $5.47. The matching muff with neck cord was selling for $4.47 and was pictured on page 212. Pictured for women on page 91 was a matching rabbit fur beret and purse selling for $21.00.

On page 213 JC Penny had a children's hand crocheted acrylic hat and mitten set with a choice of a face appliqué of Bert or Ernie on the crown of the hat and tips of the mittens, selling for $5.00.

Pictured on page 171 for men was the popular Tyrol style hat selling for $5.50. It was faux fur made of acrylic and was available in sizes small to extra large in brown or black. For women a cloche hat with a six-section crown and narrow brim was available in rust and green that sold for $5.00 was pictured on page 137.

Also for women on page 124, a self-wrap turban was pictured. It was made of polyester and had a close-fitting crown with long ends that could be wrapped or tied and it sold for $3.00. Lambs wool toques imported from Italy were selling for $13.94 and came in a choice of white, black, and white with brown tips. They could be worn for sport or dress and were made in two sections for the cuff style pictured on page 91.

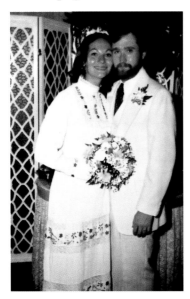

Photo by Nick Pargaro of Clifton, NJ showing bride and groom Gayle and Gary Gorga at their 1977 wedding. Gayle wears hand embroidered Mexican wedding dress with flower bouquet and headdress to match embroidery. Gary wears white three-piece suit.

Designer Oscar de la Renta

Oscar de la Renta was born in 1932 in Santo Domingo where he graduated high school. He went to Madrid to study art. His mother died while he was there and his family wanted him to earn some money on his own. Drawing came easy to him so he did fashion illustration for newspapers and magazines in Spain. Soon he was sketching his own ideas. His friends thought his work was so good that they showed it to Balenciaga, who offered him a job in the Madrid house. After six months of working there, he thought he had learned enough to get a job in Paris. He was offered a job at Antonio del Castillo as an assistant.

In 1962 he came to America and worked for Elizabeth Arden. By 1965 he opened his own business on Seventh Avenue, making clothes for men and women. He is noted for his beautiful evening gowns, which are ultra-feminine. Oscar de la Renta died in 2006.

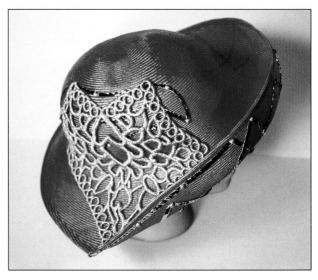

1970s flamingo color fine straw hat by Oscar de la Renta Millinery trimmed with gold metallic yarn and lace appliqué. $25-35.

1970s inside view of straw hat showing Oscar de la Renta Millinery designer label and hangtag label.

Ethnic Headdresses

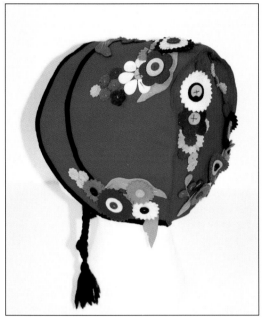

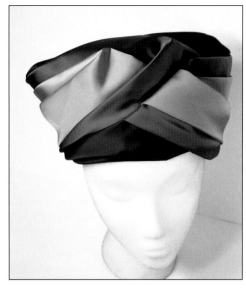

1970s ethnic style horizontally draped turban made of green, purple and aqua satin. $40-50.

Back view of hand made felt bonnet decorated with applied felt flowers, part of a traditional national costume. $15-20.

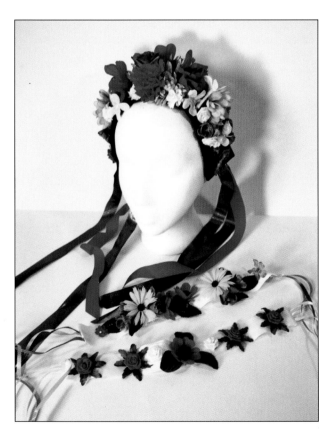

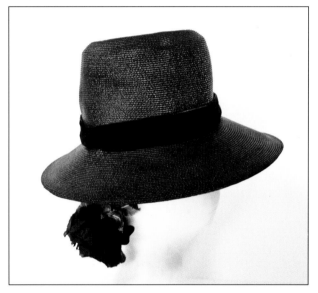

1960s black lacquered straw deep crown in Spanish style has a back velvet band supporting a rose at nape of wearer's neck. $40-55.

1970s traditional costume flower-covered bandeaux made for a school fashion show by Rose Jamieson. The large one is the Ukranian style bandeau and Polish bandeaux are smaller.

1960s costume pin of Spanish style hat. $20.

Felt Hats

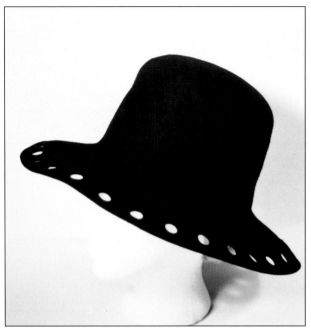

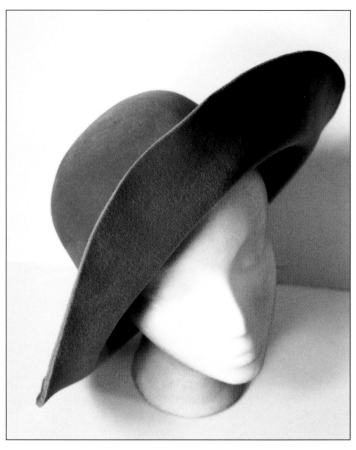

1970 black felt deep crown punched edge hippy style hat. A scarf or ribbon could be threaded through the holes to dress up the hat. $20-30.

1970s tan fur felt unblocked soft hat made by Borsalino in Rome. Eleanor Pinto purchased it at the store in Rome. *Gift of Eleanor Pinto*. $50-70.

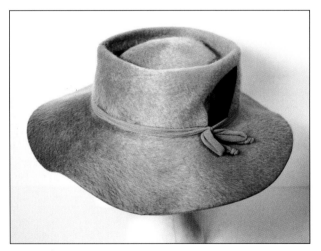

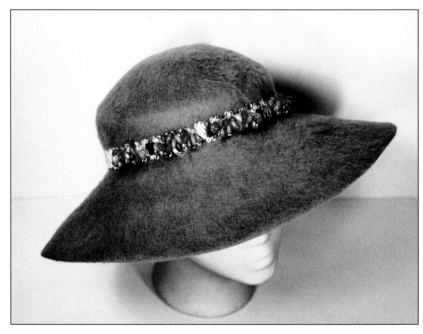

1970s soft tan felt hat is made in hippy style with pork pie crown and floppy brim. Trim is a tie made from a cotton knit stocking and brown feather. Label: Lady Dobbs. *Courtesy of Bea Cohen*. $70-85.

1960s robin's egg blue fur felt hat has large soft floppy brim. Trim is two self-fabric back bows and a band of seashells. Label: Originals by Flo Raye New York. *Courtesy of Josie V. Smull*. $50-75.

Craft Hats

1970s hand knit beret made in garter stitch. Crown of hat is trimmed with crocheted bouquet of flowers. $20-25.

1970s crocheted pink variegated acrylic yarn bonnet of double crochet with single crochet and chain stitch trim. Made by Rose Avella. $20.

1970s crocheted Granny square cloche made by Marguerite Grumer. This was a favorite hat and she wore it every winter. $20-25.

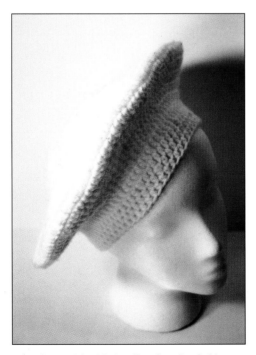

1970s beret with wide headband made of white acrylic yarn hand crocheted with double crochet stitch. $20.

1970s cloche knit hat made of bulky yarn. Body was knitted in stockinette and edge was garter stitch. Three flowers are crocheted and applied to hat. Made by Marguerite Grumer. $20-25.

Straw Hats

1970s red straw hat was made in Italy for Cali Fame of Los Angeles. The blue and white raffia form a triangular design on the crown with the brim edged in blue and white raffia X's. $20-35.

1970s straw cowboy hat by Heros has Carroll Reed signature on crown. $25-35.

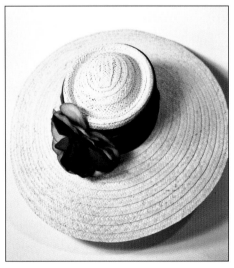

1970s top view of coiled straw cartwheel hat trimmed with blue cotton band and chou. Label: Tucan New York and Los Angeles. $25-35.

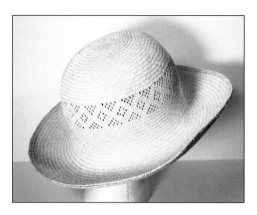

1970s finely hand woven 100% natural straw hat has open mesh diamond pattern. Label: Morgan Taylor. Made in Italy. $25-35.

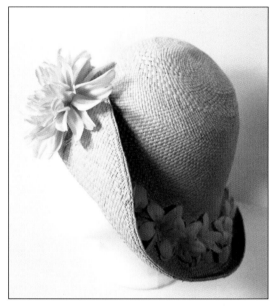

1970s finely woven Columbian straw hat decorated with silk flowers. $15-20.

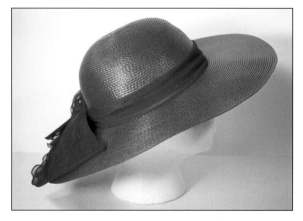

1970s red picture hat for sun protection, made in Taiwan of 100% polypropylene, is trimmed with a red silk chiffon scarf. $20-25.

Florida 1970 Marguerite Grumer in orange straw cartwheel hat and brother-in-law Jack Bird in Fedora enjoy a ride in the golf cart. Photo by Ellis Grumer. *Courtesy of Marguerite Grumer.*

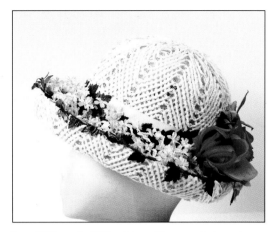

Late 1960s-early 1970s white raffia straw derby style formed over a mesh frame is trimmed with small five petal flowers and two large pink roses at the back. *Courtesy of Jeanne L. Call, Facet Designs.* $30-45.

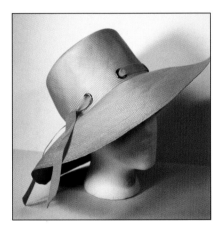

1970s fine gauge orange straw picture hat for sun has a grosgrain ribbon laced through eyelets at the crown. Label: Union Made. Designer: Lucilla Mendez Exclusive New York. $20-25.

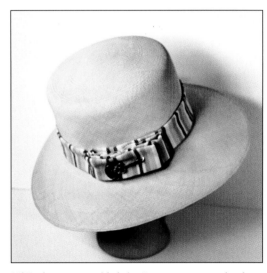

1970s deep crown wide brim Panama straw sun hat has neutral colored striped band and banjo pin. Label: Miss Lily of Dallas. $75-85.

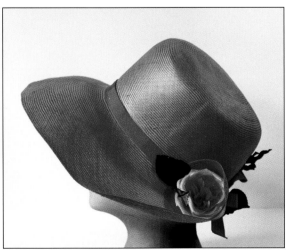

1970s pink finely woven Italian straw sun hat with slashed and rolled back brim. Roses rest in rolls. Trim is narrow pink grosgrain ribbon. Hat was also made in black. Label: Mr. John Classic New York Paris. *Courtesy of Jeanne L. Call, Facet Designs.* $30-45.

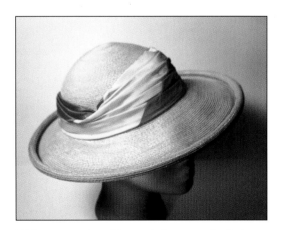

1970s straw sun hat with rounded crown and rolled brim is trimmed with bias cut peach silk scarf. Label: Individually tailored by Fish, Chicago. $60-70.

167

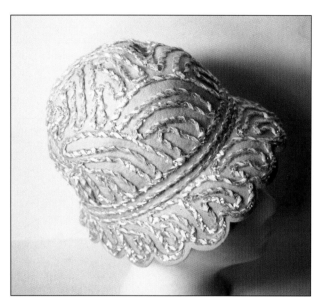

1970s pink felt cloche with narrow scalloped brim has trim made of Aurora Borealis sequins hand sewed onto tape. Tape is hand sewed to hat, a 1930s revival. *Courtesy of Marie Klaus Danko.* $45-55.

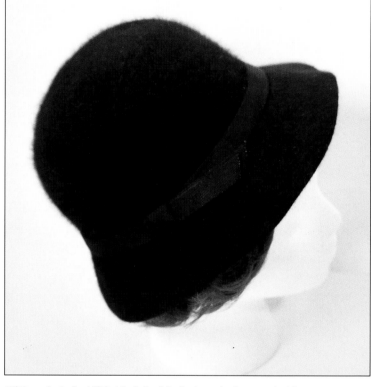

1970s revival of a 1930s black fur felt cloche style decorated with grosgrain band. *Courtesy of Tamara Selden.* It's the last hat she bought! $40-50.

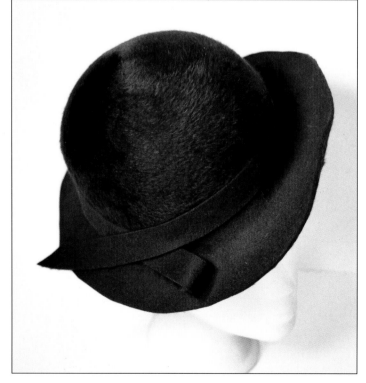

1970s Mr. John purple swagger hat in 1930s style is fully lined and trimmed with flat side self band. $45-55.

Inside the Mr. John swagger brim showing the Mr. John lining.

1970s fashionable young girl with long straight hair wears a hat with a large round crown and turned down brim.

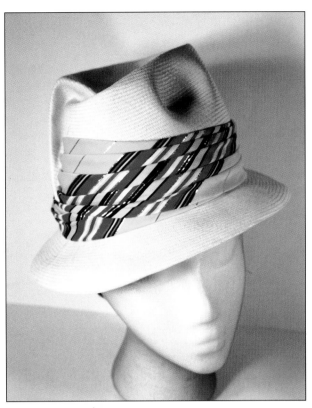

1970s lady's yellow straw Fedora trimmed in bias cut silk necktie stripe is a Straw Originals by Mr. Joseph NY. *A gift from Marie Klaus Danko.* $65-75.

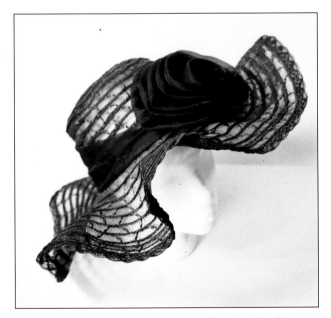

1972 flounce brim navy blue picture hat of horsehair has bias cut nylon band and large rosette. Hat was worn by Clara Garbacik as a bridesmaid's hat. *Gift of Dolores Bouch.* $20-35.

Commemorative plate of Her Majesty Queen Elizabeth the Queen Mother, 1900-2002 was made in England of Argyle Bone china. The Queen Mother wears a soft lavender hat with wide rolled brim forming a halo, which matches her lavender and white print dress. Flowers trim brim underneath and on top. *Courtesy of Joanne E. Deardorff.*

A Millinery Glossary

accessories – articles such as belts, hats, scarves, shoes and gloves worn to set off or complete an outfit.

Agnés, Mme. – 1920-'30s Parisian milliner famous for her draped turbans, use of tricot, cellophane, and designer fabrics.

aigrette – tall feather from the osprey or egret used to trim hats and was worn with headache bands in the 1920s.

Alencon lace – named after the town in Normandy, France, where this needlepoint lace was made.

Angora – soft fiber from the Angora rabbit used for making yarn.

Art Deco – a geometric decorative style for architecture adapted in the design of jewelry, fabric, and fashion introduced at the 1925 Exposition International of Arts Decoratifs et Industrials Modern in Paris. The Art Deco motif includes geometric shapes, parallel lines, waterfall designs, and stylized Deco rose.

Art Nouveau – decorative style used in jewelry, art and fashion from c. 1895-1915, showing stylized designs in women's long flowing hair, leaves, flowers, and vines.

babushka – means grandmother in Russian. A babushka is triangular scarf of cotton, silk, rayon, or lightweight wool (challis) tied under the chin.

Balenciaga, Cristobal – Spanish born, French couturier known as the "master" because he performed all operations in a custom-made garment.

bandeau – from the French for band. A headband worn around the forehead to keep hair in place, made popular by Suzanne Lenglen, French tennis player in the 1920s.

bavolet – see curtain.

beanie – small, round skullcap, a popular hat style in the 1930s, also called the calotte.

beehive – popular 1950s hairstyle in which the hair was worn in a tall dome shape on top of the head, held in place by teasing and hairspray. Beehive was also a hat style of the 1960s.

beret – soft, circular, brimless cap originating with ancient Greeks or Romans. The Basque style beret is worn with the band showing and the Madeleine style has no band.

bergere – straw skimmer with wide brim and shallow crown was revived during 1860s. It was named for Madame Bergeret, who wore it in the 1700s.

bertha – deep collar falling gently from the bodice. The neckline looks like a cape. Also can be an off the shoulder deep ruffle or suggesting a cape.

bias cut – fabrics cut at a 45-degree angle giving fabric stretch and drapeability.

bicorne – a half circle hat ending with a point at each side.

bicycle clip hat – half hat constructed over a springy piece of metal like that used to keep trousers out of bicycle spokes or chain.

boater – circular straw hat with flat crown and straight brim trimmed with ribbon band, worn by men and the Gibson girl.

Bobby's hat – hat with high domed crown and narrow turned down brim, like those worn by English policemen.

bonnet – head covering for top, back, and sides of head tying under chin. It may be decorated with ribbons, lace, flowers, and net.

Borsalino – Italian maker of the finest of mens felt hats, which were made of natural fur in Allesandria for over 100 years. Also maker of women's hats.

boudoir cap – 19th century cap worn to protect the hairstyle. It became unnecessary with 20th century short hairstyles. It was threaded with ribbons that positioned the cap and held it in place.

bowler – also known in United States as the derby. It is a hard felt hat with a round crown and a narrow brim curled at the sides. It was introduced in London in 1859, worn by London businessmen, and gave men another choice for formal wear besides the top hat. Spectators at horse races in America also wore this hat. Women wore bowlers during the 1960s with the Unisex trend.

breton – origin is French peasants of Brittany, the hat has a rolled back brim and is worn on the back of the head.

bubble beret – large bouffant beret worn to the side of the head in the early 1960s.

buckram – low thread count plain weave cotton fabric with heavy stiffening used for making hat frames.

bumper – hat with a thick padded rolled brim, popular in 1930s.

cabinet photo – first made in 1863 and popular 1870 to 1900. Photos were glued to cardboard mounts 4.5" x 6.5". The photographers imprint was below the picture.

cable knit – raised decorative pattern of twisted cables used to construct knitted sweaters and accessories.

cap – brimless head covering with a stiff visor over the forehead originally worn by workers. By the turn of the century the cap (flat hat) was popular with all men. Large, bright caps were popular in the 1960s.

cape – cloak that drapes from neck and shoulders and has no sleeve. May be various lengths from short to long.

capeline – hat having a deep crown and a wide sloping oval brim. Popular in 1920s and early 1930s.

Carnegie, Hattie – (1889-1956) Fashion and millinery designer. Born in Vienna, Austria, her family came to America and chose the name Carnegie. She began working in Macys New York trimming hats and in 1909 opened a hat shop with a partner who designed dresses.

carte de visite (meaning visiting card in French) – photo styles first made in 1854 and were most popular 1859 to 1866. They were small photos mounted on stiff cards.

cartwheel – hat with large wide brim and shallow crown, usually made of some type of straw.

chignon – hairstyle made by coiling the hair into a bun shape at the back of the head. It was worn from the 1800s to the 1920s. The style became popular again in the 1950s when a chignon form was used. 1950s chignon hats were designed to cover only the bun.

cloche – deep crowned hat with no brim or a narrow brim positioned down on the forehead but still showing the eyebrows. It was worn from 1915 to the mid-1930.

clutch purse – handbag without straps or handles made in many shapes including the large envelope bag. Purse was held between arm and body.

cockade – a hat decoration used in the late 1930s and early 1940s was made of grosgrain ribbon pleated into a circle. Used on masculine style hats for women.

complimentary color scheme – color schemes using hues directly across from each other on the color wheel. Example: red and green.

coolie hat – cone shaped hat that slopes downward for protection from sun and rain. Origin is Southeast Asia.

Cossack - term used to refer to people from Southeastern Russia.

Cossack hat – tall, brimless fur hat worn by Russian horsemen. Popular winter hat for men in 1950s and 1960s and also copied for womens styles in the 1910s.

cord – made by twisting together a group of ply yarns and used for decorating crown of hat.

cotton – natural cellulose fiber from the boll of the cotton plant.

crepe – thin worsted fabric made from a hard twisted yarn used for mourning clothing. It may be made of silk or lightweight wool.

crinoline – stiff fabric made of flax and horsehair used for 1850s petticoats. Cage frame introduced in the 1850s was used to support the silhouette of the extremely wide skirts. It originated in Paris and was made popular by Empress Eugenie.

curtain – ruffle sewed to back edge of bonnet to finish bonnet and to protect wearers neck from hot sun, also called *Bavolet*.

Daché, Lilly – milliner, born in France, who worked for Caroline Reboux. In 1924 she was hired to work in the millinery department by Macys in New York. She made draped turbans, cloches, snoods, and caps.

Dali, Salvador – Spanish surrealist artist and designer of fabric, hats, and jewelry used by milliners.

department store – large retail store offering many types of merchandise, housed in specific areas in the store called departments.

derby – man's hard felt hat in black or brown with high rounded crown and narrow brim curving up at sides. Another name for the bowler.

designer label – designers trademark on a hat or garment, giving more status to the wearer.

Dior, Christian – designer of the "New Look" fashion collection in 1947 and hats to set off those designs.

doll hat – small sized hat worn forward on the head and tilted to one

side, popular in the late 1930s and early 1940s.

Dupioni silk – occurs when two or more silk worms spin their cocoons together. The process produces the slub yarn used in making silk shantung fabric.

emboss – permanent raised and deep design on fabric done by passing it through engraved, heated rollers or irons.

Empress Eugenie hat – named after wife of Napoleon III. Small wool hat was worn forward with trailing back feather.

Eton crop – short straight haircut for women based on the short hairstyle worn by the boys of Eaton College. The style was popular in the 1920s and 1930s.

fabric – cloth made from various fibers, twisted into yarns and finally woven or knit into fabric.

faille – rib weave fabric made of silk or rayon fiber with a thick yarn running in the crosswise direction, used for making coats, dresses, hats, and linings.

fashion – clothing or an accessory that is the most popular item at a specific time.

fashion designer –person who designs new styles for garments and accessories.

fascinator – hand knit or crocheted head covering that draped on shoulders. Was fashionable during the Civil War and again during WW II.

fedora – may be a man or womans style hat with a medium brim, a high tapered crown, and crease in the center of the crown from front to back. It originated in the Austrian Tyrol. Women wore these hats for sports activities at the end of the 1800s. Men wore the Fedora from the late 1800s through the early 1950s.

felt – fibers of wool or animal hair made into hat making fabric through use of heat, moisture, and agitation.

felting – process of using moisture and heat to mat wool or fur fibers to form the non-woven fabric, felt.

fez – flat topped cylindrical felt hat originating in Turkey, was part of national costume.

flapper – 1920s term used to refer to a young woman with a short hairstyle, wearing cloche hats, short skirts, high-heeled T-strap shoes, and stockings rolled at the knee.

fleece – hair of sheep, which is the source of the natural fiber, wool.

flocking – method of decorating fabric or veil where glue is put on its surface in a specific pattern and fine fibers are then sprinkled on the glue to hold the design.

flounce – a gathered ruffle used to trim the skirt portion of a dress.

frock coat – man's long double-breasted coat of equal length in front and back.

garçonne – woman's style of the 1920s with the boyish silhouette, short haircut, and little make-up.

gaucho hat – Spanish style wide-brimmed felt hat with high flat crown, held in place under the chin with a leather tie. Popular for women in late 1960s and early 1970s.

Gibson blouse – shirtwaist illustrated by Charles Dana Gibson, which is high-necked and tailored with long full set-in sleeves and pleats over each shoulder.

Gibson Girl – young woman designed by illustrator Charles Dana Gibson who was the subject of his drawings 1890-1910. She was tall, slim, poised, independent, and athletic, the symbol of the ideal American girl.

Gibus – collapsible opera hat designed in 1835 by a Frenchman named Gibus and made of dull silk.

glengarry – a brimless hat of Scottish origin with a narrow creased crown trimmed with ribbon, feathers or veiling. Adapted for wear by women and girls in the late 1930s and early 1940s.

grosgrain – ribbon made in the rib weave with a coarse yarn running in the crosswise direction, used for millinery since the 1920s.

halo hat – popular late 1930s and 1940s hat with an upturned brim framing the wearer's face.

headdress – a head covering which is something more formal than a hat or bonnet, i.e. bridal headdress.

headscarf – square piece of fabric folded into a triangle, worn over the head, and tied under the chin.

helmet – cap closely fitting the head with sides covering the ears.

hobble skirt – designed by French designer Paul Poiret prior to WWI. The skirt was severely narrow between the knee and ankle. The wearer could take only small steps, and the style was made fun of by cartoonists.

Homburg – hard felt hat made in Homburg, Germany. It has a high crown with a deep crease from front to back and a curved brim. The crown is trimmed with a wide band of ribbon. Edward VII made the hat popular after he visited the resort of Homburg, Germany in the 1870s.

Honiton lace – the lace used for making Queen Victoria's wedding dress. It has a spotted net background with a flower design.

hood – head covering which is attached to the coat or jacket at the neckline seam.

jabot – detachable decorative lace frill worn in front at base of neck from 1859 through the 1920s, 1930s, and 1940s; also called a spitty.

jockey cap – masculine style hat adapted for women in the 1960s. A helmet style with a visor.

Juliet cap – small round, open design cap decorated with pearls or semi-precious stones. Made popular in the 1930s because of the film "Romeo and Juliet."

Kangol® – company founded in England in 1938 by Frenchman Jacques Spreiregen for making berets. Kangol also made military berets for the British during WWII. The Kangol soft angora hats and berets were popular during the 1950s. Now part of Bollman.

knickers (knickerbockers) – pants that end just below the knee and are gathered into a band and fastened. Popular in the 1920s.

knitting – method of fabric construction done by the interlooping of yarns.

lamé – fabric woven from flat metallic threads of gold and silver. Lamé became popular for eveningwear in the 1930s.

lappets – decorative streamers attached to a hat, worn in pairs hanging down the wearers back. Early lappets were hand embroidered.

leg-of-mutton sleeve – sleeve is tight from the elbow to wrist and is very large from the elbow to the shoulder. It was popular during the 1890s and again in the Edwardian period.

linen – natural cellulose fiber from the flax plant.

lowered waistline style – dress with a lowered waistline seam, called a "dropped waist" giving a long torso look, was popular in the 1920s.

Louis (XV) heel – (1715-74) thick heel that tapers in the middle and flares outward, was fashionable again in 1920s.

Lucile – French Couturiere who designed the Merry Widow hat in 1907.

mantilla – head covering worn by Spanish women made of black or white silk lace, draped over a high comb at the top of their head.

marabou – soft, fluffy feathers from a stork species used for hat decoration.

Marcel wave – waved hairstyle designed in 1872 by Marcel Grateau. The Marcel was popular in the 1920s and 1930s, until the permanent wave was introduced.

matinee hat – picture hat worn in the early 1900s for teas and other afternoon events.

Merry Widow hat – in 1907 actress Lily Elsie starred in the operetta "The Merry Widow," and wore the extremely large hat with many plumes designed by Lucile. They were made of straw or beaver, had a deep crown and were decorated with tulle and ostrich feathers.

mitten – In 1850 the mitten was really a glove of net or lace. The thumb and fingers were exposed from the first row of knuckles. Then the term changed to mean a glove that covers fingers together and the thumb separately.

mobcap – larger and fuller than a boudoir cap, it was worn indoors during the 1800s to protect the hair.

mohair – soft, lustrous, wavy hair from the Angora goat used for yarn making and for fashion accessories.

moiré – ribbed fabric treated with heat, pressure, and engraved copper rollers to produce a fabric with a watered design.

orange blossoms – symbolized chastity in the 19th century. The flowers were usually artificial and made of wax. They were used to make the headdress that held the wedding veil. The style was still used in the 1930s.

pageboy – popular late 1930s hairstyle worn through WW II and into the early 1950s, where the hair was shoulder length and rolled or curled under.

pagoda sleeve – popular in 1850s. A three quarter or half-length

171

sleeve with frills to the elbow where it became wide; resembles a pagoda.

Panama hat – tightly woven, cream colored natural straw hat in different styles made from the Carloduvica palmate plant from Ecuador. President Teddy Roosevelt wore one when he visited the Panama Canal in 1906.

panne velvet – lustrous velvet made by pressing the pile flat in one direction.

Peter Pan collar – two section flat, round collar named for Peter Pan. The collar was popular in the 1920s for the boyish silhouettes worn by women and was popular again in the late 1930s on wedding gowns.

picot – fancy milliners ribbon trimmed with small loops on each edge.

picture hat – hat having a large brim framing the face.

pill box hat – small oval or round hat with straight sides, flat top and no brim. Adrian designed one for Greta Garbo in the 1932 for the movie *As You Desire Me*. It stayed popular into the 1940s. Halston designed pillbox hats for Jackie Kennedy Onassis and she wore them back on her head.

plus fours – baggy knickers for men worn four inches below the knee. Made popular when Prince of Wales visited America in 1924.

Poiret, Paul (1880-1944) – great French designer known for Empire style dresses, tunics, and the hobble skirt (1910-1919).

poke bonnet – wide, deep brimmed bonnet with small crown at the back. It protected the sides of the face and tied under the chin. They were fashionable in the 1800s until 1860.

polonaise – a dress with draped bodice and looped-up tunic in one.

pompadour – hairstyle worn by the Gibson girls in the 1890s and early 1900s with long hair piled on top of the head.

pork pie hat – hat designed with round dish shape crease in crown, was considered a sporty style hat popular in the 1920s, 1940s, and 1950s.

printing – the process of applying a color and design to the surface of a fabric, thus a printed fabric.

profile hat – hat with brim turned up on one side and down on the other to show the wearer's face in profile. Popular in the 1930s.

purl knit – knitted fabric with horizontal rows having excellent stretch and recovery in lengthwise and crosswise directions.

Queen Alexandra (1844-1925) – born in Denmark. In 1863 she married Prince Edward VII. She is famous for the dog collar choker of pearls and Edwardian fashions.

rib weave – a plain weave variation with a cord effect running in the crosswise direction due to use of a coarse yarn.

Reboux, Caroline – French milliner who introduced the cloche and gigolo hats.

Robin Hood hat – popular during the late 1930s and early 1940s. This hat was a sporty masculine style woman's hat with a feather, a pointed crown, and a little brim.

ruched – tightly gathered fabric.

satin – lustrous fabric made by satin weave having a shine and smoothness in the lengthwise direction. Satin fabric may be made from silk, rayon, nylon, or polyester fiber.

sateen – fabric made by sateen weave using cotton fiber. Smoothness and shine run in the crosswise direction.

shirtwaist – costume of the Gibson girl, a blouse fashioned after a man's shirt worn with a necktie, bow tie, or ascot.

sideburns – covered wire loops or straight parts attached under the brim of the 1950s Dior-style hats to hold them in place.

silhouette – outline of a garment, each fashion era having its own specific silhouette.

Silk – natural protein filament fiber from the cocoon of the silkworm.

slat bonnet – a bonnet with a deep brim or poke made stiff by inserting wooden slats or stiff cardboard to hold out the brim.

slouch hat – masculine style womans hat popular in the early 1930s fashioned after a mans Fedora. It was made of soft felt, worn slanted at an angle, and pulled down over the forehead.

snap brim – mans Fedora worn with the brim down in front.

snood – made of net or knitted. It is worn to hold the hair at the back of the head. The snood was first popular in Victorian times. Adrian designed a snood for actress Hedy Lamar to wear in the movie "I Take This Woman" in 1939. In the 1940s, snoods held long hair in place while women worked with machinery during World War II.

sombrero – tall crowned, wide-brimmed hat worn for protection from the sun by men in Spain, Mexico, and South America.

sou'wester – rubber or canvas hat with wide brim, long in back and short in front to protect from rain. It was modified by Dior to become a fashion hat for women in the 1950s and 1960s.

spectator – shoe style of two-tone black or brown and white worn in the 1920s and into the 1930s. Men and women both wore this style.

spoon bonnet – Civil War period bonnet with pointed brim and net, lace, and flower trim.

Stetson – hat made by the John B. Stetson Company of Philadelphia, worn by cowboys and ranchers, with a high crown and wide brim. A brand name for cowboy and traditional hats for men and women.

sunbonnet – a head covering with a wide brim made of starched fabric or straw, a gathered full crown, chin ties, and a curtain.

surplice – 1920s style of coat closing where right front crosses over left and is buttoned at the side waistline.

taffeta – fine rib weave fabric of silk or rayon used for eveningwear, hat and coat linings.

tam-o'-shanter or "tam" – Scottish round woolen cap with a tight headband and full soft crown decorated with a pom-pom. The name comes from the hero of a Robert Burns poem. Women and girls wore "tams" in the 1930s to the 1950s.

tintype – photographic image on iron plates; also called ferrotypes. First made in 1856 and very popular until 1867. From 1870 to 1885 they had a brownish cast. From 1890 to 1920 they were made at carnivals, fairs and at resorts.

top hat – man's tall hat with narrow brim. In 1800s it was adapted for women for horseback riding. It was worn as a doll hat in late 1930s and early 1940s. In 1960s it was adapted again as a woman's masculine style.

topper – 1950s, new, short coat style more comfortble for riding in cars

toque – brimless close-fitting hat with a tall crown made of wool, jersey, or fur.

tricorn – three-cornered hat with a turned up brim, which was popular in the early 1900s and again in the 1930s.

trilby – soft felt hat with low indented crown and ribbon trim resembling the Fedora.

trotteur – walking suit first introduced in 1890s. The skirt was ankle length, flaring at the back for easy walking.

truncated – a hat with its crown top flattened or the top of a cone hat cut off. Late 1930s hats had truncated crowns.

turban – draped long scarf of cotton, linen, silk, or rayon worn wrapped around the head. Popular in 1910s through 1940s, and again in the 1960s.

tutulus – pointed or conical shaped hat with soft narrow brim around hat, worn by Etruscan men.

Tyrolean – Alpine style hat with a cone shaped tall crown popular in the late 1930s because Austria was the resort for the elite. Style continued into the 1940s and was truncated.

veil – covering for the face that was attached to the hat. Veils were made in various lengths: eye, nose, and full face, also called chin length. Veils on hats were popular on 1940s and 1950s hats. Automobile veils held the Merry Widow hats on, while women rode in early 1900s autos.

velvet – lustrous pile fabric made of silk or rayon fiber.

velveteen – pile fabric made of cotton, having short nap, and no luster.

wig hat - crocheted and covered with flowers, feathers, or petals. Completely covers the hair and was popular in the mid - 1960s.

William Penn hat – late 1960s hat with high, rounded crown and medium brim worn forward. Fashioned after hat worn by William Penn.

wimple – fabric was worn draped over the head, around the neck, and under the chin. Covering for nuns. Worn outdoors by women in medieval times and was popular again in late 1930s and early 1940s.

Bibliography

Books

Albrizio, Ann and Osnot Lustig. *Classic Millinery Techniques*. North Carolina: Lark Books, 1998.

Alger Jr., Horatio. *Struggling Upward; or, Luke Larkins Luck*. Philadelphia: John C. Winston Co., 1890.

Amphlett, Hilda. *Hats, A History of Fashion in Headwear*. New York: Dover Publications, Inc., 2003.

Atkins, Ethel. *Then and Now*. Boston, Massachusetts, 1959.

Baclowski, Karen. *The Guide to Historic Costume*. New York: Drama Book Publishers, 1995.

Blum, Dilys E. Shocking, *The Art and Fashion of Elsa Schiaparelli*. Philadelphia, Pennsylvania: Philadelphia Museum of Art, 2003.

Blum, Stella. *Everyday Fashions of the Thirties as pictured in Sears Catalogs*. New York: Dover Publications, Inc., 1986.

Blum, Stella and Louise Hamar. *Fabulous Fashion 1907-1967*. International Cultural Corporation of Australia Limited.

Boorstin Jr., Daniel, Ruth Frankel Boorstin and Kelly Brooks Molher. *A History of the United States*. Ginn and Company, 1979.

Bradley, Carolyn G. *Western World Costume, An Outline History*. New York: Appleton-Century-Crafts, Inc., 1954.

Calasibetta, Charlotte ManRey, Ph.D. *Fairchilds Dictionary of Fashion*. 2nd Edition. New York: Fairchild Publications, 1988.

Chace, Reeve. *The Complete Book of Oscar Fashion*. New York: Reed Press, 2003.

Costantino, Maria. *Fashions of a Decade, The 1930s*. New York: Facts on File, Inc., 1992.

Doyle, Marian I. *An Illustrated History of Hairstyles 1830-1930*. Atglen, Pennsylvania: Schiffer Publishing Ltd., 2003.

Frings, Ginny Stephens. *Fashion From Concept to Consumer*. New Jersey: Prentice Hall, Inc., 1987.

Gold, Annalee. *75 Years of Fashion*. New York: Fairchild Publications, Inc., 1975.

Harnung, Clarence P. *Treasury of American Design*. New York: Harry N. Abrams, Inc., 1952.

Harris, Kristina. *Victorian Fashion in America*. New York: Dover Publications, Inc., 2002.

Hendrickson, Robert. *The Grand Emporiums, The Illustrated History of America's Great Department Stores*. New York: Stein and Day, 1979.

Herald, Jacqueline. *Fashions of A Decade–The 1970s*. New York: Facts on File, 1992.

Hofstadter, Richard, William Miller and Aaron Daniel. *The United States The History of a Republic*. New Jersey: Prentice-Hall, Inc., 1964.

Hopkins, Susie. *The Century of Hats*. New Jersey: Chartwell Books, Inc., 1999.

Irons, David. *Irons By Irons*. Published by David Irons, Northampton, PA, 1994.

Kerr, Rose Netzorg. *100 Years of Costume in America*. Massachusetts: Davis Press, Inc., 1951.

Langley, Susan. *Vintage Hats and Bonnets 1770-1970 Identification and Values*. Paducah, Kentucky: Schroeder Publishing, Inc., 1998 and 2004.

Laubner, Ellie. *Collectible Fashions of the Turbulent 1930s*. Atglen, Pennsylvania: Schiffer Publishing Ltd., 2000.

—. *Fashions of the Roaring 20s*. Atglen, Pennsylvania: Schiffer Publishing Ltd., 1996.

Mace, O. Henry. *Collectors Guide to Early Photographs*. Radnor, Pennsylvania: Wallace-Homestead Book Company, 1990.

McDowell, Colin. *Hats, Status, Style, and Glamour*. New York: Rizzoli, 1992.

McFadden, Mary et Ruta Saliklis in Association with Allentown Art Museum. *Mary McFadden High Priestess of High Fashion*. Charlestown, Massachusetts: Bunker Hill Publishing Inc., 2004.

Melcher, Madame. *Le Petit Maitre…or…Home Teacher of Millinery*. New York: Madame Melcher, 1895.

Miller, Brandon Marie. *Dressed for the Occasion, What America Wore 1620-1970*. Minneapolis: Lerner Publications, 1999.

Morris, Bernadine and Barbara Walz. *The Fashion Makers*. New York: Random House, 1978.

O'Hara, Georgina. *The Encyclopedia of Fashion*. Introduction by Carrie Donovan. New York: Harry N. Abrams Inc., 1986.

Olian, Jo-Ann. *Everyday Fashions 1909-1920 as Pictured in Sears Catalogs*. New York: Dover Publications, Inc., 1995.

—. *Everyday Fashions of the Fifties as Pictured in Sears Catalogs*. New York: Dover Publications, Inc., 2002.

—. *Everyday Fashions of the Sixties as Pictured in Sears Catalogs*. New York: Dover Publications, Inc., 1999.

Perl, Lila. *From Top Hats to Baseball Caps, From Bustles to Blue Jeans, Why We Dress the Way We Do*. New York: Clarion Books, 1990.

Picken, Mary Brooks. *A Dictionary of Costume and Fashion*. New York: Dover Publications, Inc., 1985.

Probert, Christina. *Hats in Vogue Since 1910*. New York: Abbeville Press, Inc., 1981.

Reilly, Maureen and Mary Beth Detrich. *Womens Hats of the 20th Century*. Atglen, Pennsylvania: Schiffer Publishing Ltd., 1997.

Smith, Desire. *Hats with Values*. Atglen, Pennsylvania: Schiffer Publishing Ltd., 1996.

Stimson, Ermina, and Alice Lessing. *Sixty Years of Fashion*. New York: Fairchild Publications, Inc., 1963.

Tierney, Tom. *Great Fashion Designers of the Sixties*. New York: Dover Publications, 1991.

—. *Great Fashion Designs of the Belle Époque*. New York: Dover Publications, 1982.

—. *Great Fashion Designs of the Thirties*. New York; Dover Publications, Inc., 1984.

—. *Great Fashion Designs of the Twenties, Paper Dolls in Full Color*. New York: Dover Publishing, Inc., 1983.

Verlagsanstalt, F. Bruckman A-G. *Die Mode Menschen und Moden Im Neunzehnten Jahrhundert 1818-1842*. Munchen: 1907.

Wilcox, R. Turner. *The Dictionary of Costume*. New York: Charles Scribners Sons, 1969.

Wingate, Isabel B., Karen R. Gillespie and Betty G. Milgrom. *Know Your Merchandise*. 4th Edition. New York: McGraw Hill Book Company, 1975.

Catalogs

Aldens Spring and Summer. 1952.

Butterick Quarterly. Summer 1926.

Elite Styles. Vol. 21, No. 12, December 1917.

Hamilton Garment Co. *Fifth Avenue Styles for Spring and Summer 1928*.

JC Penney Christmas Catalog 1976.

Montgomery Ward and Companys Catalogue, Spring & Summer 1895, Catalogue No. 57. Dover Publications, Inc.

National Cloak & Suit Co. New York City. *Twenty-Third Anniversary Sale*. May 1911.

—. *Spring & Summer*. Vol. 24, #2, 1920.

Sears, Roebuck and Co. *Wish Book for the Christmas Season*. 1970.

Spiegel Inc. Catalog #154. *Fall and Winter*. 1942.

Periodicals

American Bicyclist and Motorcyclist, 90th Anniversary Issue. Vol. 90, No. 10, October 1969, pp. 69-79.

Delineator. Vol. 24, No. 1, July 1884, pp. 2, 34 & 35.

Delineator. Vol. 37, No. 1, January 1891, p. 39.

Delineator. Vol. 121, No. 4, October 1932. Cover & p. 2.

Delineator. Vol. 123, No. 5, November 1933. Cover & p. 2.

Delineator. Vol. 124, No. 3, March 1934. Cover & p. 2.

Delineator. Vol. 129, No. 2, August 1936. Cover & p. 15.

Esquire, The Magazine for Men. Vol. 19, No. 3, Whole No. 112, March 1943, p.18.

Esquire, The Magazine for Men. Vol. 19, No. 4, Whole No. 113, April 1943, pp. 7, 13, 110, & 138.

Esquire, The Magazine for Men. Vol. 20, No. 2, Whole No. 117, August 1943, p. 139.

Esquire, The Magazine for Men. Vol. 20, No. 3, Whole No. 118, September 1943, pp. 98, 103, 119, & 146.

Esquire, The Magazine for Men. Vol. 22, No. 5, Whole No. 132, December 1944, pp. 124, & 133.

Harpers Bazaar. Vol. 5, No. 23, June 8, 1872. Cover & p. 384.

Ladies' Home Journal. November 1916, pp. 87, 118.

Ladies' Home Journal. November 1938, p. 29.

Life. "Golden Days of Style, Vol. 49, No. 26, December 26, 1960, pp. 105-108.

Life. "Now the Fad is Dolls Hats," July 1938, pp. 34, 55.

Life. "Radiant Elizabeth Presides over Her First Parliament." Vol. 33, No. 20, November 17, 1952, pp. 42-43.

Life. "The Return of the Wimple," Vol. 6, No. 1, Jan. 2, 1939, pp. 5, 52, 53.

Life. "25 years of *Life* Special Double Issues." Vol. 43, No. 26, p.108.

Life. Vol. 70, No. 23, June 18, 1971, cover.

Life. Vol. 72, No. 22, June 9, 1972, cover.

Modern Bride, A Complete Guide For the Bride To Be. Vol. 1, No. 1, Fall 1949, p. 26.

Penny Pictorial Magazine (London). No. 91, Vol. VII. March 2, 1901, p. 513.

Penny Pictorial Magazine (London). No. 102, Vol. VIII. May 18, 1901, p. 451.

Penny Pictorial Magazine (London). No. 108, Vol. IX. June 29, 1901, p. 121.

Photoplay combined with Movie Mirror. Vol. 19, No. 4, September 1941, p. 35.

Playbill for the St. James Theatre. "Oklahoma!" September 2, 1945, p. 2 & 4.

Vogue 50 Years That Vogue Has Seen. November 1943.

Womens Home Companion. Vol. 51, No. 1, January 1929, p. 73.

Articles from Periodicals

Bauman, Richard. "The Stetson Rides Again." *The Elks Magazine*. Vol. 80, No. 4, October 2001, pp. 40-42, 48.

Burke, Kathleen. "Winning the Hearts and Minds of An America Facing War." *Smithsonian*. March 1994, pp. 66-69.

Coffin, Patricia. "The Sixties Our Unbelievable Decade." *Look*. December 30, 1969, Vol. 33, No. 26, pp. 12-31.

Cushman, Wilhela, editor. "Paris Hats-Handle With Care!" *The Ladies Home Journal*. November 1938, pp. 28-29.

Farbman, N.R. and Parks, Gordon. "A Hectic Week of Paris Showings Busy U.S. Buyers Crowd the Spring Collections." *Life*. March 5, 1951, Vol. 30, No. 10, pp. 100-107, cover.

"Fashion Degrees That Our Feathered Songsters Must Be Slain." *The Penny Pictorial Magazine*. London, March 9, 1901, No. 92, Vol. 8, pp. 50-52.

"FYI Tip-Top Topper." *Forbes*. June 6, 2005, p. 16.

"Gainsborough Look in New Fashions." *Life*. May 14, 1956, Vol. 40, No. 20, pp. Cover, 132-133, 135.

"Hatless Hats." *Life Magazine*. February 12, 1951, pp. 67-68.

Jackson, Susan. "Quick, Where Do They Make Panama Hats?" *Business Week*. September 25, 1995, pp. 50A-50B.

Milbank, Renolds Caroline. "The Legacy of Lilly Daché." *Interview*. Vol. 17, May 1987, p. 90.

Miller, Tom. "The Crown of Montechisti." *Global Economy Natural History*. June 2000, pp. 54-62.

Parkard, Ruth Mary. "A Mesh A Minute." *Ladies' Home Journal*. June 1939, p. 60.

Rafferty, Diane. "The Many Faces of YVES The Designer of the Half Century." *The Connoisseur*. Vol. 220, No. 937, February 1990, 56-67.

Robb, Inez. "Sallys Sensational Hats." *Post*. February 17, 1962.

Schultz, Christine. "Why Are Hats Off?" *US Airways Attaché 4*. 1999, pp. 41-49.

Stevenson, Peggy. "Summer's Coming Up." *Ladies' Home Journal*. Vol. 41, No. 6, June 1939, 65.

"The Johnny Jeep Hat-The Army Fatigue Hat Inspires New Fashion Fad." *Life*. August 24, 1942, Vol. 13, No. 8, pp. cover, 16, 104-105.

"The Tricycle" and "The Golden Age Part II: The 90s." *American Bicyclist and Motorcyclist 90th Anniversary Issue*. Vol. 90, No. 10, October 1969, pp. 69-79.

Watson, Bruce. "In The Heyday of Mens Hats-Fashions Began at the Top." *Smithsonian*. Vol. 24, No. 12, pp. 73-78, 80-81.

Wiebel, Jerry, editor. "The Facts About Cowboy Hats." *Country Extra 7*. Vol. II, No. 2, 2000, pp. 20-21.

Newspaper Articles

"Fashions of Elsa Schiaparelli Featured in Philadelphia." *Antiques and The Arts Weekly*. Connecticut; Bee Publishing Co., Inc., November 21, 2003, p. 28.

Martin, Douglas. "Alfred Solomon, 104, Dies: Innovator in the Sale of Hats." *New York Times*. 9/12/2004, Vol. 153, Issue 52970, p. 42, 999p, 1bw.

Moyer, Barbara. "1840s Fashion Section." *Express Times*. June 2, 1995.

New York American-An American Paper for American People. July 7, 1918, p. 3.

Schiro, Ann Mare. "Mr. John, 91 Hat Designer for Stars and Society." *New York Times*. Obituaries. June 29, 1993, p. L D23.

Shaw, Donna and Julie Stoiber. "Wanamaker Stores to be Sold." *The Philadelphia Inquirer*. June 22, 1995, Cover, p. 14.

Womens Wear Daily. "Lilly Daché, French Milliner, Dies at 97," Jan. 5, 1992.

Instruction Booklets

Barsaloux, Elsa. *The Sweater Book Original Model Creations & Designs*. New York: David N. Barsaloux Publisher, July 1918, pp. 13, 37, 40-41.

Easy to Make Hats, Scarves and Accessories. Book #192, USA: The Spool Cotton Company, 1943, p. 3, 5 & 13.

Fleishers Hand Knit Apparel. Vol. 37, p. 25.

Hats, Bags, and Accessories. Book No. 200. USA: The Spool Cotton Company, 1943, p. 4. *Headliners*. 1st Edition. Book No. 215. New York: The Spool Cotton Company, 1944, p. 4.

Hiawatha Cordet and Chenille Hats and Bags Styled By Melina. No. 9. Heirloom Needlework Guild, Inc., 1944, p. 20.

Hoyer, Mary. *Marys Dollies*. Vol. 9, Reading, PA: Juvenile Styles Publishing Company, 1944.

Instructions for Bangle Hats Made of Wool Yarn. New York: Walco Products, Inc., 1962.

Jack Frost Handbags. Vol. 48, New York: Gottlieb Bros., 1944.

Make and Mend for Victory. Book No. S-10, USA: The Spool Cotton Company, 1942. Inside cover & pp. 18 & 19.

Minerva Style Book. Vol. 36, USA: 1934, pp. 8, 18 & 41.

New Hats Star Hat Book No. 117. New York: The American Thread Company, 1950s, p. 12.

Peter Pan Hat Book. Vol. 5. New York: Wool Trading Co., Inc., 1940s.

Smart Bags. Book No. 209, USA: The Spool Company, 1944, p. 7.

Index